# Wild Shots

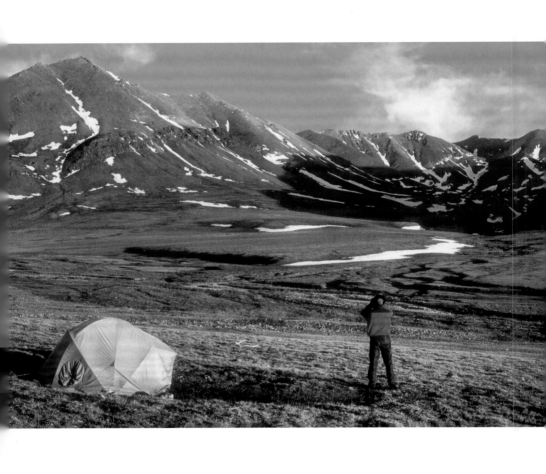

# Wild Shots

## A Photographer's
## Life in Alaska

# TOM WALKER

MOUNTAINEERS
BOOKS

**MOUNTAINEERS BOOKS** is dedicated to the exploration, preservation, and enjoyment of outdoor and wilderness areas.

1001 SW Klickitat Way, Suite 201, Seattle, WA 98134
800-553-4453, www.mountaineersbooks.org

Printed in China
Distributed in the United Kingdom by Cordee, www.cordee.co.uk
22 21 20 19        1 2 3 4 5

Copyeditor: Ali Shaw, Indigo Editing
Design and layout: Melissa McFeeters, www.melissamcfeeters.com
All photographs by the author unless credited otherwise
Cover photograph: *A bull moose pauses near the author's cabin in the Alaska Range, with Mount Fellows in the background.*
Frontispiece: *The author searches for wolves in Sunset Pass, Brooks Range, Arctic National Wildlife Refuge.*

Portions of the stories in this collection have appeared elsewhere in slightly different form: "Cheechako" in *Alaska* magazine; "Camping with the Wehrmacht" on APRN, KUAC-FM; "Ram Country" in *Alaska* magazine; "Wolf Howls" in *Shadows on the Tundra* by the author; "Apex Predators" in *Denali Journal* by the author; "Making Contact" in *Alaska* magazine; "On the Edge" in *Shadows on the Tundra* and *Caribou: Wanderer of the Tundra*, both by the author; "Ice Bears" in *Defenders* magazine; "Goddess of the Dawn" on APRN, KUAC-FM; "Wolverine" in *Alaska* magazine. Part of "Calving Grounds" appeared in *Caribou: Wanderer of the Tundra* and is reprinted with permission.

Library of Congress Cataloging-in-Publication Data is on file for this title at
https://lccn.loc.gov/2019000160.

Mountaineers Books titles may be purchased for corporate, educational, or other promotional sales, and our authors are available for a wide range of events. For information on special discounts or booking an author, contact our customer service at 800-553-4453 or mbooks@mountaineersbooks.org.

Printed on FSC®-certified materials

ISBN (paperback): 978-1-68051-227-4
ISBN (ebook): 978-1-68051-228-1

MIX
Paper from
responsible sources
FSC
www.fsc.org   FSC® C008047

*An independent nonprofit publisher since 1960*

*We can judge the heart of man by his treatment of animals.*

**—IMMANUEL KANT**

# Contents

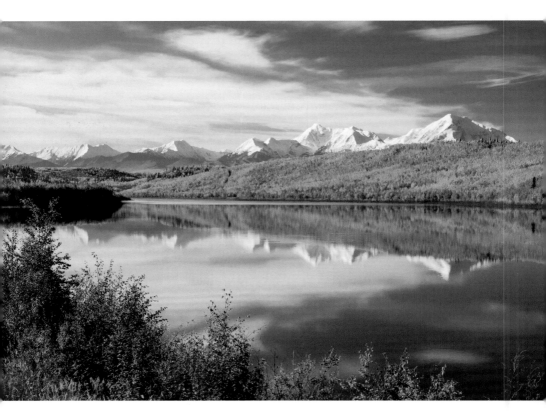

The summits of the central Alaska Range tower over an autumnal wash of color, much like the day I arrived in Alaska.

# *Awakenings*

**ONCE, I DREAMED OF A LIFE AT SEA,** on a sailboat or an island, wearing little or nothing at all. I had visions of crystal water, endless sunshine, lush ports of call and Polynesian beauties, fantasy nights cooled by tropical breezes. Memories of these teenage dreams always bring to mind one question: *How the hell did I end up spending more than fifty years in Alaska?*

I grew up in Los Angeles, smothered by smog, assaulted by heat and ceaseless traffic. The one great wilderness known to me as a boy, the sea, stretched west to far horizons, with distant sails hinting at mystery and adventure. Reading *The Sea-Wolf, Coming of Age in Samoa*, and *Mutiny on the Bounty* fired my desire to be somewhere with pristine air and water and unspoiled environment. Places where wildlife—whales, porpoises, sea turtles, and albatrosses—flourished and a person could forage for food from sea and shore. Places where living meant more than a nine-to-five grind. Seeking cool offshore winds, I explored coastal tide pools and watched pastel sunsets, lured by the siren's song of the distant unknown.

The urban landscape, the tracts of identical houses, the importance placed on glitzy cars and fashion repelled me, a child raised by parents who'd passed on their simple Midwestern values. My grandfather was an alcoholic, a mean drunk, who took his son, my father, out of the third grade to work in a coal mine. They migrated to California in the '20s building boom to cash in on the need for labor. My mother was forty when I was born in 1945, my father forty-three, a construction worker, and neither had the inclination to guide me through the shoals of adolescence. We were poor, limited by my father's education, living on the edge of an affluent suburb that was home to Hollywood stars like John Wayne. Unable to blend in with others my age, who mostly enjoyed material advantages, I sought escape in wandering along the coast and among the chaparral hillsides. Studying the journals of Lewis and Clark, I became convinced I had been born in the wrong century.

Decades-old adventure movies and documentaries revealed worlds beyond my narrow experience. Time and again I watched the grainy, flickering films of cinematographers and explorers Osa and Martin Johnson and their journeys to the wildest places on earth. Another hero was Frank "Bring 'Em Back Alive" Buck, who captured wild animals all over the world. In one movie he wrestled a giant boa constrictor, the coils tightening around him while the breathless narrator heralded his doom, only to be rescued at the last minute by a group of his faithful native trackers. I later realized his thrilling, almost melodramatic, films were often staged reenactments, sometimes pitting captive animals against their keepers.

The wildlife films of Walt Disney were my favorite Saturday matinees. On television I watched reruns of *Bear Country*, *Beaver Valley*, *Living Desert*, and other Disney nature narratives. These films turned my attention from the sea. After reading Jack London's northern classics and Robert Service's iconic Klondike poems, I became fixated on Alaska and the Yukon, the far northern wilderness realm of moose, grizzly bears, and wolves. Dreams of a cabin in the woods slowly replaced visions of life at sea.

A wild animal park just north of LA in Thousand Oaks, California— Jungleland USA—was an irresistible attraction for me. Big cats were the main draw, but I gawked at all manner of wildlife, from bats to bears, most housed in cramped and smelly cages, their ceaseless pacing troubling me. The animal show of Mel Koontz, the premier trainer of Hollywood's golden age famous for training the MGM lion, rivaled anything staged by the finest circuses. He put lions and tigers through their paces, jumping them from one high perch to another or through rings of fire, all accompanied by the crack of whips, blanks fired from revolvers, and the roars and snarls of the apex predators pushed into contact with mortal enemies. Koontz greeted the public after his shows, and I saw the vivid scars that laced his arms.

In high school I had few friends; I was a nerdy, lonesome kid who didn't fit in. Many of my classmates drove shiny cars they spent small fortunes on to soup up. Girls wouldn't take a second look at a bespectacled, awkward boy driving a hundred-dollar beater. I turned ever inward.

My friend Jim Voges and I pored over the gear catalogs sent from South Dakota by Herter's, one of the few companies besides L.L.Bean that supplied outdoor gear at the time. We shared George Leonard Herter books, notably his

*Professional Guide's Manual,* which contained hilarious advice: When charged by a dangerous animal, lion, bear, or whatever, wait until the last second and then "spit in its mouth. This never fails to turn the charge." Jim and I had one thing in common: love for the outdoors and nature, which made us weirdos in the eyes of our peers. His family lived in a ranch-style house on a parcel of land in the chaparral hills, wildlife his passion, deer and coyotes and snakes often in his yard.

Each summer my family went camping at Mammoth Lakes in the eastern High Sierra. Trout fishing was my dad's cherished pastime. Twice a year, beginning when I was two years old, my father, mother, older brother, and I made the long drive north on Highway 395 to campgrounds in the Sierra. When old enough, I dutifully flogged the water of lakes and streams, mostly without luck, all the while my eyes fixed on the distant granite spires, longing to know what stretched beyond.

Closer to home, the Santa Monica Mountains, which we simply called "the hills," separated Los Angeles proper from the San Fernando Valley. Alone, or with Jim, I explored the rocky drainages and chaparral thickets, finding caves, a few adobe ruins of unknown origin, and one or two oases of springwater that attracted all sorts of wildlife. Today the area is part of a national recreation area, but then it was largely unprotected and threatened by development.

My first few encounters with coyotes and deer in the hills left indelible impressions—each sighting a moment of excitement in an otherwise sterile urban setting. More than one neighbor warned me that the hills were "rattlesnake infested" and to stay out. A popular horror story at that time was about a toddler bitten six times as she lifted a rattler into the air while yelling, "Look, Dad, what I found." With each telling the number of strikes increased, eventually to twelve. By then, I had spent innumerable hours in the hills *looking* for snakes, trying to capture them, rarely with luck. Jim caught several Pacific rattlesnakes, which he brought home and kept in an aquarium in his room—including one specimen measuring five and a half feet—then, the biggest on record. Most of the time our snake-catching expeditions came up empty, except for loads of blood-sucking ticks.

A surprising variety of wildlife abounded in the chaparral: gray foxes, mule deer, raccoons, striped and spotted skunks, bobcats, badgers, and lots of coyotes. California quail, horned owls, phainopepla, turkey vultures, red-tailed

hawks, and kestrels were common bird species.
Most people living in tract homes near the edge
of the chaparral had heard the yodeling of coyotes
or had a deer or snake wander out of the brush
and into their yards. Those animals were just a
hint of what lived nearby.

Other, rarer critters lived there too, including
ringtail cats and possums. In the summer of 1961,
Jim captured a coati mundi, an animal far from its
native range, and brought it home in a cage before
releasing it a few days later. Twice we came upon
the huge pugmarks of a mountain lion pressed
into the canyon sand, one touch hot enough to
burn the imagination. But we never saw one.

Just to the north of the valley, in the Sespe
Creek Wilderness, I saw some of the last truly
wild California condors. Once while hiking
I rounded a bend in the trail and surprised a
condor feeding on a deer carcass. Its wingtip
seemed to graze me in its panicked escape . . .
and such a wingspan, almost *ten feet!* In junior
college I gave a presentation on the desperate
efforts to save the last California condors, and
was stunned when a student expressed a fear
of such a "giant ugly bird" and two others mut-
tered, "Who cares?" The comments saddened
me, and I learned that most people held little
concern for wildlife. (With certain extinction facing the species, in 1987,
scientists captured the last twenty-seven remaining condors for a contro-
versial captive breeding program. Today over five hundred condors fly free
in Arizona, Utah, California, and Baja.)

In one remote canyon in the hills, a friend and I found a sandstone cave,
twenty feet high at the mouth and tapering into darkness, but the dry buzz
of a rattlesnake echoing from the shadows sent us packing. The next day we
returned with flashlights, a gunnysack, and a crude snake stick. Searching to

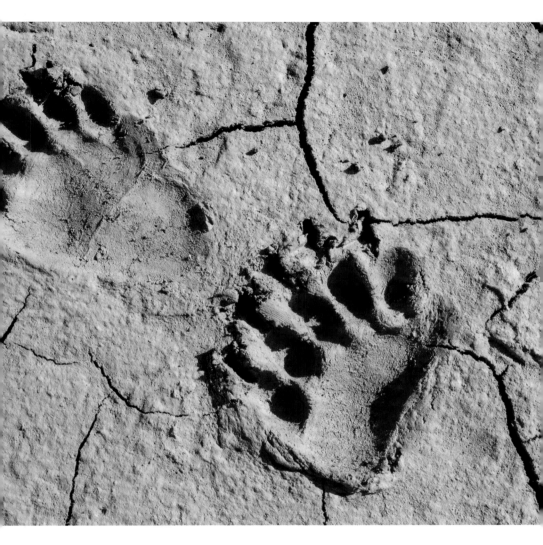

the narrow back of the cave, we saw only tracks and trails in the sand, no snakes or mammals. Halfway in, our lights fell on short, deep, parallel grooves cut into the wall, some

Almost one hundred years ago, the last grizzlies, once abundant in California, were exterminated in the state.

over seven feet off the ground. My friend said they looked identical to the scratchings of a bear that he'd seen on a tree in Yosemite. My splayed fingers barely spanned the scrapes. "Too big for a black bear," my friend said. In the dim light we stared wide-eyed, both thinking, *Grizzly.*

Grizzly bears had been extinct in California since 1924, but we believed we'd found a relic of the past. We'd learned in school that grizzlies were once common, and the state flag predated statehood for the golden bear republic. Early vaqueros, we were told, roped bears for sport and staged fights between bears and bulls. Like elsewhere, the great bear fell to westward expansion, gone the way of the wolf. I still cling to the notion that we found the claw marks of a grizzly in that cave.

Grizzlies and wolves seemed to be lost treasures of North America's marvelous megafauna and gone for good from California. In a stunning turn, in 2011, a radio-collared wolf—designated OR-7, nicknamed "Journey"— wandered into Northern California after an epic thousand-mile trek, the first of its kind since 1924. The Yellowstone wolf recovery project had succeeded beyond any expectations, with the canids spreading across the west. OR-7's arrival in California was greeted with the mix of delight and loathing that the species provokes everywhere. In 2015, researchers released photos of the Shasta Pack, the first wolf family group in California in a century.

Some of my knowledge of wildlife stemmed from the discovery of bones, droppings, or carrion. Any clue or trace of wildlife was something to study and examine. Roadkills were of special interest to me and my friends, and we brought home all sorts of dead things so that we could preserve their skins and skulls. One classmate, Gary Varney, whose father was a beekeeper with apiaries in the hills, thought he had found the El Dorado of roadkill when he spied the long golden tail of a mountain lion extending from the brush aside Topanga Canyon Road. When he pulled the big cat out of the brush, he discovered not a native big cat but a dead African lion. Imagine an African lioness running loose in the hills above Los Angeles! At school the next day, Varney displayed the lion in the back of his truck and explained in vivid detail how it had attacked him. Somehow, without suffering even a scratch, he had battled it to the death.

Tall tales tend to circulate rapidly. Two days later, the Varneys had just started supper when someone hammered on the front door. Gary's father opened it to a nearly berserk giant demanding to meet the person who'd killed his pet lion. Only after hearing the actual story for the third time did the man calm down. The lion's owner was actor Mickey Hargitay, a former Mr. Universe and husband of actress Jayne Mansfield. His pet lioness had

escaped the day Gary found it dead by the road. Hargitay retrieved the lion's skin from a local taxidermist where Varney had taken it. The story made the evening news.

No one believed me when I described the things I saw in my wanderings. My interest in photography was born of a need for evidence—as proof of the bucks I stalked, the snakes we caught, and the raccoons that peered down at us from live oaks. Whenever I got the usual "Right. Sure thing, kid," I'd pull out a stack of prints and point. It would be years before I could afford a good camera, but even those grainy snapshots were invaluable treasures.

From my science teachers and my own readings, I had formed a clear image of early California. Two hundred years ago Southern California was a compelling natural landscape, home to wildlife as diverse as elephant seals and grizzly bears. You could look one way at snowcapped peaks, look the opposite way and see surf pounding rocky coastlines, where the warm desert winds were cooled by sea breezes. With a temperate, almost Mediterranean climate, the soil, when irrigated, would grow just about anything—cotton to cantaloupes. As I was growing up in the 1950s and early '60s, the building boom that had begun in the 1920s was roaring full tilt. Bulldozers turned chaparral-covered hillsides into terraces for tract homes, developing a sprawling metropolis of concrete, steel, and asphalt spiderwebbed with new freeways. In the era before the federal mandates of the Clean Air Act of 1970, smog often rendered the summer air unfit to breathe. The ugly brown haze seared our eyes and lungs. With the temperature frequently above 90 degrees, summer conditions were usually intolerable, the only escape the beach or the distant Sierra. The frequency of bulldozers knocking over live oaks and manzanita, scraping the land flat and bare, disgusted me. There seemed to be no hope for the natural landscape that I had fallen in love with.

Decades before I heard the term *monkey wrenching*, some friends and I began to fight back. Yet another country club had eliminated one of our favorite haunts, putting in a golf course in what had been prime habitat for foxes, quail, and mule deer. A two-mile-long access road ran along a ridge to the main entrance, obliterating the familiar trail we had followed into the canyons beyond.

That summer we found the road lined with the club's advertising signs, in our view unnecessary since the road dead-ended without side roads, and

worse, marring the view of our beloved hillsides. One night the signs mysteri-
ously disappeared. Soon, more signs appeared, igniting a juvenile insurrection.
As fast as the signs went up, we tore them down. When the country club secu-
rity began to drive the road at night looking for vandals, we figured out the
schedule and struck in the early hours before school. Often the signs got bigger
and the posts driven deeper. Eventually the battle seemed to run out of steam,
and for weeks no new signs appeared. Then one day, while driving to a friend's
house, I saw the ultimate escalation at the beginning of the access road—a giant
billboard, supported by three stout poles. *Damn!* This was beyond us. What the
hell were we going to do now?

Stan Kohler, an infrequent combatant in the sign insurrection, master-
minded an ingenious counterattack. He had kept a careful eye on a city sewer
project uprooting his neighborhood, which each night left heavy equipment
parked on the street near his house. He'd seen where a driver at quitting time
had hidden the keys to a dump truck. Late one Friday night, Stan fired up the
truck and drove the two miles to the onerous billboard while another friend
and I followed in the getaway car, all of us now guilty of Grand Theft Dump
Truck as well as imminent vandalism.

Stopping in front of the billboard, Stan backed the dump truck over the
curb, intent on ramming the sign. (Stan, concerned about damaging the truck,
roared in backward, assuming the rear gate was indestructible.) The jolt over
the curb produced an enormous clang of metal, and lights went on in a dark-
ened house across the street. Stan gunned the engine and rammed the far pole;
the signboard leaned but didn't fall. The crash triggered more neighborhood
lights. He pulled forward and then lurched backward again, smashing into the
middle pole, snapping it—but the sign stayed up. More lights. He maneuvered
into position and rammed the remaining pole. The sign shattered, crashing to
the ground.

Stan jumped from the cab and raced across the street to where we waited,
lights off, expecting sirens any minute. In darkness, we squealed off into the
night. Three days later the dump truck was back at the job site in front of Stan's
house, minor dents in the tailgate the only evidence of its late night detour.
Afraid, embarrassed, or both, none of us returned to the scene of the battle for
several days, and when we did, the billboard stood like new—but supported by
four poles instead of three. We finally conceded to defeat.

Looking back, fortunately we never attempted any eco-sabotage the likes of Edward Abbey's *The Monkey Wrench Gang*, our skirmishes only an outlet for frustration and anger over the damage to something we cherished.

After high school I worked as a wrangler for Mammoth Lakes Pack Outfit, carting Boy Scouts, Sierra Clubbers, hikers, and fishermen to alpine lakes to enjoy the John Muir Trail and wilderness just east of Yosemite. In neighboring Ventura County I discovered rodeo during high school, ushering in a jolting, episodic era of bucking horses, spinning bulls, and cheap cowboy bars that lasted for over a decade. When I think about that time, I am somewhat chagrinned, chalking up the courage to ride rough stock to the anesthesia of youth, fueled by poisonous levels of testosterone. I didn't quit until sometime in my midtwenties, when I was sobered by the near catastrophe of cracking my third cervical vertebra when bucked off a horse named Cimmaron.

The outskirts of the San Fernando Valley were fringed with small ranches. Part-time jobs working in stables and with livestock were plentiful, and I was never too lazy to shun shoveling manure for a chance to work with prized thoroughbreds. When I left home at twenty, a volunteer for the U.S. Army, I knew I'd never go back, never live in a big city again—the rural life the only life worth living. Except for infrequent holiday visits and a three-month-long vigil when my father was sick and then died, I happily stayed away.

On my last visit to LA, in the wake of my mother's death, in need of solitude and an escape from grief, I drove into the hills to my most treasured sanctuary, a perennial stream we called Stunt Creek. Fearful of what I'd find, I almost didn't go. In high school I'd spent hours on the creek looking for owls and quail, lizards, king snakes, and salamanders, the summer heat cooled and freshened by the dense vegetation. Turning onto Cold Creek Road, my heart fell, my worst nightmare confirmed. Terraces of California ranch-style houses, with typical red-tile roofs, crept up the hillside—the chaparral, sumac, chamise, and scrub oaks bulldozed away. I slowed almost to a crawl as I rounded the last bends to where the creek crossed the narrow road.

Negotiating the last curve, I was confounded—the slopes on both sides of the drainage were untouched, dense chaparral and live oaks choking the lower riparian zone. I parked in a pullout opposite a padlocked chain-link fence that spanned the canyon mouth. The sign on the gate, across our old foot trail, read:

NO TRESPASSING
MANAGED BY THE SANTA MONICA MOUNTAINS CONSERVANCY. THIS
PROPERTY PROTECTS THE COLD CREEK WATERSHED, PERHAPS THE
BEST PRESERVED AND MOST BIOLOGICALLY DIVERSE WATERSHED
AREA WITHIN THE SANTA MONICA MOUNTAINS.

Out of relief that this treasure had been spared, on top of my grief from my
mother's death, I cried.

# Cheechako

I

**FROM THE AIR, A MOSAIC** of golden birch and emerald-green spruce stretched to the far summits. A thrill raced through me as the Alaska Airlines jet descended to land in Anchorage in September 1966, my ninety-nine-dollar one-way ticket from Seattle the culmination of a dream nurtured since I was a child with writings and images of vast open spaces and wildlife. *Alaska!* The very word conjured images of undiminished wildlife and unchanged wilderness. I envisioned it the perfect place for me.

On the tarmac, as I walked from the plane, the air smelled of autumn, fresh and chilled. A plywood tunnel led passengers past the sounds of heavy demolition, the terminal buildings still under reconstruction from the devastating Good Friday earthquake two years before. The tumult was a disquieting but oddly energizing counterpoint to the forest beyond the airport. Fellow travelers pointed to snow on the peaks and called it "termination dust," a signal of the end of commercial fishing and construction seasons. While waiting for the bus into town, I stood in front of the terminal staring at the glittering Chugach Mountains and wondering what wildlife lived there.

Three days later, I was settled into modest digs on the edge of the city and spending most of my time job hunting. As soon as I could, I hiked off toward the mountains, following a two-track that cut through dense timber and willow thickets. Within an hour I saw my first moose, two cows staring from the forest edge. *They are enormous*, I thought. *They dwarf the deer back home.* From a distance I snapped a few photos with my Kodak Instamatic.

When the moose moved off into the timber, I continued but a little more cautiously. Giants populated these woods. A few minutes later, my nerves on edge, a blur exploded from the grass at my feet, jolting me backward. A blue-gray bird pulsed up into a tree and turned to peer down at me. With shaky hands I took a picture of the first spruce grouse I'd ever seen.

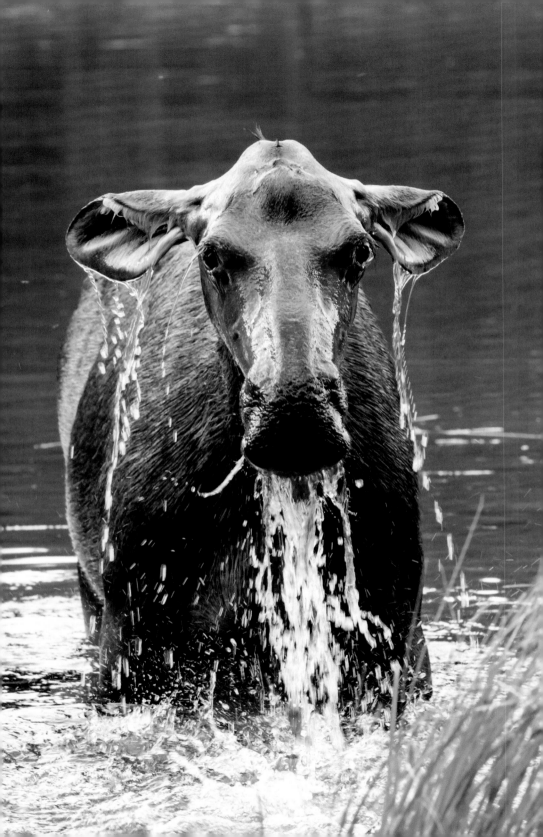

It was a magical foray, encountering moose and grouse amid a striking autumn palette, distant peaks swathed in white. For days I eagerly awaited the return of my processed photos, but they were a letdown. Instead of two moose dominant in the frame, I peered at two black blobs with ears, mere spots in the trees. The grouse sort of looked like a bird shadow. Two weeks later I used nearly all my first paycheck to buy a 35mm camera, a single lens reflex Petriflex. The well-used camera body came with a 55mm "normal" lens but without a built-in light meter. When the salesman heard that I intended to photograph wildlife, he offered me a 400mm f/5.6 lens at a "list price of sixty dollars but for you only forty." *Sold!* At the time I had no idea that a quality telephoto of comparable focal length would cost at least ten times the amount. The lens I bought had all the resolution of a focusable pop bottle and at f/5.6 was considered slow because it didn't let in enough light for use at the higher shutter speeds necessary to stop action.

Regardless of their limitations, that camera and telephoto got a real work-out. I spent every free moment afield searching for subjects, and every extra dollar on film and processing. I'd read that all the professionals used either Kodak color slide film or black-and-white print film. At the time, the only Kodak slide film available in Alaska was Kodachrome 25 with an ASA (now ISO) of 25. (The ISO rates a film's sensitivity to light, and Kodachrome 25 needed a lot of light.)

At the time, I didn't realize that I had the worst possible setup for wildlife photography—a camera without a light meter, loaded with slow film, coupled to a cheap lens. Almost any action or movement was beyond capture. I had to wait for the animal to stop, or at least slow down. The lens was hard to focus—autofocus did not exist in those days—and even when I had a stationary subject, the resulting pictures were inferior, with fuzzy resolution and inaccurate color.

My static images were the epitome of boring, yet I assaulted my new friends with hours of yawn-producing slide shows. I discovered that wildlife was a keen interest of almost every Alaskan I met; slide shows were a big draw in the era before satellite television. In Alaska in the 1960s, before the oil boom, everyone seemed to be there for the outdoor pursuits: hunting, fishing, flying, whatever. It was easy to make friends because we all shared the same

I was awed by my first moose, enormous animals dwarfing the deer back home.

interests. Despite those early horrid slide shows, I'm still friends with some of the people I met through them.

Undeterred, I kept at it. I loved getting to know the Alaskan outdoors and seeing so much wildlife. I carried my camera everywhere, even at work. I made all the rookie mistakes, the most egregious trying to chase after an animal to get close enough for a picture. Untrained in photography, I reinvented the wheel, learning composition, lighting, and technique as I went, a years-long process. One upside to using a camera without a light meter was that I became proficient at judging the light and presetting the camera for the conditions, a skill that would prove invaluable.

## II

Even the judge's eyebrows went up. He'd probably heard it all before, but this testimony more than stretched credibility. When the prosecutor asked the defendant why he'd illegally killed those Dall sheep and left them to rot on the hillside, he replied: "I been huntin' up here for three years tryin' to get me a ram and never seen a legal one. After I made my sneak, I found not a ram in that bunch. I just got pissed off and shot 'em all." Twelve lambs and ewes left dead to rot on a slope above Eklutna Lake.

The prosecution rested without further comment; the public defender had no questions or cross-examination. The judge rapped his gavel. "Guilty as charged. Thirty days community service and a five-hundred-dollar fine. See the clerk." And with that, my second case as a wildlife officer was wrapped up with the usual light sentence.

My first job in Alaska was as a wildlife conservation officer for the military, which controlled vast acreage in the state, home to moose, bison, Dall sheep, black bears and grizzly bears, and other iconic northern species. How I got the job is still somewhat of a mystery to me. Perhaps it was due to a blend of desire, being in the right place at the right time, and a patron—a civilian employee overseeing the wildlife conservation section on Fort Richardson—ready to give me, a total *cheechako*, as greenhorns are called in Alaska, a chance. The varied and exciting work inspired total commitment. Hours didn't matter to me, with workdays that sometimes lasted twelve to fourteen hours. I conducted aerial surveys, collared moose, transplanted

beavers, mapped habitat, issued permits for fishing and hunting and trap-
ping, responded to moose and vehicle collisions at all hours, and enforced
the regulations. It was simply the best job I had ever had, especially the law
enforcement duties protecting wildlife from poachers. My experience was
not directly related, but I fell naturally to the work.

Over a period of two years, I apprehended the shooter of a bald eagle, a father
and son who shot a sow grizzly and her two cubs, moose poachers, and numer-
ous salmon poachers; and I helped catch the man who killed those dozen sheep.

A colleague, a seasonal fisheries technician, and I once apprehended
two men thrill-killing king salmon on Ship Creek, which runs through
Anchorage. At that time, the salmon run on the creek had not yet recovered
from nearly being wiped out. Overfishing in the years after World War II
had all but ended the creek's once-robust runs of silver and king salmon.
My boss estimated that more salmon were being poached than were actually
spawning. Two of us technicians, as we were called, were assigned to patrol
and slow down the illegal take.

One day, at the peak of a particularly weak salmon run, we conducted a
stealthy surveillance on one of the prime fishing holes; my partner approached
from upstream, and I from downstream. Edging through the dense willows
and alders that lined the creek, I heard splashing, voices, and loud laughter.
Then my partner shouted a command. I rushed forward and found him con-
fronting two men, one of whom was brandishing a pole with a giant hook.
Neither of us was armed; it was a dangerous moment. When I called out, the
two men saw me and dropped the pole.

My partner had caught the men red-handed as they wielded the seven-
foot-long pole and sixteen-inch-long hook to gaff king salmon. From hiding,
he watched as they would sneak along the bank until they spotted one of the
bright-red spawning salmon, then creep up and reach out to hook the fish
through the body. After fighting it awhile, they'd flip the fish loose. Before
confronting them, he had witnessed each man kill a fish, one a forty-five-
pound female rich with eggs. They made no effort to retrieve or retain either
fish. After having witnessed this disgusting, illegal waste, we issued a citation,
confiscated the hooked pole, and retrieved the two dead fish.

"Before you showed up, I was sure they were going to hook me," my part-
ner said, somewhat shaken. Within a few weeks the men paid a small fine. I

still can't understand such senseless waste of a precious resource or the judicial system's consistent leniency with such crimes.

After Alaska statehood was granted in 1959, wildlife protection was a section within the Alaska Department of Fish and Game, but in 1969 the duties were transferred to the Department of Public Safety. My boss, and several of his longtime colleagues, rebelled, unwilling to take on duties like traffic enforcement when they already had minimal resources to enforce game laws. The revolt failed and he, and others, moved on. I spent my last summer with Fish and Game surveying salmon-spawning tributaries of the Susitna River.

Like other young people who grew up fishing and hunting, I had thought a career as a wildlife biologist would be ideal. After high school, I had done course work in the biological sciences. By 1970, however, I had become disillusioned with pursuing a resource agency career.

The previous winter I had attended a wildlife management seminar headlined by a renowned wildlife biologist specializing in mountain sheep research, author of several professional and popular wildlife books. His keynote address was highly anticipated, the auditorium overflowing, mostly with resource professionals. His opening statement was: "Any animal that dies a natural death is wasted." He went on to say that modern wildlife management was so advanced that all mature animals, or those deemed "surplus," should be harvested by hunters without detriment to the well-being of the species.

I was shocked. Everything else he said was lost on me. In the Q&A that followed, not one person questioned his strange statements. *Is this the best we can do?* I thought. *Is this how little the biological sciences have advanced?* For days I thought about his comments as well as something that a refuge manager had once told me: "Fish are to be caught and animals to be shot." He saw no value in wildlife other than as something to "harvest," the sportsmen's euphemism for killing. Neither expert appeared to see any intrinsic value in wildlife besides utilitarian.

I couldn't reconcile the notion that a natural death was a waste. I believed (and still do) that all life has inherent value, and if we are to kill animals for our own use, it must be with great respect and forethought. Any notion of my having a career as a wildlife "manager" ended in those weeks. Certainly other varied reasons factored into my decision, not the least of which was that I would

have to return to school to pursue an advanced degree in order to acquire a permanent position. Then, to work as a biologist for a resource agency, a master's degree was almost mandatory. Having tasted the outdoor life, I had no desire to go back to school for an extended period.

Courtesy of my brief foray into agency work, I had discovered an unusual menagerie in Anchorage that fascinated me. It was maintained by the federal government as a research facility and a place where we sometimes took roadkill moose that had spoiled but was still good for animal feed.

Our contact there was an animal keeper we called "the Z-Man," a big man with a bright-red beard and infectious laugh. I don't remember his given name, but I can still vividly picture his workplace: an animal collection run by a government agency, home to caged lynx, coyotes, wolves, foxes, and bears, including a cross between a grizzly and a polar bear which the Z-Man called a "pizzly bear." I am grateful that he allowed me to sit and observe the various animals, most of which simply slept or stared back at me. I once watched a lynx for two hours as it did little but blink. Although I found the studies and cages repulsive, I seized on this rare opportunity to observe animals close up and learn intimate details.

These animals were kept primarily for disease studies, with rabies—endemic to Alaska—of particular interest. The researchers also conducted other experiments on the animals that the Z-Man didn't discuss. On one visit we walked by an old Quonset hut and heard horrific sounds coming from within, sounds much like monkeys in terror or rage. "You never want to go in that building," the Z-Man said. "I never do. In fact let's get the hell away from it."

Later he took me to a large pen where a black bear paced nervously. At our approach, the bear stopped and turned to face us, huffing and chomping its teeth in agitation and warning. I stood near the gate wide-eyed at the closest look I'd ever had at a live bear, impressed by its threat display. When the bear made a hop-bluff charge, I stepped back. To my astonishment, the Z-Man flung open the gate and charged into the enclosure with his own loud roar. The bear catapulted backward and scampered up the fence to the upper corner of the cage, where it clung in panic.

The Z-Man had stopped two steps into the cage and came out laughing. "They bluff a lot," he said, "but always retreat when faced with attack. All show and no go. When they bluff charge, just don't run."

I asked, "How do you know if it's a bluff or the real thing?"
The Z-Man chortled, "You don't."

## III

Once I had a log cabin on a lake, with the reflection of Denali, North America's highest peak, shimmering in calm waters. Loons nested in the shore grass, elegant trumpeter swans congregated in spring and fall, and moose and black bears wandered through the surrounding forest. Many nights, I awoke to the clatter of a pine marten running across the roof and got up to watch it, check the woodstove, and look for the aurora skimming the distant summits. For six years, I lived the Alaskan dream.

I'd pined for a home like this my entire youth, visions of a life lived close to nature and wildlife. I learned that no life was idyllic, that travails and conflict were unavoidable components of life regardless of home and lifestyle.

The exploits of early frontiersmen as revealed in histories and journals had always enthralled me, and when young I strove to learn the outdoor skills that those men possessed. Those pioneers had only themselves to rely on. My dad had taught me how to sharpen an axe, the use of varied materials to build a campfire, and other outdoor basics. In the High Sierra I'd learned to shoe horses, throw a diamond hitch on a packhorse, and pitch a comfortable camp in open, exposed terrain. In my first job in Alaska, I learned how to find and study northern wildlife. John McPhee, in his book, *Coming into the Country*, writes of rural residents who are skillful in a multitude of crafts and can do almost anything. McPhee used the term "man of maximum practical application" to apply to such a person, almost awarding a degree, an MPA, in practical ability. In the vast stretches of the northern wilderness, such accomplished men are prized and said to have "golden hands." I'd met and admired such men, like commercial fisherman and guide Red Beeman of Chugiak, who could do most anything from boatbuilding to engine repair. I wanted to acquire similar practical skills, useful for living in the bush.

For me, the handcrafted log cabin was a frontier symbol—proof of a person's effort and resourcefulness, the pinnacle of wilderness skills. Back in the

Martens, members of the weasel family, prey on red squirrels, voles, and grouse. At Loon Lake, I'd often awaken at night to one running around on the cabin roof or peering in the window.

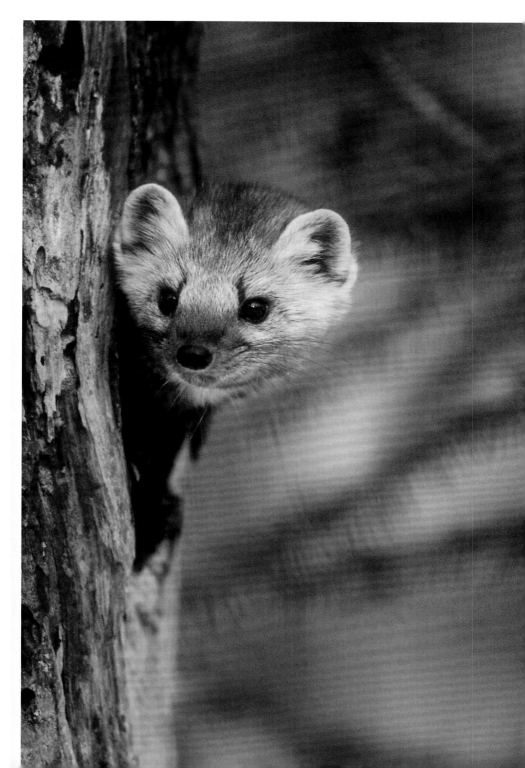

'50s on one of our family trips to the Sierra, I had heard about a "real log cabin" some forty miles from where we were camped, and I badgered my father to drive me there so I could see it. Although it was only a decaying husk, I remember being thrilled. I smile about it now, but the visit left an indelible mark. In my first years in Alaska, I saw numerous log cabins, ranging from rather grand houses in Anchorage to simple, often crude, trapper or miner bush cabins. I burned to learn how to build with logs, creating not just slap-dash affairs but carefully crafted structures hewn with respect for wood and detail.

My first home in Alaska, built with minimal investment other than hard work, seemed the culmination of the Alaska Dream, a cabin on a remote lakeshore.

Before moving to the bush, I apprenticed with a log builder in Fairbanks. Every would-be log builder starts out in the same place, at a log pile with a drawknife. Peeling logs is very hard work. Dried-on bark doesn't come off easily but must be removed because it holds moisture and harbors damaging insects. After the first day or two, many first-time peelers often fail to return to work. Despite a few blisters, I stuck to the task. My muscles hardened, my calluses thickened, and I won the trust of the builder. Once the pile of logs was peeled, I was shown the other rudimentary skills of log construction.

The days of going into the wilderness and building a cabin anywhere you wished were long over by the time I got to Alaska. However, in that era, the State of Alaska offered a program called Open to Entry. Anyone could enter designated state land, stake a parcel, build a cabin, and own it for a minimal fee, a system not unlike the old Homestead Act. I married in 1969, and my wife and I shared a dream to live a simple, minimalist lifestyle close to the land. Ours

would not be a true subsistence lifestyle, but we would supplement with berries, wild plants, and moose meat. So, in 1972 after studying the state's Open to Entry offerings, I flew in to a lake I'd once visited while working with Fish and Game and staked a five-acre parcel. Later that year, our daughter, Mary Anne, was born.

Using mostly dead standing timber and a few spruce trees cut on the parcel, I soon began work on a cabin. Moving the logs alone—by hand—with rope, roller blocks, and a ratchet "come-along," the essential bush tool, was backbreaking labor. One day stands out. In ankle-deep water, falling rain, and clouds of ravenous mosquitoes, I bent and shoved and pulled the ridgepole two hundred feet from stump to cabin. I remember thinking, *So much for the*

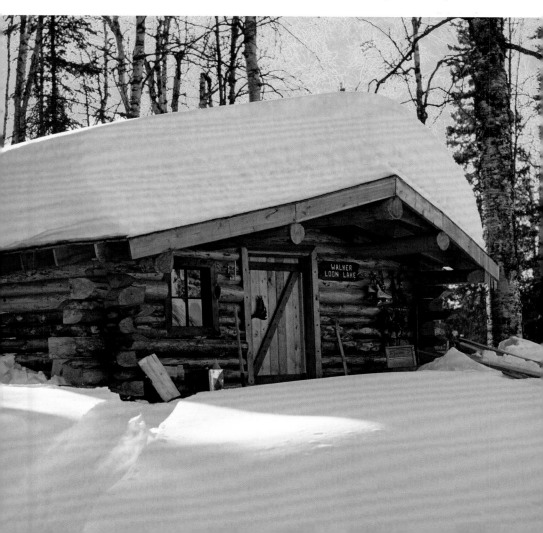

*romance of cabin building.* In time the cabin was built and became our home, debt-free.

Mary Anne was two when we moved in full-time, the only access by air, snow machine, skis, or snowshoes. Our belongings, supplies, and food came over the trail. Our first Christmas in the new cabin was immensely satisfying. The early hours were colored by the aurora, the dawn turning bright and clear, the air slightly below zero. Handmade presents and boxes sent by distant relatives enlivened the day. The cabin was warm and comfortable, and full of a child's laughter.

Each summer we would leave the lake for a few weeks so that I could earn money guiding rafters, fishermen, photographers, and a few hunters, and also to work with another log builder. Life in the bush, although sometimes hard due to the vagaries of weather, was immensely fulfilling. In time, I built an addition to the cabin, a workshop, and then a sauna. If the bush teaches anything, it is self-sufficiency. Just imagine two people hoisting a sixteen-foot-long, thousand-pound ridgepole log and setting it seventeen feet in the air atop a gable end using only a come-along and ropes. Do many things like that, which often the bush life demands, and you soon learn that you can do almost anything. No need to stand back and call for help. Just do it. It was a simple, uncomplicated life, largely removed from modern consternations.

Wildlife photography remained one of my passions. My love for being around animals grew, the joy of observation bringing peace and tranquility. My photography steadily improved, and I sold my first photo—a bull moose feeding in a lake—in 1970. Making a living as a wildlife photographer seemed iffy at best, but I wanted to try. Living so close to wildlife offered the chance to learn a great deal. Black bears stumbled onto our porch at night or climbed the back wall of the cabin. Moose sometimes ruminated in the snow by the woodshed. We learned to live in harmony with these potentially dangerous animals. Birds of all kinds fed at our feeder, and once a mink stole the suet left out for the woodpeckers.

By the time my daughter was eight, she had been to Katmai, McKinley Park, McNeil River, and other wildlife hotspots. When little, she loved watching critters and reading *Ranger Rick*, a children's nature magazine. Her favorite animal was the short-tailed weasel often found around the cabin. One

Christmas she received a farm set and was truly bewildered by the animals. She thought a cow was a goofy-looking moose and a pig a very poorly made bear.

Like many pleasant dreams, that life ended too soon and I was left a single father of a young daughter, which necessitated our move to town. Even the tumult of that transition could not eliminate the satisfaction of life in the Alaskan bush: the self-sufficiency that built personal confidence, the daily joys of wildlife observation, the repetition of skills that built competence, the keen awareness that life was not about acquiring material goods, and the joy of raising a smart, aware child.

In my early thirties I gave up guiding altogether, preferring the craft of log building. There was just something about doing a hard day's work and at quitting time seeing the tangible fruits of one's labor, a genuine satisfaction in doing a project well and to completion. Log home building also allowed me plenty of time to get out in the field with my camera. Then in my late thirties, I underwent invasive surgery, which, within a few years, prevented me from continuing as a log builder. By the time I had to quit, I'd built thirty-five log structures, including the Cooper Landing Community Library on the Kenai Peninsula, and was proud of the workmanship. My focus shifted to photography and writing.

I look back to the early 1970s as a time of intense energy. I felt a keen satisfaction in learning old, time-honored skills and forging a simple, rigorous life. My desire to learn everything I could about wildlife has never faded. My life in the bush transformed me, as it had many others. Bush life only strengthened that desire, and I continued to seek out mentors steeped in the ways of Alaskan wildlife.

## IV

Low clouds scudded eastward, caressing the snow-patched peaks of the Alaska Range, the chill wind scented by moldy leaves and cranberries. The lime, crimson, and gold autumn tundra below Polychrome Pass contrasted starkly with the gray, rocky riverbeds lacing it.

A mile west of the summit I sat glassing for caribou. A half mile out, I spotted five white-maned bulls feeding westward, all but one adorned with large antlers, prime subjects for photography. I parked the truck, slipped on my

pack, slung my tripod over my shoulder, and headed down a dry creek bed that fed out onto the flats.

Dense willows crowded the creek, and I made plenty of noise to alert bears of my approach. Once I was out on the open tundra I moved easily through knee-high dwarf birch. The folds in the terrain concealed the caribou, so I angled slightly west of where I'd last seen them.

Tips of antlers waggling above a tundra rise led me to the bulls. Caribou startle easily, so I altered direction to be farther away when I came into their view. I topped a ridge seventy yards from the nearest bull and saw his head snap up to study me. After a few moments, satisfied that I was harmless, he resumed grazing. Here was a perfect scene: a prime bull with blood-red antlers draped with remnants of freshly scraped-off velvet, set against vivid tundra and distant snowy peaks. Excited, I rummaged in my pack for my camera. Finally ready, I looked up and caught unexpected movement to my right. Another photographer was ahead of me and already at work.

In that era it was considered rude, even unethical, to approach an animal being filmed by another photographer, so I dropped my pack and sat down to watch. The bull seemed at ease with the man's presence, continuing to graze with only a casual glance his way. On occasion the bull would look toward his four companions or scan the horizon, but he paid us little attention.

The photographer, moving ever so slowly, changed positions once in a while, but the bull ignored him. Soon the other four bulls had fed into the clearing and were arrayed in front of him. I longed to join in, but the first on scene had certain unstated rights. Many professionals felt that groups impacted wildlife in negative ways, ruining the opportunity for both subject and photographer. A lone person, moving carefully, had no impact on behavior or the animal's well-being.

I thought something about the man seemed familiar, but his face was hidden. He wore a blue hat with an upturned bill, a red chamois shirt, a down vest, and blue jeans. It was 1972, yet he carried an old Trapper Nelson pack board dating back to the 1920s and used a wooden tripod of the type preferred by cinematographers. He hadn't been visible from the road, or I wouldn't have come out.

My binoculars were at the bottom of my pack. When I dug them out and took a look, I recognized Cecil Rhode, a pioneering photographer. Maybe I could learn from the master.

Cecil hardly moved as the caribou fed around and in front of him. Every now and then he shifted the big telephoto lens, each motion slow and deliberate.

The bull continued to crop the dry grass and move ever closer to Cecil, eventually passing within twenty feet, too close for photographs. Cecil stood still, silent, doing nothing to bother the animal. He was as motionless as a tree or bush.

Some moments passed before the bull again wandered into camera range. Almost as if on cue, the bull turned and looked back at Cecil, assuming a classic pose, as if proud of his enormous antlers. I heard the shutter click and watched as Cecil advanced the film lever and shot again.

For an hour, the two seemed as one, the man creating, the animal accepting, unafraid. The shutter clicked rarely but always at the right moment: when the bull raked his antlers through a bush, when he threatened another bull with his rack, and when he scratched his head with a hind hoof. On a patch of crimson bearberry the bull posed against a backdrop of gleaming peaks, a gust of wind ruffling his white mane—for a photographer, a dream shot.

All at once the bull stopped feeding, as if aware for the first time that he was alone, the other bulls gone to the west. He seemed to hesitate. First he looked at them, then at Cecil, then at me. Decided, he broke into a trot toward his distant fellows.

Rhode stepped from his camera, put his hands on his hips, and bent backward. "Saw you coming earlier," he said as I walked up. "Thought you'd work him too."

"I intended to, Cecil, but then I saw you. I didn't know anyone else was here, or I wouldn't have come down. He gave you a show, didn't he?"

"Well, thanks for not horning in. Did look like I had him on the payroll, didn't it? I might've managed a few good shots, but who knows? I'm all done for today if you want to go after them."

We talked a short while longer as Cecil packed his gear. After we shook hands I trailed after the bulls now grazing in a marsh a half mile distant.

Cecil's bull was closest to me, and I approached cautiously. He seemed nervous now, not as relaxed. I tried for better than a half hour to make a good composition. The colorful tundra, sparkling mountains, and prime bull offered an ideal combination for a great photo. Yet something was always wrong. Either the bull turned away, or a bush or the backside of another caribou ruined the composition. When the bull finally faced me, his head drooped and he dozed

off. Frustrated, I changed positions twice, but to no avail. Emulating Cecil, I did not crowd the bull but waited for the key moment.

Long minutes passed while the bull dozed. Then suddenly his head jerked up and he turned slightly to his left. Wide-eyed, he watched a blur of movement in the distant willows. Here was the classic pose I had waited for, and I shot several frames. A count of ten passed before the bull hustled off after the other bulls now rapidly trotting west.

My shoot was over for the day. Hiking hard, I caught up with Cecil just as he reached the road.

"Did you manage to get a good picture?" he asked.

"Cecil, I owe you a commission."

## V

In 1979, I saw Cecil in Igloo Canyon where the park road parallels the creek of the same name. Through binoculars I spotted him almost to the summit of a knife-backed ridge and edging toward a band of Dall rams. By eight o'clock in the morning, Cecil, age seventy-seven, had already climbed a slab-sided canyon and was nearing the summit. I watched him approach, then sit down within fifty feet of the rams. Impressed, I fervently hoped that when I got to be his age, I would be capable of doing the same thing.

I'd first heard of Cecil Rhode during my first year in Alaska; even then he was a legend, a true pioneer in his field. In the 1930s, impoverished by the Great Depression, brothers Cecil and Leo Rhode decided that Alaska was the place to start anew, a poor man's paradise where a person could homestead, build a cabin, live off the land, and be better off than standing in a bread line. In Seattle, short of funds to buy passage on a steamer, they bought a rowboat and headed north. Weeks later the brothers rowed into the Ketchikan dock and soon found work in a mine. Later their cousin Clarence Rhode followed them to Alaska and eventually became the territorial head of the U.S. Fish and Wildlife Service. In 1937, Cecil homesteaded on the shore of Kenai Lake, where he built a log cabin, the family home to this day. During World War II he returned to Seattle to work for Boeing. While there, he wooed Helen, his wife-to-be.

Cecil and Helen Rhode in Sable Pass on a bright autumn day, both excellent photographers in their own right

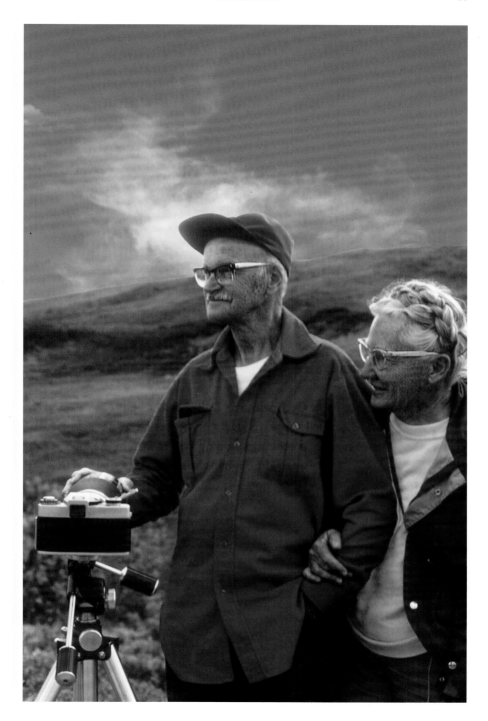

He was a genuine wilderness man. Carrying a rifle and a backpack, he would disappear into the wilds for weeks at a time and emerge with film of huge bears, moose, and other animals. Walt Disney had used some of Cecil's footage in the True-Life Adventure series that I'd grown up with. In August 1954, *National Geographic* published Cecil's story, "When Giant Bears Go Fishing," the location withheld at the time to protect the brown bears of McNeil River. It was a powerful opening salvo in the war to protect this magical world treasure.

I had met the Rhodes through a mutual friend, Bill Ruth, and whenever I saw them in McKinley Park, we took time to visit. (In 1980, Mount McKinley National Park was expanded and renamed Denali National Park and Preserve.) Cecil and Helen patiently answered my endless questions. They were understandably somewhat reluctant to reveal prime photo spots, but they otherwise happily shared their knowledge. I questioned Cecil about wildlife behavior and found him a font of information, full of fascinating tidbits of things he'd seen and experienced. He gave me one bit of advice I'll never forget: "To capture good animal behavior, you have to be very careful never to intrude or interfere. Learn to read the signs and know when to back off. You've got to be like a tree or bush, or rock on the tundra, never altering the wildlife's behaviors."

The evening after I saw Cecil with the Dall sheep, a light rain fell and the thermometer edged toward snow. In such conditions I was not surprised to see Cecil and Helen later that evening standing arm in arm in the lobby of the old Mount McKinley Park Hotel, although in the seven years since I'd first met them, I'd seldom seen them in the hotel.

"A good night for a gin and tonic," Helen said, inviting me to join them in the Spike bar. Once we secured a table, Cecil excused himself and went back to the lobby. Helen watched him go, then leaned across the table. "For some reason or other," she confided, "Cec's having trouble staying warm this fall."

"It must be tough to keep warm in that tent," I said, thinking of their old canvas umbrella tent I had seen, which was little more than basic shelter. Most people their age used a van or trailer for camping. Helen shook her head and said, "No, that's not it. He is never bothered by the cold like this. Even on warm days he wears his down vest. He almost never complains of the cold, but he's mentioned it lately." Just then Cecil returned, and we spent the next hour

swapping stories. I said good night to the Rhodes as they descended the hotel porch into the darkness.

It was the last time I saw Cecil alive.

I learned later that when Cecil and Helen returned from the park to their Kenai Lake cabin in 1979, they dove into their autumn chore of gathering and cutting firewood ("woodin'," as they called it). As winter came on, Cecil's health declined and he visited a doctor in Soldotna. A battery of tests revealed colon cancer. Cecil listened calmly to the news then asked a series of questions. What would happen next? How would the disease progress? Would there be much pain? What were the treatments? What would he gain if he submitted to surgery and chemotherapy?

The doctor said that even if Cecil underwent the full course of treatment, his disease was so far advanced that he would at best have only a year to live. He listened then made his decision. No surgery, no chemo, nothing. "Surely you want painkillers," the doctor said. "Nope. Nothing," Cecil said. And with that, he went home to the lake. He died at home barely two months later.

Friends and neighbors closed around the family. Their son, David, and neighbors thawed frozen ground in the small Cooper Landing Cemetery and hand dug a grave. Another friend built a simple wooden casket. On a raw winter day, over a hundred people gathered for the funeral. Many broke down when the pallbearers passed by, one of Cecil's trademark hats perched atop the casket. The simple remembrance testified to a life devoted to wilderness and wildlife and a death with dignity. Later, a 4,405-foot mountain south of Kenai Lake was named in his honor.

In the years following Cecil's death, I grew closer to Helen, seventeen years younger than her late husband. She was gregarious and outgoing, somewhat the opposite of Cecil. She welcomed friends into her home with coffee, treats, and good stories. She and David counted their friends in the hundreds.

Helen was an award-winning photographer herself, her work published in national magazines and books. She said she learned the photography "game" from Cecil so she could accompany him on his trips. "With a camera I was as engrossed as he was," she once said. "I just loved watching wildlife, especially moose. They act so humanlike sometimes." Cecil had bought her an Exakta and 500mm lens and taught her the basics. "You never push them," she said.

"Cecil showed me to ease in. What you want to do is just sit and let them do the natural thing. You become sort of a giant ground squirrel, which they ignore." Her simple, uncomplicated technique was to stay put and wait until something happened. Helen amazed her peers and friends with the quality of her pictures. A brown bear cub high in a spruce tree. Two bull caribou sparring by a pond. A grizzly nursing her cub. A wobbly moose calf peering from beneath its mother's legs.

Helen had come north with Cecil after the war in 1946 and settled into a subsistence lifestyle in their simple home. They hunted, fished, cut wood, and nurtured a lush garden—a frugal but rich life. "You didn't have to buy much," Helen said. "We ate moose, grouse, rabbits, and wore old clothes." They first visited McKinley Park in the early 1950s, when the railroad offered the only means of access. They loaded their vehicle on the train in Anchorage, disembarked at McKinley Station, and spent the summer in the park, seeing very few people but plentiful wildlife.

After Cecil passed, David accompanied his mother to the park each fall. They camped at Teklanika River Campground, and in bad weather or during periods of poor light, they chatted with rangers, photographers, and visitors alike. Even when slowed by age, Helen kept trying for great photographs. Instead of expressing frustration with her limitations, she spoke with self-deprecating humor. "Since I always get there when the animal is leaving," she once said, "I'm going to do a book of pictures of animal butts. I'm going to call it *The Living End* or *Don't Give Me Any Ands or Butts.*"

An article in the *Anchorage Daily News* described her as the "grande dame" of nature photography. She asked me several times what that meant. I assured her that it was an honorific designation, but Helen loved to debate things. Days later she said, "I've got it. I know what it means. I looked it up in the dictionary. *Grande* means 'big'! I'm the big dame of photography!"

The last time I saw Helen, she was in the Anchorage hospital ill with cancer. Her one complaint: "I haven't taken a picture all fall." It seemed almost more upsetting to her than her illness. Only when I saw the ice cream melting untouched on her tray did I realize how sick she really was. She loved her sweets.

Helen died a few weeks later, in September 1992, at age seventy-three. Over 150 people gathered in Cooper Landing to pay tribute to their beloved friend.

After her death, the Alaska Chapter of the American Society of Magazine Photographers awarded Helen their Lifetime Achievement Award. David scattered a portion of his mother's ashes along the shore of Kenai Lake. The next summer he took the remainder to Denali Park to spread near one of her favorite places. For several days he hesitated, as if reluctant to let his mother go. Late one day, with Denali glowing with light, David hiked up Stony Dome and tossed Helen's ashes into a stout wind racing toward the mountain. Some of us like to believe she is there, looking down at her friends, both human and wild.

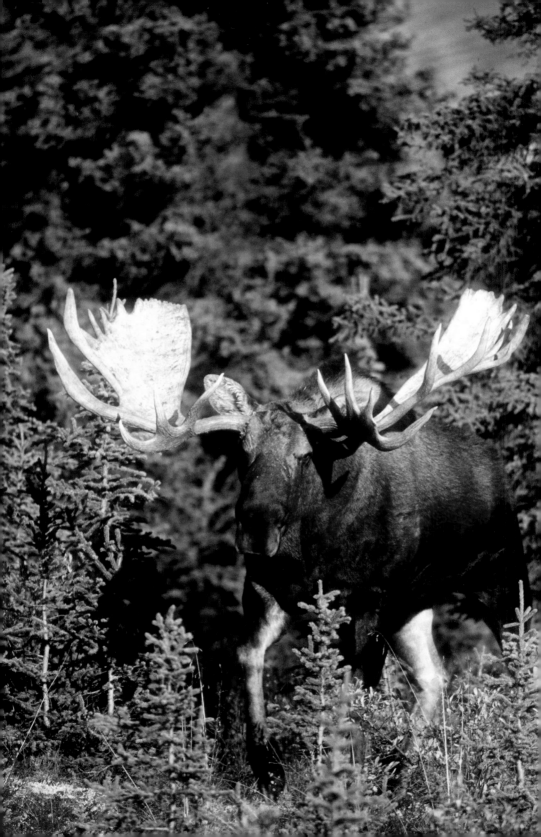

# Camping with the Wehrmacht

## I

**ALASKAN SOURDOUGHS,** as old-timers are known, rate the 1950s as the best years in the Northland for hunting, when animals were plentiful and competition nil. As late as the 1960s it was still possible to camp in a prime spot near the road system and never see another person or even hear a plane.

I grew up around hunters and fishermen, and as a teenager I hunted deer, pheasant, and quail. Hunting seemed an honorable, worthy endeavor, especially when conducted in the old way, with horses and pack mules trailed far into the wilderness. In California I had led pack strings of fishermen and hunters in the High Sierra wilderness, feeling much like a pioneer. The best hunting was done on foot, out of a spike camp of wall tents accessed by horseback. The entire experience was to be savored: cowboy coffee boiled in a blackened pot, simple meals cooked over an open fire, long days of climbing and hiking the meadows and scree slopes, hours spent studying the terrain through field glasses, and the thrill of a stalk well made. Killing an animal for horns and meat was part of the adventure but not the entire purpose. Even when I was new to Alaska in the 1960s, I could see that airplanes and vehicles were fast replacing the old traditions of fair chase and wilderness travel.

In the late '60s I worked for an outfitter hunting with horses so I could work outdoors as much as possible. Two lodges I worked at specialized in guiding European moose hunters. The owner of one of the lodges had served in the Allied occupation of Germany after World War II and had married a German woman. He spoke the language fluently and had developed a German clientele.

Many of his German and Austrian clients expressed a broad knowledge of forests and wildlife management,

The world's largest deer, Alaska moose grow outsized antlers, highly prized by hunters and photographers alike.

far beyond that of most American hunters. Many traveled halfway around the world solely to kill a large bull moose, which they called *Elch*. Killing a large moose seemed to confer special status. They spent small fortunes to hunt what one Austrian called "Alaska's king of all animals."

One major difference separated German hunters from American—in Germany not just anyone could buy a license and go hunting. There, a person had to earn a license by passing a comprehensive test that covered regulations, traditions, wildlife management, field care, and firearms safety. Hunters also had to demonstrate shooting proficiency. In addition they followed specific traditions and rules not mandated by law. Because of limited public land open to hunting, most hunters belonged to exclusive clubs and hunted on private property, accessible only to a few.

Most German and Austrian hunters traveled light, arriving in Alaska with just a small rucksack and their personal firearm. Invariably they were dressed in their hunting clothes: knickers, hat, sweater, and thick socks—and everything was green. Small pieces of fur or feathers stuck in the band of a T*irolerhut* symbolized hunting success.

For the most part I admired their traditions, based apparently on ancient rituals, and especially the respect shown for the slain animal. After killing a moose, a hunter would place a small sprig of evergreen in its mouth, *der letzte Bissen*, "the last bite," and another piece under their hatband. This sign of respect indicated a reconciliation of the animal's spirit and God. (Alaska's traditional Koyukon people put fish or meat in the mouth of a slain wolf as a final offering.) Many of these Europeans seemed particularly happy when wandering through dense timber, perhaps because it reminded them of home.

Although I appreciated the reverence these *Jägers* expressed for their slain quarry, I didn't understand the compulsion to kill a big moose. One seventy-eight-year-old man, the owner of a large pharmaceutical company, flew to Alaska to kill a moose, knowing in advance that as soon as he left Germany, his sons would try to seize control of his corporation. On the third day of his two-week hunt, he killed a huge bull. That very night he was on the plane back home.

Most hunters were much older than I and rich enough to afford such a hunting trip. When you share a tent with someone, even a stranger, you get to know a lot about them—family, friends, hobbies, philosophy. Sometimes brief

snippets of these older men's war history emerged. Several were Wehrmacht veterans, and one had been a Luftwaffe pilot. Significantly, none had fought on the brutal Russian Front. The oldest, the pharmaceutical executive, had served as an adjutant general in the Afrika Korps under Field Marshal Erwin Rommel; his companions treated him with great deference. Two of the youngest men had been in the Hitler Youth and fought with the home guard as the Allies advanced through France. One of them told me that when he saw an American flag on an approaching tank, he surrendered without firing a shot. He was fourteen years old.

One of the younger Germans I met, a man named Wolfgang, said that his father had been a high-ranking member of the Nazi Party. None of the others had ever mentioned party affiliation, but Wolfgang volunteered it. Although he was hunting with his father's Mauser, he railed at the Allies for confiscating their hunting guns. "They took all our rifles away after the war," he said, "even the antiques." Apparently a few had been hidden away.

Talkative, he told stories of varied trips. Some were entertaining, a few boastful, and one quite revealing. Once, when staying at a four-star hotel in Paris, a bedbug crawled out on the pillow by his wife's head. He immediately called the manager and demanded another room. "Paris is an old, lovely city," he said. "Too bad we didn't burn it when we had the chance."

One evening he described a night in his father's Bavarian hunting lodge and seeing his father, Hermann Göring, and Adolf Hitler drinking toasts in front of the fireplace. (I later learned that Göring was the first *Reichsjägermeister*, or imperial gamekeeper, under the Nazi regime.) Wolfgang then made an astounding comment. "Hitler was misunderstood," he said. "Today no one realizes all the good that he did. Hitler was a great man and highly misinterpreted." Even though he had been a small boy during the war and had taken no part, I came to loathe Wolfgang for his beliefs and arrogance.

When Wolfgang's trip was over, my next client was a Swiss whose family had emigrated from Germany to Switzerland in the 1930s to avoid living under the Third Reich. I told him about Wolfgang's comments, and he exploded in anger. "That damned idiot," he said. "Those damn fools are just waiting for the right person to come along and then do the same things all over again."

Later that fall, an event transpired that follows me to this day. I was the only Alaskan sharing a 1920s-era cabin with seven German hunters. After frying

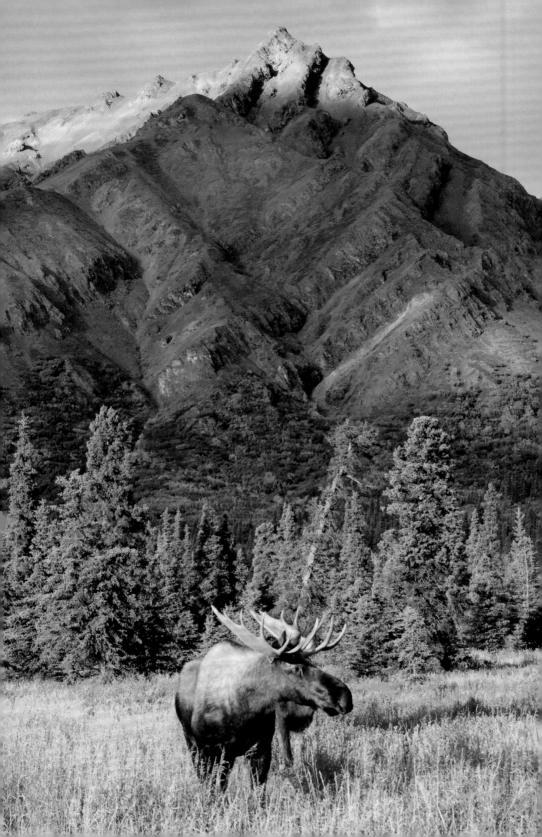

potatoes and moose steaks for dinner, I sat on a bunk in the back of the cabin to watch some sort of traditional *Weidmann* (hunter) ceremony.

Even today I can close my eyes and see the interior of that old log cabin, a long table dominating the center. I envision seven men sitting at the table, three to each side and one at the head, all dressed in green uniform-like clothing. Boughs of spruce form the table's centerpiece, with four candles providing the only illumination. Belt knives, bright buttons, and rings sparkle in the firelight. A dignified-looking, gray-haired man—the *Jägermeister*—stands at the head of the table with his cup raised, offering a long-winded salute. His face glows in the candlelight, and he speaks German with crisp earnestness. At a sudden command, the six men stand, raise their cups, and in unison shout: "*Weidmanns Heil! Weidmanns Heil! Weidmanns Heil!*" The leader responds to this cry of "hunters luck" with a loud retort, then drains his cup of schnapps. With a shout, the men drain their cups and break into laughter.

After witnessing this, it took a few moments before I realized that one of them was asking me to come to the table. My thoughts were far away, in another time, in another place, a Bavarian hunting lodge, and I went to the table slightly leery of the men I'd spent so much time with but would never really know.

## II

Not every German I guided was a war veteran or a hunter bent on slaying a moose. I guided fishermen, rafters, and a few photographers. Every trip, regardless of goal, meant work—and often, diplomacy.

Don DeHart, the late Alaskan hunting guide, once wrote a book entitled *Oh, for the Life of a Guide.* It took just a short immersion into the guiding profession for me to fully appreciate the irony. At first blush, guiding seems a great way to make a living. You do the things you love—camping, photography, fishing, hunting—and get paid for it. *What a life!* And it is, except for one thing: some of the people, or clients, as guides call them. My dad used to say that if you really want to find out what a man's like, take him camping. He was right, of course, because out in the field, with all the social props removed, people are swiftly reduced to their basic nature.

In the shadow of Igloo Mountain, a small bull moose, in autumn prime, searches for receptive cows as the rut intensifies.

Extended outings have a way of straining, even destroying, friendships. Now imagine taking a stranger who hasn't the foggiest notion of Alaska's vagaries into the wilderness and perhaps you've a glimmer of the potential for disaster.

Quite surprisingly, however, the bulk of guided trips I led turned out very well. Successful guides, I learned, are not necessarily the most skilled outdoorspersons but often the best at dealing with people. The key ingredient is respect—respect for the client, the wildlife, and the wilderness. The very best trips are the ones where the client and guide become genuine friends.

Each client holds specific, sometimes peculiar, priorities. A good guide works hard to fulfill his client's wish list. One of my all-time favorite trips was with a couple from Frankfurt. Hans spoke absolutely no English; Linda, his wife, was fluent. The first morning, after saddling and packing the horses, I gave Hans and Linda my standard safety-around-horses speech. I finished off with a recitation of the other hazards to be encountered, such as river crossings, boggy ground, and steep inclines.

"Any questions about the horses?" I asked. There were none.

"OK, then. Anything else?"

"Hans vants to zee and photograph vut you call a pork-q-pine."

"Uh, huh."

"Zis is important," Linda replied, as if my response was not reassuring. "He vants to zee a pork-q-pine number one."

"No problem," I said. "They're everywhere. We'll see lots."

One thing you learn as a guide is to project an air of confidence, of being in command. Even if you have doubts or anxieties, never let on. You're the leader, you're the Daniel Boone; they are the pilgrims. Answer quickly and decisively—even, I might add, if you haven't a clue what you're talking about. I hadn't seen six porcupines in three months, but I knew they were out there.

"Now vee must teach you to zay *pork-q-pine* in *Deutsch*," Linda said.

Uh-oh. "OK, shoot," I said with mock enthusiasm.

"Zay after me, *Stachelschwein*."

I dutifully gave what I thought was a good rendering of the name, which I took to mean something like "sticker pig." (Later I learned that *stachel* means "needles.")

"*Nein! Nein!*" Linda corrected, "*Stachelschwein*."

I tried again.

"*Nein! Nein!*"

And again . . . and yet again. I stood there on the tundra repeating that strange name over and over while she waved her arms like a demented orchestra conductor leading the Berlin symphony playing Wagner.

After about the tenth go-around, Linda dropped her hands and looked back at Hans. "*Ja, ja, das ist gut,*" he said with a broad grin. "*Das ist gut!*"

Linda turned back and gave me a smile, not unlike—I suspected—kind owners give a slow puppy who's finally learned to sit.

Newly fluent in the German language, I finished loading the packhorse, and soon we were under way, heading off for two weeks in the mountains, far from highways, phones, television, or any other modern contrivance. Over the first couple of hours, I thought a lot about Hans's number one priority. I could well understand spending time and money to travel halfway around the world to swat mosquitoes and shiver in the rain to photograph grizzlies, moose, caribou, or Dall sheep—even shoot a moose—but to see a porcupine? *Oh, well,* I thought, *if that's what floats his boat, I'll search for the trophy porcupine.*

For the next twelve days we rode up one river drainage, then down another, crossed mountain passes, and wandered over tundra flats. We camped in heavy timber and in alpine meadows. We experienced rain, snow, wind, cold, and sun. We photographed two grizzlies, four very large bull moose, several bands of Dall rams, and a few dozen caribou. We even heard the howling of wolves. But nowhere did we see a single porcupine. Not one. Not a pellet.

Throughout history, guides have prided themselves on being able to find routes, places, or animals that mere mortals could never find on their own. Kit Carson would be a fine example for a modern guide to emulate, except he didn't have to carry a forty-pound pack of camera gear, sneak right up to a grizzly, and rip off several rolls of film to be considered successful. Failure is a terrible blow to a guide's ego. Fortunately, guides seldom fail, and if you don't believe that, just ask one.

On the thirteenth day of the fourteen-day trip, we headed back upriver toward the lodge and the airplane that would start Hans and Linda on their way home to Frankfurt. I would miss them. They were great sports. Never whined, never demanded anything unreasonable or unsafe, and never complained about my cooking. We had seen lots of wildlife and camped in

genuine wilderness amid vivid autumn colors. If the success of a trip can be measured by the amount of film exposed, ours had been a rousing success. Somehow, though, I was feeling defeated. It was the porcupine—the wily, elusive porcupine.

The trip's next-to-last day was warm, calm, and sunny, with only a few white puffy clouds hanging over the snow-tipped peaks. We rode along the riverbank on a trail that wound through spare golden-leaved aspens. We stopped often for pictures.

While waiting for Hans at one such stop, I heard a slight rustle in the spruce behind me. I turned, and there, not five feet away, was a porcupine. *Oh, my God*, I thought. *What was that German word again?* My mind went blank. I panicked. My instinct was to turn and shout, *"Porcupine!"* much in the same manner as miners had once shouted, *"Eureka!"* but I thought Hans would think I was warning of danger.

*What was that damn word anyway? The last part of it was something vaguely familiar, but what was it?* Dog, *that's it*, I thought. *That's it. The last part of the word was German for* dog ... *which is* ... *is* ... hund. *That's it! Now if I can only remember the first part. Got it! Got it! It sounds like* sticks.

Excited, and on the verge of the climactic moment of the trip, I turned around and, with a sweeping gesture, shouted, *"Swizzle-hund! Swizzle-hund!"*

*"Was?"* they both said. I turned and repeated myself, this time louder, *"Swizzle-hund! Swizzle-hund!"* Hans and Linda exchanged puzzled looks. Clearly they didn't know what the hell I was saying.

*"Swizzle-hund?"* I tried again, but tentatively now. They shrugged their shoulders in confusion.

*"Was ist Swizzle-hund?"* Linda finally asked.

"Umm, it's a ... um ... porcupine."

"Ahhh! Pork-q-pine ... pork-q-pine," Hans repeated, dismounting from his horse in a clatter of camera gear. It was the first word of English he'd spoken in two weeks.

I sat there with my mouth agape. All I could think of was that first day's German lesson. Hans could say *porcupine* (in English) better than I could ever say anything in German. Embarrassed, I turned around and sat there trying to look smug, as if I had said *porcupine* in Latin.

Hans started shooting pictures as soon as his feet touched the ground. Ten rolls of film later, with the porcupine never having moved an inch, we were under way again.

*Oh, for the life of a guide.*

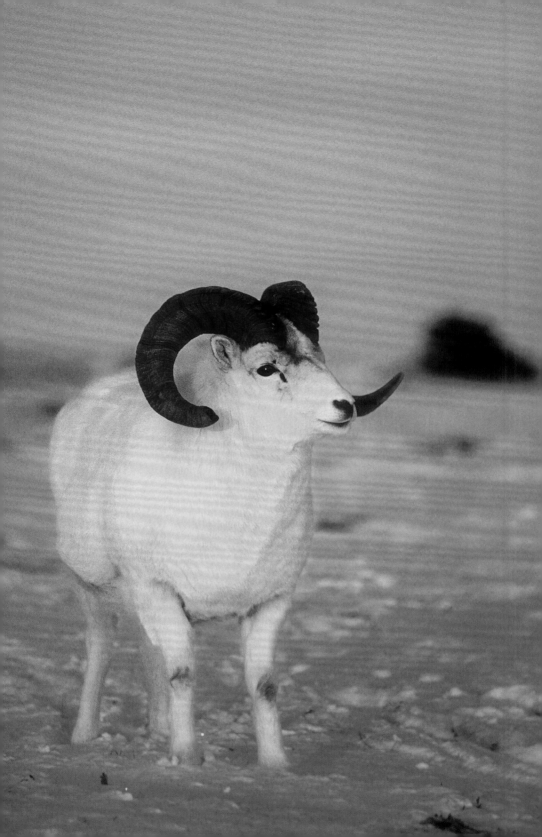

# *Ram Country*

**HIGH BASINS LACED WITH SNOW** and perpetual ice. Precipices where golden eagles nest and marmots whistle from the rocks. Slab-sided slopes etched with ages-old trails cut by generations of jewel-eyed, golden-horned Dall sheep, masters of the high and wild northern mountains.

I fell in love with Dall sheep on my first climb into the alpine realm of the Chugach Mountains. The white specks traversing the talus slopes seemed otherworldly. They roamed amid larkspur and campion and other wildflowers new to me—avens, saxifrage, scarlet plumes, lousewort, and the blooms of crowberry. Burbling water echoed from deep under the lichen-covered rocks, its music punctuated by the calls of marmots, pikas, and ravens. Crystalline pools of water nurtured delicate mosses and brought the sheep relief from the hot, high-country sun.

On the cliffs I found rocky beds dotted with raisin-sized pellets and tufts of white hair, some beds protected by sheer cliffs that only a sheep could climb. I reveled in the sweeping views they commanded.

The sheep's rugged, wind-scoured home tested me even on brief forays. To spend time with them required hard climbing in precipitous terrain and backpacking a camp into the clouds. My first days camping amid those sun-dappled heights in July were visits to Eden. Then followed days of freezing rain and wind: the slick rocks too dangerous to negotiate, and the air smelling of the long dark days of winter. Confined to my tent, I marveled at the sheep's ability to survive it all. That following winter, contemplating those same mountains, hammered by subzero cold, killing wind, and darkness, I came to revere those wild sheep.

Alpenglow on a frigid day lights the thick winter coat of a mature ram wandering in search of ewes receptive to breeding.

I first visited what was then called Mount McKinley National Park on July 4, 1969, in a storm that left over a foot of snow in the high

passes. I saw but four cars that day and counted fourteen hundred large mammals, mostly caribou and sheep—the animals the park had been established to protect. The wanderings of those white rams through the snow thrilled me and hold my spirit captive to this day.

## II

We were in the Alaska Range, and a summer storm was heading our way. Mosquitoes attacked us in ferocious assaults, and nothing kept them at bay. It was as hot as I'd ever known it in sheep country, perhaps more than 80 degrees, and instead of T-shirts, we wore flannel shirts soaked with bug dope. The heat

Sheep inhabit the high peaks and basins where wind and cooler temperatures offer some relief from the lands and wetlands below that produce countless mosquitoes.

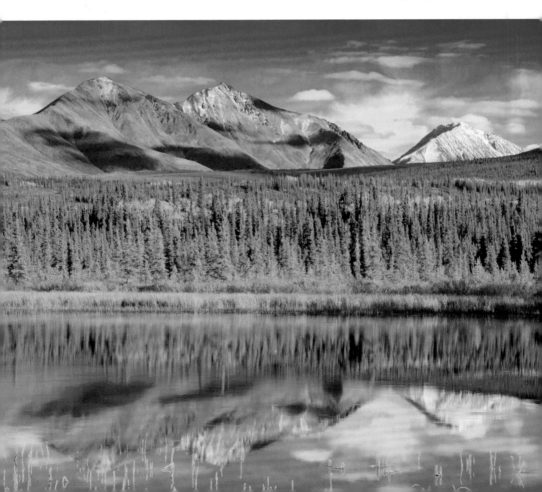

and heavy clothes made climbing with a loaded backpack an ordeal. I twitched constantly as the swarms bit through the repellent and sweat-stained cloth. Still, my friend Ron Lambert and I were immeasurably better off than the Dall rams we saw. Insects ringed their eyes and nostrils and crawled over their soft undersides, their thin summer coats offering little protection. Blood oozed through white hair.

In late evening, a light breeze finally brought some relief. We followed the rams out onto a spur of the ridge exposed to the wind and sat down within comfortable camera range. For perhaps the first time that day, the rams grazed in peace, and we photographed their quiet movements.

Around eleven o'clock, with the sun just going down, we put the tent up. In summer almost twenty hours of daylight energizes the Alaska Range with a pace even humans find hard to resist. We'd been up since six and with the

rams all day, yet we weren't exhausted, only glad the damn bugs were gone. Once inside the tent—which we'd erected to keep the mosquitos off, should the wind quit— we lay on our sleeping bags watching the light thin out over hills, the rams grazing in cool air.

Our tiny camp was pitched on a spur ridge near what was then called "Ram Country" or Hankins Ridge, named for Joe Hankins, an ex-logger who'd spent many sum- mers there following his beloved Dall rams. One sum- mer, when Joe was in his seventies, he made over forty hikes to that high ridge to see his sheep and share them with others. He'd taken me there in 1970, and I consid- ered it an honor. For years it was the best place to find the heavy-horned bachelor bands that roamed apart from the herds of ewes and lambs, males and females not mingling until breeding season. Hankins Ridge has long been forgotten, the undeveloped trail overgrown, but the legacy of that simple man—who, when he died, left a small fortune to the national parks—lives on. I think Joe Hankins would have been happy that after his passing, his favored place had returned solely to the haunt of the

wild sheep, a quiet spot unbothered by people, except for the few like Ron and me who remembered.

While I camped there with Ron, sometime after midnight I awoke to the nylon tent fabric rattling in a stiff wind and a distant roll of thunder. I could see gray scud drifting over the valley and mountains. As the wind built, the thunder crept closer, and soon far flashes of lightning jabbed the Alaska Range.

The wind also woke Ron. He rolled over in time to watch the lightning bolts edge across the valley. Soon the storm was directly over us; thunder louder than any I'd ever heard, powerful enough to feel. Although we were only inches apart we had to holler to make ourselves heard. Excited, we whooped aloud as multiple bolts of lightning daggered the slopes.

The wind, the thunder, the lightning more than made up for our earlier travails. Then a thought struck me. "Ron," I yelled over the tumult, "do you know anything about lightning rods?" He started to say something but instead grabbed the tent pole by the door. And just as quickly, I pulled down the back pole.

It seemed then that the bolts rained down terribly nearby. One stabbed the south end of our ridge. We gathered the tent around us and watched the storm move east. As the front passed and the wind died, huge splatters of rain began to fall. We replaced the tent poles and curled back into our bags as the deluge continued, the earth redolent with the scents of soil, wildflowers, and mountain sheep.

Some hours later I awoke in sunlight amid the hum of mosquitoes battering the netting. I heard a noise nearby and looked out. A short distance away, a ram stood staring out over the valley, his damp coat steaming in the golden light. Every now and then he stamped his hind leg in agitation at the insects biting his underbelly, his brief respite over.

### III

North of the Arctic Circle, on the slopes where Dall sheep live, it was cold and gray one late November day. The sun had set here in the Brooks Range before Thanksgiving in the heart of winter and would not rise again until early January. For about four hours each day the horizon brightened with twilight, but the sun never rose. It was minus 30 degrees, and the wind was blowing.

The thirty rams, ewes, and lambs I was watching were gathered on a rocky cliff about a half mile across the frozen Koyukuk River. This was the breeding season, and the sheep seemed interested only in one another, unbothered by the almost minus-60-degree windchill. Despite layers and layers of protective clothing, a down sleeping bag over my shoulders, and a sheltered place to sit, I was miserable. Because of the conditions, my vigil would be brief and photography out of the question. My heavy mittens barely flexed enough to allow adjustment of my spotting scope.

It was just past two in the afternoon, and already it was growing dark. South of here 250 miles, near my home in the Alaska Range, I had often climbed through snow and over icy slopes to watch rutting sheep. There, in early December, sunlight lasted three or four hours. Here, there had only been twilight.

I'd come to the Koyukuk out of curiosity, a desire to learn more about how mountain sheep behave in almost perpetual darkness. All four kinds of North America's wild mountain sheep are diurnal, usually exhibiting little nocturnal activity. Sheep herds above the Arctic Circle are the northernmost wild sheep population in North America. *When it grows completely dark*, I wondered, *what happens? Do they suddenly shut down and stop everything? Curl up for twenty hours, waiting for twilight?* Hardly probable or possible, given their basic survival needs.

Dall sheep, named for pioneer naturalist William H. Dall, are one of the world's forty kinds of mountain sheep and the only all-white one. Millions of hollow hairs lock in body heat and insulate against the cold. In sharp contrast to summer, when sheep look sleek in their thin coats, they look blocky, almost roly-poly in their winter pelage. Despite their color, they are not hard to find in winter: their tracks show up in the right light, and they look somewhat yellow against new snow. Originally I believed that these sheep wore their white coats for camouflage, but my late friend Lyman Nichols, a sheep biologist, told me that he believed their color is more important in summer for protection from the twenty-four hours of sunshine baking their treeless alpine home.

Both sexes have horns. Ram horns are massive and curling—sometimes fifty inches in length—while those of ewes are slender, short, and pointed. In proportion to their body size, wild sheep grow the largest horns of all ruminants, comprising 8 to 12 percent of a ram's body weight. I have held sets of ram horns

that weighed eighteen pounds and have run my fingers over their rough texture and broken or shattered horn tips. During the rut, horn growth slows, almost stops. This pause leaves behind an annual ring that chronicles a ram's age.

As I watched the herd in the twilight, I recognized that I'd seen no more beautiful sight than a band of rams single-filing through fresh powder snow, even as stunning as they could be on green, flower-studded summer slopes. I marveled at Dall sheep for their ability to prosper on spare alpine vegetation, to elude predators by scaling steep precipices, and to survive arctic winters that can be seven months long. Few species live in such extreme conditions. Despite these sheep's hardiness, their lives are a constant challenge. Weather, accidents, disease, and parasites kill some. Wolves and golden eagles kill others, especially lambs. A twelve-year-old sheep is considered old, and very few live to sixteen.

In defiance of the onset of winter, the mating season of Dall sheep runs from mid-November through mid-December. One biologist observed copulation in early January. The demands placed on these animals by the weather and minimal rations of frozen grass, sedge stems, lichens, and moss should be challenge enough without the rigors of the rut. Timing is crucial. Lambing must occur in the spring at the beginning of the brief growing season, which in the Arctic comes in late May and early June. With mild weather so limited, it's not surprising, then, that the most northerly mountain sheep rut later than their southern cousins. In Arizona, for example, I once watched desert bighorn sheep rutting in August and September, a timing that ensured that lambing would occur in the coolest, wettest time of the desert year.

Ideal winter Dall sheep habitat combines rugged escape terrain with subfreezing temperatures, light snowfall, and winds that scour the slopes and ridges free of snow. Sudden thaws or freezing rain create ice barriers that prevent sheep from digging down to their forage. The dry, windy, austere Brooks Range is good sheep habitat, but the short growing season limits forage. Of the sixty to ninety thousand Dall sheep that range throughout the mountains of northwestern Canada and Alaska, twelve thousand live in the Brooks Range. As I'd discovered by this point on my excursion, premier winter sheep habitat is not hospitable to people.

In summer, all-white Dall rams roam alpine pastures in bachelor herds, only mingling with ewes and lambs during the early winter breeding season.

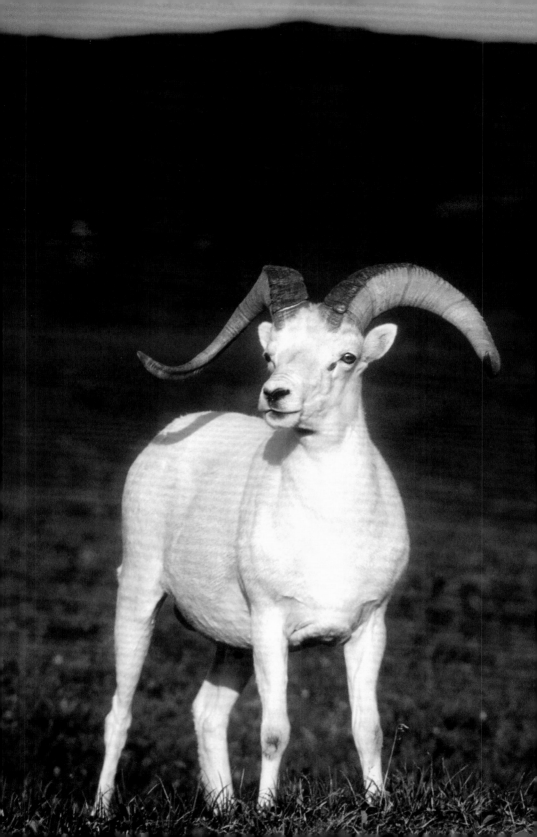

In their thick, all-white coats, a few rams appeared as though they weighed four hundred pounds instead of two hundred. As I hunched behind my spotting scope, I wished for just such a coat.

Since morning the herd had been in flux, the rams moving from ewe to ewe in search of breeding receptivity. (Lambs, now six months old, spent most of their day feeding and trying to avoid the besotted rams.) By scent alone, a ram can determine a ewe's readiness. I watched one ram chase a ewe through the herd only to give up to follow another. When not harassed by rams, ewes pawed through the thin snow and grazed the exposed forage. Dominant rams guarding their chosen ewe attacked lesser rams that approached, remaining in nearly constant motion. None of the rams I watched ever stopped to feed.

Entering the rut, sheep are heavy with fat. To survive, wintering sheep reduce their daily activities to avoid needless energy loss. Therein lies the

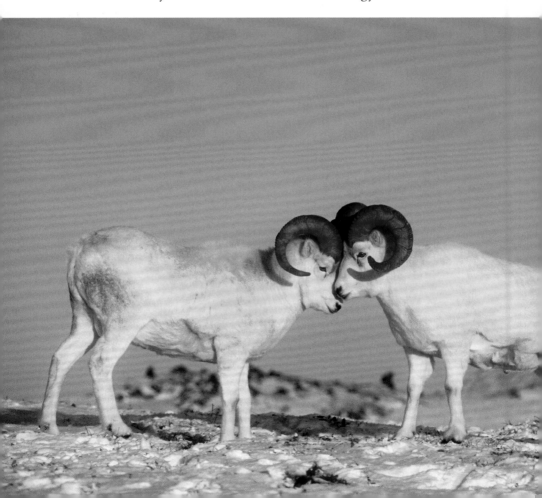

challenge, and contradiction, of the late rut. Because a dominant ram feeds sparingly during the rut, he can lose up to one-sixth of his body weight in one month and face winter in a weakened condition, his survival dependent on residual body fat. By spring, surviving lambs and yearlings will have lost up to 40 percent of their body mass. Winter's famine takes a harsh toll on the youngest and oldest sheep.

As I watched, a hundred yards from the main herd, the largest ram on the hill shadowed a single ewe and courted her through the entire four hours of twilight. With horns held high, he pranced around her, making gentle contact. She didn't move away but instead approached him. She rubbed against his shoulder, enticing him. Darkness and blowing snow prevented me from seeing their actual copulation, but perhaps I'd witnessed the last days of the oldest ram as well as the first moments of the youngest.

In the days prior to the breeding season, rams test each other's fitness and strength. Jarring, head-butting jousts can last for hours until dominance is determined.

Rams move from one group of females to another, always searching for a ewe ready to breed. Sometimes rams make fairly long treks to reach the widely scattered bands. During the rut, equal-sized rams will fight over an estrus ewe, but usually a predetermined dominance hierarchy minimizes conflict.

Back in October, at about the time of the first snowfall, the rams had tested one another. All summer the rams had fed placidly together, but as autumn progressed, hormonal surges led to intolerance and aggression. Rams began to gather in tight huddles to display their curling headgear. Bigger rams easily intimidated subordinate rams, the showy horns enough to establish dominance without actual combat. Similar-sized rams settled dominance through intense clashes.

Serious dominance battles are highly stylized affairs. Rams approach each other in a challenge posture called the "low stretch." The two then stand eye-to-eye for several minutes, as if examining each other's

horns. Direct eye contact might also be a challenge and stimulate the belliger-
ents. Next, the rams shove each other or kick out with a stiffened foreleg. They
may then threat-jump at each other, stopping short of actual contact. After a
prolonged tête-à-tête, they seem to lose interest and move apart, maybe even
graze a little. Suddenly, they whirl, rear to their hind legs, and charge. When
only a few feet apart, they lower and smash into each other with a twist of
horns and all the force their driving legs can muster. The head-on collision
can stagger one or both animals. Almost immediately they face off, assuming
a rather dignified and rigid upright body posture. They try to intimidate each
other, show their toughness. After a rest, the whole procedure is repeated until
finally one ram gives in. Rubbing or licking the horns and face of another ram
signals submission.

Some of these head-on jousts can last for hours. Shoulder and head inju-
ries are not uncommon. (The brain is protected by a double layer of bone.)
Biologist Lyman Nichols estimated that 95 percent of horn breakage, called
brooming, results from head butts. Mature, heavy-horned dominant rams
control the breeding. It is nature's way of selecting the strongest animals with
the potential for the longest lives. Although rams can sire offspring at as early
as eighteen months of age, they do not normally participate in breeding until
they are about seven to eight years old, when their horns are close to full curl.
Ironically, because rams of lesser stature burn less energy during the rut, they
stand a better chance of winter survival.

Just before dark I saw two rams chase a ewe out over an icy, wind-blasted
slope. On the precipice they stopped, pivoted, and smashed into each other.
Despite the distance the collision sounded like two boulders slamming together.
I feared that one or both would plunge from the cliff, one slip likely fatal.

As I packed for the short hike back to the old cabin I was living in, bor-
rowed from a friend who mined for gold nearby in summer, I saw no sign that
the herd was settling in for the night. Some of the ewes and most of the lambs
had bedded down and were chewing their cuds, but most of the rams contin-
ued to caper about.

An hour later, I stepped out of the cabin into full darkness to gather an
armload of firewood. The wind had stilled, the temperature had dropped,
and the only sound was the crunch of snow underfoot. Already the first faint,
green bands of the aurora drifted overhead and a gibbous moon hung above

the peaks. Balancing the load of split spruce, I turned to hurry back inside. Then I heard a sound and stopped. *There!* Faintly. *Again!* Out of the darkness, from across the river, the crash of horn against horn. Two rams skirmishing in the night, challenging the heart of winter.

## IV

In Alaska from 1990 to 2010, Dall sheep populations declined. Places in Denali National Park and Preserve where I once regularly found sheep are now nearly devoid of them. Statewide, the herds plummeted from 56,740 to 45,010. Rather than predation, changes in weather appear the likely culprit.

Alpine habitat is shrinking. Biologist Roman Dial has documented historic reductions in alpine tundra, the result of climate change. Dial writes that in the Chugach and Kenai Mountains, the lower edge of alpine tundra has shifted upward 150 to 275 feet in elevation in fifty years, in correlation with lengthening growing seasons and increasing temperatures. As shrubby plants replace the Dall sheep's preferred forage, overall nutrition suffers, which results in declining birth rates.

There is little that can be done in the short term about the changing weather that alters habitat. One biologist likened the shrubs crawling up the slopes as "a slow-motion avalanche in reverse." And like any avalanche, the result can be catastrophic.

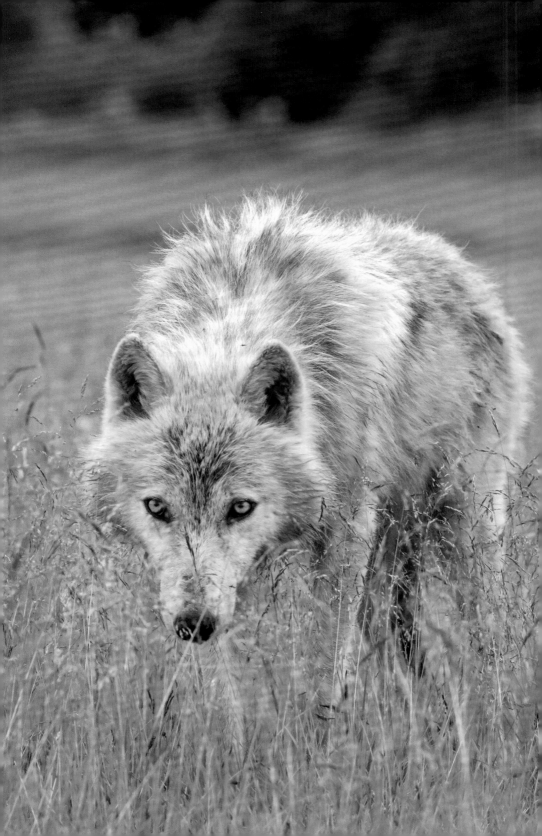

# Wolf Howls

## I

**THE FIRST SEPTEMBER SNOW** at my cabin began at dusk. Big soft flakes thickened as the night wore on. I knew the storm would be raging at higher elevations. By morning, a foot of powder blanketed the timber, muskeg, and surrounding summits. A leaden sky promised more snow and continued cold.

Yesterday, in a biting wind and occasional squalls, I climbed a ridge in Savage River Canyon hoping for photos of animals in the fresh snow and located thirty Dall rams. Activity had been high, the rams sparring in pre-rut ritual. The overnight snowfall would not keep me away. I filled my rucksack with extra clothes and a small canister of hot tea. On the twenty-mile drive to the river, I conjured majestic images of rams jousting in fresh powder.

I parked at the trailhead, the only car on the road except for the snowplow that rumbled ahead of me. Once the plow moved on, silence was my sole companion. I crossed the road bridge to the unmarked trailhead, the path buried and pristine. Where the route narrowed, I hiked by feel and memory, my passage knocking snow off the waist-high brush, leaving a wake of brown limbs and twigs.

A quarter mile down the trail, I paused to scan the high ridges but saw only rock and snow. When I lowered my binoculars I noticed a brown line through the snow to the left and parallel with my trail. Not far ahead the paths crossed, and I edged forward on alert for the possibility of a bear. Where the trails intersected, I found tracks, not of a bear but of wolves, perhaps four, moving in single file from downstream. I knelt down and splayed my fingers over one distinct print, barely spanning it. I touched the sharp, frozen edges of the toe pads and nail marks, proof that the wolves had passed in the night rather than minutes before.

Wolves are inquisitive, intelligent, and far-roaming—qualities that make them superior predators.

I looked back and now saw that the route the wolves had taken had paralleled the main trail the whole way and extended back toward the road. The wolves were behind me somewhere. Through binoculars, I traced their route but it faded out with no clear end. Were they hidden there? Watching from the snow-laden brush? I studied their trail, anxious for movement or sound. Long minutes passed in total silence except for the purling river. I thought about going back to look for tracks on the road, but with snow imminent, I decided to continue.

From then on I hiked a broken trail, a muddy mess of tracks glinting in the light. Down that corridor of barren branches, I marveled at the size of the wolves. Where a fox or lynx would have ducked between the bushes, leaving little sign, the wolves had toppled the snow on either side of the path. The wet brush raking my legs almost felt warm, like residual body heat, only increasing as I hiked along. I had the intense sensation of being watched.

Where the canyon narrowed and the trail steepened, the trails veered left and the tracks came straight downhill. Here the wolves had come from the sheep haunts above, and I scanned the slopes with my binoculars but saw only mist and drifting snow. I debated turning around. With wolves in the clouds, the rams likely would be long gone. But I continued on.

The climb up the knife-edged ridge was taxing and at times hazardous. An hour from the bottom I climbed safely into the basin but found it empty. No sheep, no tracks, no trails. Snow drifted off the summit, and somewhere above, a ptarmigan called.

Chilled by the wind, and disheartened, I started back down. The descent was more difficult than the climb. I tested each foot- and handhold before placing my weight. There was no room here for a mistake.

Safely off the slope, I made good time over the broken trail. Snow began to fall in earnest but not enough to blot out my tracks or those made by the wolves. Halfway back to the road and just beyond the intersection with the wolf trail, I slammed to a stop. Over my boot track was a crystalline wolf track. One giant, perfect print where a wolf had trod over my steps, had perhaps even followed me. I swiveled about, peering in all directions, a chill—like an icy breath—fluttering over my neck. Long minutes passed, still and silent, the unseen being more powerful than the physical presence.

## II

Most of the time we have only bits of evidence of a wolf's presence: fur snagged on a twig, hair-filled scat, tracks in mud or snow. We touch the biggest paw prints. Trace toe and heel pads with an index finger, feel the surfaces, guess their age.

Tracks tell stories. Which way was the wolf going? Was it alone or with others? How many? Were they running or walking? On human trails, the tracks often appear overnight, evidence of shadows stalking the darkened woods. Invariably we peer about, craning to spot the wolves.

Sometimes it is a distant howl out of the darkness. *There, do you hear it? Wolves!* Something in that feral, vibrant song spears our senses. Not even the most jaded Alaskan remains unstirred. We know that the wolves are talking, but what are they saying to one another? And to us? Or about us? Perhaps our mimicry of their songs led to the first close, nonviolent contact. Led to the conquest of the animal we now call "dog."

No matter how often I see a wolf, my response is invariably the same: surprise mixed with confusion, then an adrenaline rush. First: "Oh, a dog." Then: "No, that's no dog—that's a wolf!" The excitement is intense, and if a close encounter, the gaze of those intelligent yellow eyes sears the soul and tests our courage.

Maybe our response lies in genetic memory, visceral, etched in bygone eras when fur-clad people hunkered in dark caves around pitiful fires, clinging with sweaty palms to their cudgels and spears while listening to ominous night sounds, the footfalls of dire wolves and cave bears.

Wolves wander through our dreams yet defy our senses. Sometimes they secretly approach or follow people. When we discover them at close quarters, we stop and stare, our pulses soaring. We search for comfort in the belief that wolves "rarely attack humans," but still . . .

Possibly it's the ancient hint of threat that inflames our passion. In all our time on earth, we have made no deeper compact with another animal than the wolf, whose relatives live in our homes and enrich our lives. Maybe that's why wolves incite such strong reactions—we envy, sometimes resent, their freedom and wildness, their refusal to come to our hearths.

## III

Years back, I spent a winter in a small log cabin on the Juneau Lake Trail near Cooper Landing. I was there to build a cabin for a friend. One snowy night in late winter, after a full day of felling trees and chopping firewood, I turned in early and slept soundly until about two o'clock in the morning. The howling of wolves woke me—howls louder and more vibrant than any I'd ever heard. In the darkness I felt the wolves moving around the cabin, heard footfalls in the crunchy snow.

I admit to surprise mixed with fear. The wee hours of morning have never been good for me. Unrested, I don't like it when the world is pitch-dark and ominous. With the stove out, the cabin was cold, probably near freezing. It took a long time to clear my head and fully realize where I was, and that the wolves were on the outside of stout, log walls.

How long the wolves had been howling before I awoke, I can't say. I do know that I lay there rigid, afraid to make any sound that would break the spell.

All at once, their song stopped. There was no crescendo, no dramatic withering wail. Just sudden complete silence, the kind only possible on a dark, cold night in the boreal mountains. I took a deep breath and sat up, the night still.

The next morning I went outside at first light. The proof was there. It had been no dream. Two wolves had come down the old lake trail and had walked up to the cabin, their tracks burned through the snow. They'd sat and howled just thirty feet from the cabin door.

At twilight that day, I stood on the porch watching and listening. I thought of my friend Rollie who stood outside his cabin every night and howled like a wolf to see if any would answer. I'd always chuckled at his melodramatic howling, but I thought now I'd try—but no, it seemed foolish. I went back inside.

But the idea haunted me, and in a few minutes I was back on the porch. I took a deep breath and let go. My howl seemed too high-pitched, phonier even than Rollie's. Surely no wolf would be fooled. In disgust I turned to go back in when, to my astonishment, from the ridge to the north, wolves howled into the night. I waited, and then howled again.

They answered, this time closer. After a long pause I called again, but now the reply came from somewhere below the cabin. In the gloaming, I strained to see the wolves flitting through the timber. The silence stretched into minutes.

I howled once more but at once knew it was a mistake. At this distance, the wolves would not be fooled. I shivered on the porch until full darkness and then went inside. The next morning I discovered tracks, perhaps of three wolves, on the road below.

That night, and the next, I lay awake or watched from the porch. I saw northern lights and stars. An owl hooted in the timber, and vehicles rumbled on the distant highway, but I heard no wolf song. A week later I learned that someone had seen two wolves running on the river ice below my cabin. The man had grabbed his rifle and fired five shots. His shots went wide.

## IV

Decades ago I hunted moose in the Brooks Range, and for years after, I went back to watch and attempt to photograph wolves in a remote valley there. On one trip my tent overlooked a broad tundra plain stretching to the snow-kissed high peaks. Geese, high and fast, called on the wind. Moose rumbled in the timber, and on a far slope grizzlies gorged on blueberries. Autumn in the Arctic, always a bittersweet season, lasts but a few short days with the lethal frost of winter close at hand. On that trip, nature painted these crisp autumn days with fiery brush strokes of crimson and gold.

Nights in camp brought great joy: stories around the fire and moose steaks roasted over the coals. Night winds carried the scent of woodsmoke, fallen leaves, and sometimes the strong musk of a bull moose in rut. On one night my friends and I heard moose antlers crashing in the dark. The fire, pitched in front of our mountain tents, though hot, could not keep the chill at bay. It felt colder than the 20°F registered on the thermometer, and my companions turned in early.

I sat alone in deep thought, staring into the flames. The wind had faded, but the cold came alive. A spruce round chucked into the coals sent a storm of sparks upward toward the stars. The ragged peaks to the north, lost earlier in the blackness, loomed against a wall of radiant green of the northern lights. In a few short minutes the green separated into three distinct bands; three immense waves flashed south, ghosting the ground in fevered light. Horizon to horizon, the sky writhed with patterns so intense, they seemed close enough to touch. At times the aurora masked the outlines of Orion and the Great

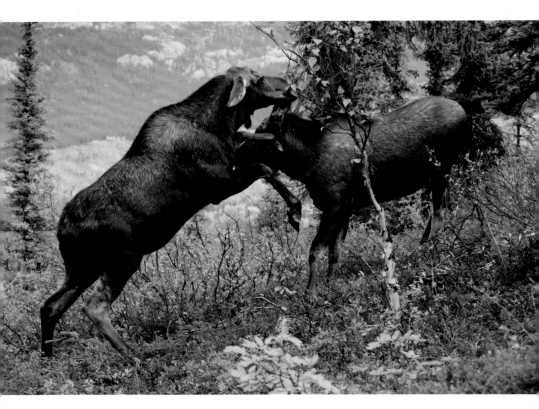

Bear, the light fading here, then there, only to brighten with a rush and snap elsewhere.

During the breeding season, a cow moose can become ill-tempered—a strike with its forelegs dangerous, even lethal, to smaller animals, like wolves.

How long the wolf had been howling before I heard it, I couldn't say. Old sourdoughs speak of hearing the aurora. Perhaps at that moment the song seemed part of the ethereal light and I missed it. Only when the second and third wolves added their voices did the hair on my neck prickle. I came—wide-eyed—to my feet, peering north over the tall aspens, straining to see shapes coursing the muskeg, as four, five, perhaps six wolves conspired in the night. I dropped wood on the fire and stood rigid, watching, with wind-torn tears on my cheeks. The howling—long, deep notes blending, rising, fading—seemed to come ever closer. Was that my imagination? Or did the sound ebb and flow on the whim of the wind?

All at once the chorus stopped, leaving the night—the mother of fear and mystery—to the glow of fire in wood and sky. I held my breath, strained to

hear, but silence persisted. When I looked up, the aurora had vanished, the stars again bright and crisp.

Later, shivering in my sleeping bag, I tried to sleep but lay awake to night sounds, my eyes open to the stars and cosmic light.

A few mornings later I sat on the rocky knoll behind camp, glassing the flats beyond the pond below camp. Just as the dawn light slanted full onto the tundra, flashes of white streaked from the timber. Two wolves sprinted into the sunlight as if pursued. Near the pond they slowed to a walk and came softly through the reeds, pausing side by side to drink.

I clearly recall that image. The glittering water, the tousled reeds, and the two wolves, tails and fur curling in the wind, all bathed in amber dawn light. The white wolf raised its head to sniff the air, silver water dripping from its muzzle. The wolves nuzzled each other before turning away to race back into the timber.

Sights like these charged that valley on the south side of the Brooks Range with a luminous energy. In that remote and otherwise undistinguished tributary, wolves denned, reared their young, and taught them to hunt. On almost any night there, you could hear their voices. Sometimes I'd see them, pups and adults alike, running the tundra or ghosting the woods. Just for the chance to watch, I searched for the den, but it remained elusive.

Numerous sightings confirmed that many wolves lived in the valley, sharing it with grizzlies that competed with them for the offal left by hunters. One crisp autumn morning, I climbed a bluff behind a mining camp to glass the remains of a moose shot for winter meat. Ravens and magpies darted over the distant gut pile hidden in the low willows. In dawn light I saw only squabbling birds, but later in the afternoon I spotted three wolves blitzing the kill site.

The wolves were in constant motion. In graceful leaps and sprints they seemed to taunt something hidden in the brush. In concert they would dart in, then leap away, dart in again. All at once they stopped and came together, peering into the brush. Then one wolf charged alone into the willows. A moment passed, and then the other two followed. A second later all three wolves raced back into view with a grizzly in full pursuit. One wolf, now limping, fell behind, but just as the bear closed in, the other wolves attacked it and rescued their pack mate. The fitful chase continued a short distance before a second

bear charged into the open. This bear quickly caught up to the first, but instead of joining the attack, both bears stopped to watch the wolves sprint away.

During the brief chase, the wolves didn't make actual contact with the bear that I could see but feinted in close enough to distract it. Even after the wolves had gone, the grizzlies stomped about, bluff charging the now vacant tundra. Once the dominance display lost its steam, the bears lumbered back to the spoils.

Over the years I usually saw wolves at a distance but sometimes at close quarters. Once, at a sharp turn in the trail, I surprised a wolf at close range. We both stopped and stared. The wolf paused briefly before slipping away into the willows. That was the way of most close contact. A brief look, then gone.

On that very trail, near the same spot, one of the miners who worked a nearby gold claim had a more memorable experience. He too came on a wolf that

The intense stare of a wolf, inquiring, judging, can be unsettling.

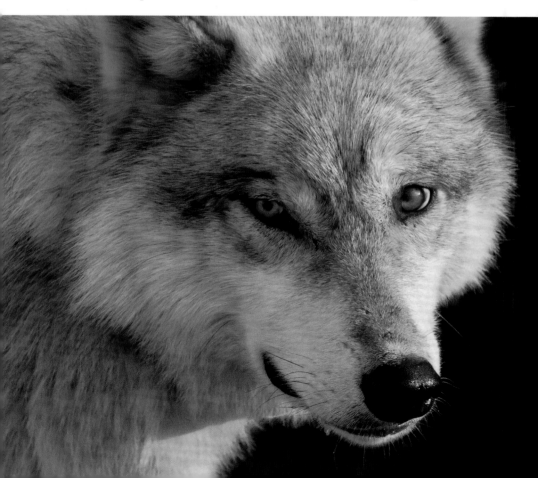

the brush. He walked on. A few minutes later he looked back
~~~~ to see the wolf following him. If he hurried, the wolf hurried.
~~~~ wolf slowed. A strong man more accustomed to the roar and
~~~~nery than the silent glide of a wolf, he later admitted to fear.
~~~~ what the damn thing was going to do." The situation twisted
~~~~ontrol when, around another bend in the trail, the miner saw
~~~~g toward him. "Good Lord." Unarmed, he bolted for a nearby
~~~~e snapping branches startled both wolf and bear. From fifteen
~~~~ed down to see the two animals peering up at him. When the
~~~~ toward the tree, the miner climbed until there was no more
~~~~b. Unseen by the bear, the wolf ran in the opposite direction.
~~~~tered and paced below the tree until near dark, then wandered
~~~~e miner to descend. He said the walk back to camp in the dark
~~~~ars.

I never found a wolf den on that trip to the Brooks
Range, but I chanced upon one later in the nearby Koyukuk
River canyon. On that day thunder boomed, a hard wind
blew, and an ominous wall of black clouds smothered the
peaks. I'd been on a long journey to the North Slope, and the
last thing I wanted was to be caught by a cloudburst. Unable
to make my usual campsite before nightfall, I left my route
and plunged downhill toward the river thickets that offered
shelter for my small tent.

I hurried down a well-used trail etched along a sparsely
forested ridge that bisected the muskeg. Absorbed in secur-
ing my footing, I failed to see the movement until I was
nearly on it. A ball of fur ran across the trail and into a screen
of alders. *Grizzly cub!* I slammed to a stop. *No. A bushy tail. A
cross fox. That's no fox . . . it's a wolf pup.* I shrugged out of my
backpack and broke through the alders to look out over the
expanse of open muskeg, but the pup was gone.

I kept watch for a brief time and considered the possibili-
ties. It was mid-June, and the pup was too small to be off on
its own or trailing adults on a hunt. Perhaps the pup was lost
or on a short ramble from a den hidden somewhere close by.

The buffeting wind ended my search. Intent on shelter I reclaimed my pack, and with thunder breaking right overhead, I hurried on into a thin copse of spruce. Piles of loam and large holes laced the ground beneath the trees. Wolf tracks, large and small, engraved the mounds littered with gnawed bones and tufts of fur. The smell of scat and urine perfumed the air, and mosquitoes droned above the dark burrows. *I am standing on a den.* Strange sensations of wonder, elation, intrusion, fear—a mix of emotions—pushed me away from there. With my feet almost on fire, I charged off toward the river.

Well into the open, I looked back. The den, sheltered by black spruce and willow, was sited at the end of the ridge where it overlooked the river. The timber provided cover from storms but also an unhampered view of the surroundings. Sensing movement behind me, I whirled in time to see four pups dash across the tundra and into the willows lining the river. One tumbled head over rump but was up in an instant, hardly missing a stride. The pups varied in color from gray to black and looked as wide as they were long. In moments they were gone into the very spot I had aimed for.

Just as I decided to turn back, an adult wolf emerged from the dense willows near the pups. Perhaps it had called to them, but I'd heard nothing over the wind. The wolf began barking, exactly like a dog defending home turf—a harsh relentless cadence, the anxiety unmistakable.

I backed slowly away, every fiber of my being on edge, wanting to get as far away from there as quickly as possible. The wolf dogged me as I hurried back the way I had come. It kept barking, once even howled—one short crisp call—which I hoped wasn't a cry for help. Relief washed over me when the wolf finally turned back. I forged ahead into the rain.

Then the full fury of the storm broke: thunder, jabs of lightning, chilling wind, and torrential rain. An hour later, drenched and exhausted, I made camp in distant timber.

## V

Bob Shelton, a neighbor who worked at Camp Denali, and I sat on the edge of Denali's Polychrome Pass—alone, in silence, lunching on ham sandwiches. Just a few days ago buses had been traversing the pass, passengers enjoying the autumn palette of tundra and snowy summits. Gone were the visitors. Ours

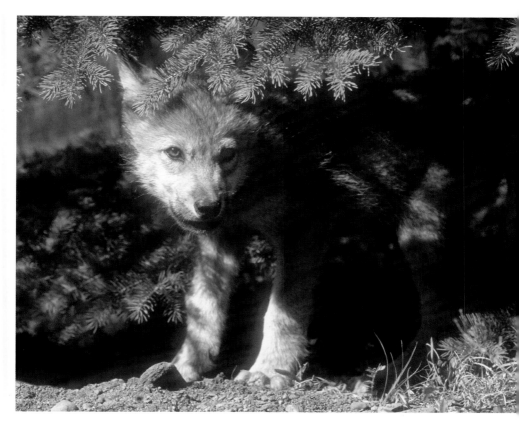

may have been one of the last vehicle trips of the year over the now-closed park road. Winter was on the wind and in the ice-rimmed puddles.

A wolf pup briefly peers from the mouth of a burrow at an elaborate den that featured fifteen openings to the tunnel below.

Zeke, a local truck driver, passed by and waved, headed west, like us, to Camp Denali. We watched him negotiate the hairpin. His brake lights came on as he stopped at the pullout on the point. He beckoned, and we drove west to join him. He was watching a gray wolf stalking along the road ditch. It crept forward, using the cutbank and willows as cover from five Dall sheep, two of them lambs, grazing a hundred yards up the slope.

Unseen by the sheep, the wolf reached a willow draw west of the sheep and started upward. If it could reach the same elevation as the sheep, it would break from cover only forty yards from them. The sheep were alert, pausing now and then to scan the slope. They looked at us once but not again.

The cry of a golden eagle broke the silence as it swooped from the ridge crest and dove on the wolf at the top of the draw. Another eagle rose from the summit and swooped. Time and again they dove, coming as close to the cowering wolf as they could get without contact. Alerted by the eagles, the sheep spotted the wolf and bolted straight uphill, then slowed as pursuit failed to materialize. Just beneath a steep outcrop, they stopped to peer back.

The sheep appeared to be watching something else in the rocks to the east. It was another wolf, broken from cover at the same level on the slope where the sheep had been grazing. One long look and the sheep raced off, up and over the summit. The second wolf descended toward its partner.

Once the eagles tired of their game and soared off, the first wolf slinked into the open, head down and tail between its legs. The two wolves slowly came together, the second wolf darker and one-third larger. After brief body contact, the wolves descended to the road and trotted westward. A quarter mile ahead, they veered down a small drainage and soon melded into the distant willows. Scudding clouds tore on the peaks, leaves rustled in the wind, and somewhere to the east an eagle called.

For days I pondered what we'd witnessed, a simple but intricate pincer hunting maneuver, an ambush foiled only by the eagles. *How do wolves communicate? How did they plan their attack? How did they lay out their converging stalks?*

## VI

My friend Tom Meier, a wildlife biologist then studying wolves in Denali National Park, found my story of the wolves stalking the Dall sheep on Polychrome Pass of interest but not unusual; he had seen similar incidents. Our conversation turned to Dall sheep behavior in general. Based on his years of fieldwork, Meier doubted that mountain sheep would ever make a stand against wolves. Unless safely perched on a cliff, he said, sheep would always panic into flight. I had another story to share with him.

One subzero November day near Kluane Lake in the Yukon Territory, I climbed a steep, snow-covered ridge where two rams sparred in head-jolting collision. Partway up the incline, I paused to catch my breath and question my sanity for being out at minus 30 degrees on an ice-encrusted cliff. The frozen expanse of the lake below separated chains of peaks shouldering into a pure

azure sky. When I turned to look uphill, I spotted a wolf creeping through a scatter of boulders near the rams; they saw it almost at the same instant. Without hesitation the rams raced off the ridge and down into a steep avalanche chute to my right, the wolf in close pursuit. Then I made a big mistake. In an attempt to keep the chase in sight, I also descended into the chute. At once I was in trouble, the slope steep, icy, and dangerous. All of my focus turned to retreat, each step and handhold critical. Relieved to be on top again, I saw the rams scaling the opposite side of the chute but the wolf nowhere in sight.

From the ridgetop, I had a view of a bald knob in the center of the cirque, a herd of sheep on top. Through binoculars I saw rams, ewes, and lambs jammed together, two wolves just scant feet away. A ewe lowered her horns and bluff charged. Then, at some signal, the entire group tightened and charged at the wolves, forcing them to dodge away. Three times the herd charged until one of the wolves cut away, tail between its legs. The other wolf tried to circle in toward a lamb, but the herd en masse drove it away. Astounded, I watched the wolves cross the cirque, climb the slope, and disappear over the ridge.

Doubtless these were young, inexperienced wolves. Stories circulate of wolves attacking herds of sheep resulting in multiple kills. A biologist in the Wrangell Mountains documented wolves killing a whole band of mature rams, unusual snow conditions aiding an undeniable case of surplus killing. At Kluane I had witnessed a rare moment, a herd of Dall sheep fending off their mortal enemies.

## VII

The howling of wolves never fails to stir ill-defined emotions within me, but how do other animals react? How do they respond? One autumn, I saw how moose respond to the presence of wolves.

Early one cold morning, the tundra agleam in autumn color, I followed and photographed a huge bull moose courting four cows. In midmorning they all lay down to rest in a spruce thicket near a small pond. I'd just taken the first bite of my breakfast, a frozen peanut butter sandwich, when the first howl drifted over the trees.

The five moose got up and ambled *toward* the sound emanating from a knoll a half mile away. The moose strode to the edge of their grove to where

they could look out over the meadow. They stood stiff as statues studying the terrain before them. I admired the bull's massive antlers, the size and strength of those autumn-prime bodies, unable to imagine a wolf killing one.

The howling died away, but the moose remained alert. After a long pause, another wolf howled, this time behind us on the river to the east, and was immediately answered from the knoll. The moose never once glanced back, but I looked over *my* shoulder.

Then, almost as one, the heads of all five moose swiveled to their left. About two hundred yards away a wolf dashed from the timber and into the meadow, heading for the knoll. Dense willow and dwarf birch forced the wolf to leap from opening to opening, not unlike a hare in tall brush. I had an extraordinary view of the wolf's grace and agility as it worked its way forward. After the wolf trotted into the dense brush fringing the knoll, I looked back at the moose. Other than the intensity of their body posture, they seemed undaunted. One by one they began to browse on the golden willows around them, subtly altering direction to work their way away from the knoll. In time they crossed the river to the dense timber on its far bank.

These moose knew the danger. They had no safe retreat. Distance was their only protection, and they knew to seek it. As they wandered into the far wood, only a chittering squirrel broke the silence.

# *Apex Predators*

## I

**ON SUNSET PASS IN THE BROOKS RANGE** I saw a wolf kill a caribou calf. Spring had come late to the high Arctic that year. Frequent storms and persistent snows had delayed migration for the caribou, and the majority of the herd had calved in the mountains well away from the traditional arctic plain. The Porcupine Caribou Herd, perhaps 175,000 animals, had begun filtering back through the Brooks Range on the long, slow meander into the Yukon Territory. The range of this herd, named for the river of the same name, includes the Arctic National Wildlife Refuge. Thousands of caribou wandered through the pass in the two and a half weeks that I camped in the refuge.

On an overcast morning, chilled by sleet, I sat on a knoll near camp watching a small group of cows and calves ford a clear, rocky stream. The lead animals crossed without hesitation and trotted off downstream. After their passage, a single cow returned to the ford where a calf struggled with a broken hind leg, newly fractured in the cobblestones. Urged on by its mother, the calf hobbled out of the water but collapsed on the bank.

The cow was torn between the calf and the retreating herd. Her urge to move on was powerful but so was the connection to her calf. When the small herd went over a nearby ridge, the cow raced after them, leaving her calf behind. Three times the calf struggled to follow but each time collapsed.

Just when the calf appeared to be abandoned, the entire herd raced back over the ridge and stampeded past. A half mile upstream the herd slowed to look back, but I saw nothing in pursuit. The caribou soon resumed their dash.

Through binoculars I watched the herd disappear in the distance. When I looked back at the calf I saw a wolf bounding toward it, the chase over in an instant. A body slam, a slash to the neck, and the calf was subdued. The wolf ripped open the calf's stomach and fed briefly.

78       W I L D  S H O T S

After feeding, the wolf groomed itself, licked its muzzle and paws. Then it looked to where I stood in plain view less than a quarter mile away. The wolf yawned once, then trotted right toward me, its gray-brown coat blending with the sere tundra. I momentarily lost sight of it in the low willows and tussocks. It reappeared again less than thirty yards away. Through binoculars I gazed into those yellow eyes and noted the bloody jowls.

For long moments we traded stares before the wolf, its curiosity satisfied, turned and trotted off into the distant tundra.

Once it had gone, I walked to the creek and examined the calf's remains, its body flayed open as if by a surgeon. Only the heart, liver, and kidneys were eaten, nothing else. The critical injury was a broken hind leg. Only a little over a half hour ago, the small band of caribou had splashed through the inches-deep water covering the cobbles here. One minute the calf was healthy and vigorous, the next almost helpless, now dead. I bent and felt its tiny hooves, stroked the head and ears, ruing the lost promise. I had witnessed the classic predator-prey scenario in which the predator supposedly kills only the weak, sick, or lame.

This mythic example of predation bothered me in unexpected ways. I pondered the "waste" of the calf's life. But isn't waste a human notion? Aren't some animals born as prey? Born in greater numbers than the habitat could ever sustain? Wouldn't the calf have died anyway? Wasn't a swift kill preferable to starvation? And wouldn't the birds and foxes clean up the remainder? The wolf didn't return; jaegers, a golden eagle, and red foxes consumed the remains, bones the only remnant. I again mulled the notion of a wild animal's sense of grief and a predator's sense of cruelty. Twice I saw caribou pass the kill site, and in both instances a cow stopped to sniff and nuzzle the bones. The scent of death and blood must have been strong, but the animals showed no fear.

<div align="center">II</div>

Wolves will test most any animal they cross paths with, but they kill relatively few. Research indicates that wolves kill less than 10 percent of the moose they encounter in winter. Some wolf packs, however, may specialize in certain prey. One pack might focus on Dall sheep, another on caribou, yet another on moose. Wolves don't kill just large mammals. I once saw a wolf

gorging on a fat beaver, the wolf a member of a pack adept at hunting them. I watched a female wolf catch and eat eight ground squirrels in four hours, a total of almost twenty pounds of meat to consume and later disgorge to her pups. When snowshoe hare populations cycle to high levels, wolves feast. Biologists at Denali observed thirteen wolves chasing a single hare, an absurd chase that ended when the hare escaped. Later the researchers found that wolves had killed at least four hares in that same thicket. Denning success and pup survival may be linked in some years to hare abundance.

Salmon account for a portion of some wolves' diet, ranging as high as 89 percent in different seasons and locations. Biologist Dominique Watts found that marine resources accounted for 28 to 56 percent of the diet of Southwest Alaska wolves. Not only do wolves catch salmon—or scavenge carcasses—in spring, but some also eat dead fish preserved over the winter beneath the ice. Hungry wolves will eat most anything.

Late one spring day, near Gorge Creek in Denali, I watched a wolf hunting ground squirrels in a willow thicket. Within a half hour it caught and tore apart two squirrels. A hundred yards beyond the wolf's last kill, a female northern harrier watched from a tussock in the center of a small marsh. The wolf, finished with its meal, slowly padded toward the hawk, which took off when the wolf was just five feet away. The wolf, nose to the ground, circled the tussock, perhaps, I thought, seeking remnants of the hawk's prey. Like a bloodhound, the wolf slowly widened its search through the brush lining the marsh. The harrier dive-bombed the wolf but failed to stop or deflect its search. Suddenly the wolf froze, then pounced hard. The harrier dove repeatedly, talons within inches of the wolf's back. I watched the wolf tear two white objects from the brush and eat them.

After the wolf had gone, I searched the spot and found a nest and the feathers of two, perhaps three, juvenile harriers. (Birds are not always the victims. A Yupik elder told me he once saw an eagle take a wolf pup. In 2004, Swedish wildlife wardens watched an eagle snatch a brown bear cub.)

That same spring, my friend Melanie Heacox, while on a hike in Highway Pass, heard a sound unlike anything that she had ever heard before, something she described as "part wail, part cry of grief." She soon spotted a gray wolf in the brush orbited by two red foxes, the source of the horrific mewling. The foxes were nipping at the wolf burrowing into their den, coming as close as

they dared in a vain attempt to save their litter. Melanie watched as the wolf excavated and devoured the pups one by one. "I'll never forget that sound," she said. "I tried not to be emotionally involved and view it as a natural event, but that sound was terrible."

Predators killing predators.

### III

Coyotes and wolves do not share ranges in harmony. Well into the early 1980s the Kenai Peninsula supported large coyote populations mostly because of the absence of wolves. Biologist Lyman Nichols once saw thirty-three coyotes, an unusual congregation, hunting sheep in the mountains above Cooper Landing. Wolves began to recolonize the Kenai in the 1980s and, just as biologists predicted, coyote numbers plummeted. Prior to wolf reintroduction to Yellowstone National Park in 1995, coyotes had wandered there in large numbers. Again, as predicted, increasing numbers of wolves rapidly killed off much of the coyote population in Yellowstone too.

When the wolf population in Denali National Park declined a few years ago, coyotes appeared on open tundra, where they hadn't been common. Late one warm summer day I led a hike up Tattler Creek, a tributary of Igloo Creek. We walked briskly upstream through hare-gnawed willow thickets that lined the creek. In less than a mile, a quick scramble up a rocky bluff led us to a bench with a view of the serrated ridges and sun-splashed drainage. Almost at once I saw a white wolf, wearing a radio collar, climbing a flank of Sable Mountain. A short distance downhill was a larger wolf, a gray that blended with the scree and multihued rock. (We learned later that the white wolf was the alpha female of the East Fork Pack.)

I soon spotted two smaller animals a short distance behind the wolves. I mistook them at first for pups but quickly saw they were coyotes. Despite the wind we could hear them barking and yipping. The wolves climbed a knife-edge ridge to the base of a cliff and lay facing downhill, focused on their noisy

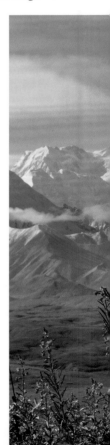

shadows. On the surrounding hillsides, marmots and pikas sounded the alarm. Overhead, a golden eagle soared on the thermals.

Earlier that day we had seen a lone coyote on a hillside above Igloo Creek, my third sighting of coyotes there in as many weeks. Perhaps the coyotes had denned somewhere nearby and now we were witnessing an attempt to distract the wolves, a risky gamble.

The coyotes worked their way up the slope to within one hundred feet of the wolves. The white wolf sprang to her feet, provoking the coyotes to yammer even louder. Suddenly she charged.

"There she goes!" I yelled just as the gray wolf joined the chase. The charge scattered the coyotes; one raced across the slope, the other dashed straight down the scree. The white wolf raced for the coyote traversing the contour; the other wolf sprinted downhill to cut off escape in that direction. Just as the wolf closed within a few feet, the coyote turned sharply

Denali dominates the central Alaska Range and the wildlife-rich foothills and valleys to the north.

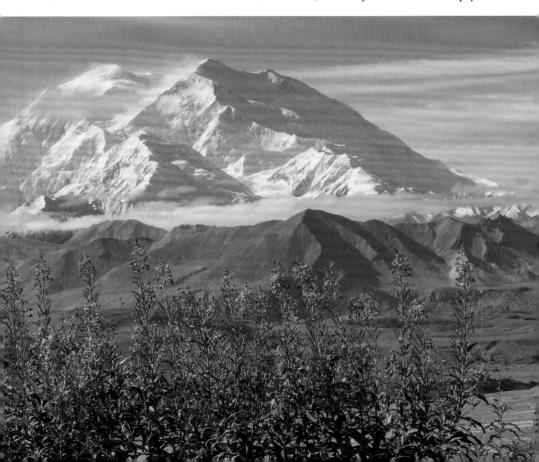

uphill, rapidly opening space from its pursuers. The distance widened; clearly, the larger wolves were unable to run uphill as fast as the coyote. We lost sight of the canids as they raced behind the ridge. The second coyote trailed the chase, yipping, almost wailing.

My group rushed to a better vantage point and caught a brief view of a wolf cresting the ridge. In a moment we heard two very loud, high-pitched yelps, then silence.

## IV

Young wolves dispersing from their natal territory face great peril when traversing adjoining or distant territories. Intraspecific strife—wolves killing other wolves—is the main control on their population. Twice I've found the carcasses of wolves killed by other wolves, their stories written in the snow.

Despite the inherent danger, dispersing wolves are capable of long movements in search of vacant territory. In 1988, biologists collared a young male wolf near Point Possession on the Kenai Peninsula's northern tip. Two years later a trapper caught him on the Chatanika River, 80 miles northwest of Fairbanks and 350 air miles from where he had been collared. The wolf had traveled many more miles than that, crossing mountains, rivers, and roads, and bypassing Turnagain Arm and Anchorage, Alaska's largest city. Other dispersing Kenai Peninsula wolves reached the upper Susitna River and Broad Pass, but none were documented traveling as far as the Point Possession wolf. (During severe winters, 60 percent of all wolves under three years old may travel up to five hundred miles to find vacant territory.)

In Yukon–Charley Rivers National Preserve, biologists collared a young silver-black male in 2010 that had bonded with a female, the lone survivor of the Edwards Creek Pack. Four months later, his mate dead of starvation, the male was on the move, drifting north to the edge of the Arctic Ocean and east to the Yukon's Mackenzie River. Early in 2011, the male established a tenuous territory of his own twenty miles east of Prudhoe Bay, where he lingered at his peril from resident wolf packs.

On his journey to that date, the wolf had been smart, stealthy, and lucky. The loner had played a dangerous game, running the gauntlet of several packs, to reach the Arctic Coast, a ramble of fifteen hundred miles.

Late that same year the male was on the move again. South of the Brooks Range, not far from the Arctic Circle, his incredible journey ended. In mid-October 2011, biologists found the wolf curled up under a spruce tree, dead of starvation. When collared, he'd weighed 103 pounds but when found, just 69 pounds. In six months the wolf had traveled 2,085 miles, never crossing a road.

## V

With wolves and bears sharing the same terrain, competition and conflict are inevitable. Wolves are known to attack and kill black bears. Because of the threat from grizzlies and wolves, black bears seldom roam far from timber, where they can find safety in the trees. Wolves pose particular threat to black bear cubs—rarely, it is thought, to grizzly cubs. (Biologists refer to *Ursus arctos* as brown/grizzly bears, just one species. In practice, coastal bears are called brown bears and inland bears, grizzlies.)

On a cool, overcast day in Denali National Park in 1989, busloads of tourists witnessed an epic wolf-grizzly battle. Early that morning, a friend of mine spotted eleven wolves in a low saddle on the south side of the road near the East Fork cabin. In the creek below them, he also saw a female grizzly trailed by three cubs. The animals appeared unaware of each other but traveling on an intersecting course. The wolves caught the scent of the bears and turned to follow them rambling upstream.

A short while later and a half mile to the east, another friend, a tour bus driver, saw six wolves bunched together, wagging tails and touching muzzles. She also spotted four bears in an opening in the brush upwind and south of the wolves. She recognized them as the bear family she had seen several times that summer, the cubs distinguished by their small size, forty to fifty pounds. My friend and her passengers saw the wolves charge and the cubs race for the protection of their mother. The six wolves, joined by others previously hidden in the willows, forced the bears through the brush and onto open tundra.

The pack chased the bears uphill and into a grassy swale. The female turned repeatedly to defend her cubs, placing herself between them and the wolves. Several times she charged and drove off individual wolves. The cubs would not stay together, bolting off on their own. The wolves, attacking from all angles,

confused and distracted the mother bear. Clearly the wolves fought to isolate the cubs. By my friend's account, the bear spent much of her power and energy sprinting in defense of one imperiled cub or another.

The wolves drove the bears out of sight into a narrow depression. In less than half a minute, a single cub bolted into view, followed closely by its mother. The sow stopped several times to look back but each time turned away to race on behind her surviving cub, seeking shelter in distant, thick brush.

One by one, the wolves wandered out of concealment, some flopping onto the tundra to rest. After a bit, a large white wolf (perhaps the East Fork alpha female) trotted out with a portion of a cub in its jaws and lay down to feed.

"The entire attack lasted less than thirty minutes. The whole process seemed damn easy for the wolves," my friend said. "Just imagine the sound in that depression as eleven wolves attacked and four grizzlies fought for life," added an onlooker. "The snarling and roaring must have been tremendous. I felt the fear of those cubs."

Not two days later, just a few miles west, my friend spotted a grizzly with two spring cubs feeding in the willows along the East Fork River. When she stopped her bus, she saw three wolves sneaking on the bears. "All I could think was, *Oh, no! Not again*," she told me. "The white wolf was not with these three, but it seemed likely they'd been in on the kill two days before."

Breaking from cover, the wolves charged. The tiny cubs dashed to their mother, diving beneath and behind her. Frantically, the grizzly lunged at the wolves.

"Again, it looked like the wolves were trying to isolate the cubs. These younger, smaller cubs stayed very close to their mother and ran under her whenever possible," my friend said. The battle raged through the brush, wolves circling, the grizzly countering each threat. "When the bears finally opened some space, the female, determined to escape across the river, raced for the water, but her cubs were unable to keep up. The wolves quickly closed in on them. Just as the adult hit the water, she looked over her shoulder and saw the wolves near her cubs. Just in the nick of time she raced back and intercepted them, her cubs once again safely between her legs. The wolves backed off."

The deadly struggle continued upriver and reached a climax behind a distant ridgeline. Several minutes passed before all three bears ran into sight and fled across the open tundra, the wolves nowhere to be seen.

Biologists say that these bear-wolf interactions are consistent with other observations. Spring cubs, when threatened, tend to stick closer to their mother than do yearlings, which often cower together or panic into flight. "Wolves are likely not a threat to adult grizzlies," one biologist said, "but every time I see a sow with one cub, or no cubs, I can't help but wonder how many she had in spring."

## VI

One blustery, rain-lashed day in the Alaska Range, I watched a wolf gorge on a dead caribou. I'd spotted the intact carcass the night before, but now the next day, it had been torn apart and mostly consumed. I had no idea the cause of death, but clearly the wolf savored the meat. A bald eagle perched nearby; three ravens circled on the wind. After feeding, the wolf went to the river for water. Its thirst slaked, the wolf returned to the kill, sniffed and pawed it, but did not feed, then strolled off into the surrounding willow thicket. The eagle and several magpies descended on the leftovers.

Thirty minutes later the wolf padded into open ground just downstream from the kill, followed by a small grizzly, the two separated by less than twenty feet. When the grizzly charged, the wolf bolted ahead. After a brief chase the wolf suddenly stopped, the bear skidding to a halt behind it. Now only ten feet—or one good jump—separated them. When the bear charged a second time, the wolf leaped away. After a few bounds, the wolf again stopped, causing the grizzly to swerve to keep from running into it. Without looking back, the wolf then lay down, butt to the bear. For long moments the grizzly peered at the wolf less than a body length away. Apparently satisfied the game was over, the bear waded the river, leaving the wolf sprawled asleep in the heavy, cold rain.

Other observations of benign encounters between wolves and grizzlies indicate these great beasts know and respect each other's power. Confident in their speed and agility, wolves readily approach grizzlies but seem aware that even brief physical contact carries great risk. Witnesses have seen wolf packs approach and surround adult grizzlies, but without interaction, the wolves either testing potential prey or simply curious. Competition for prey sometimes brings conflict or enormous windfall.

Twice I have seen wolves attack and maim bull caribou only to lose their prey to grizzlies. Early one morning years ago I watched five wolves chase a bull caribou across the broad gravel bars of the Toklat River. Just south of the road bridge, two wolves caught the bull, slashing open his hindquarters. The bull struggled on, one wolf snapping at his side and another at his heels. The whole pack closed in. Exhausted, the bull stopped, lunging about with his antlers. The wolves easily dodged the awkward thrusts. Blood splattered the cobbles and dwarf willows.

The attack abruptly ceased. With lowered tines the bull faced the wolves spread in a half circle before him. Minutes dragged by before the wolves drifted away to leave the bull to weaken or die of his wounds. Upstream a short distance, one of the wolves waded the shallow, turbid river and curled up under a willow to keep watch. The others wandered farther upstream and sat or sprawled on the ground to rest, their nonchalant air compromised by long looks back toward the wounded bull.

Within a half hour, the four wolves got up and jogged off a mile into the thick brush southwest of Divide Mountain, where just upstream a grizzly trailed by three cubs meandered along the bank.

I waited and watched as the injured bull weakened and collapsed to the ground. A little after full daylight, the sentinel wolf, apparently alarmed by road traffic, got up and trotted away. The caribou struggled to his feet to watch the departing wolf but faltered when it tried to walk. He lurched forward twice but foundered each time.

Upstream, the grizzlies continued to wander closer. Not even a faint wind ruffled the willows. With even a slight breeze, the bears, just a half mile away, would scent the bloody caribou.

The sow and cubs forded a river channel, placing them on the same side as the bull, which saw them and wobbled to his feet. The four grizzlies paused to crop berries and dig roots two hundred yards from the caribou. A slight breeze stirred. In a clearing the sow slammed to a stop; her head came up, swiveled toward the bull. Without a glance at her cubs, she bolted forward. When she saw the bull, she charged full-out. The caribou tried to flee but stumbled into the river. And like that, the grizzly was there, plunging in with a spray of water. With both teeth and claws, the grizzly seized the bull by the shoulders, the two lunging about like a rodeo bulldogger. At a single blow,

the bull's stomach burst like a smashed watermelon, a flash of blood and guts spilling into the river.

For long minutes, the grizzly held the bull against the current before finally yanking him down. Now in command, the grizzly tore at the helpless bull, the silty water turning crimson. The bear made no apparent attempt to kill the bull outright but simply began to feed. The three cubs had been hesitant to approach, but once into the fray, they joined the feast. Perhaps a full twenty minutes passed before the bull ceased to kick, long after the bears had begun to feed.

Throughout the day the bears fed and napped by their kill. At twilight, a lone wolf came downriver and warily circled the bears asleep atop their treasure.

## VII

On a cold, windy, overcast afternoon in Denali Park, I scanned a distant ridge-line for Dall sheep. It took determination, and a warm parka, to sit staring into the spotting scope. In the alpine above Bergh Lake, I finally saw what at first appeared to be a sheep but turned out to be a light-gray wolf sleeping in the rocks. I spotted another wolf nearby sniffing at ground squirrel burrows that pocked the slope. When the first wolf roused, the second joined it, the two trotting off uphill.

The wolves climbed the slope and disappeared behind the summit ridge, where yesterday I'd seen a band of ewes and lambs. A half hour passed before the wolves came into view and descended into Highway Pass. From a different vantage point, I watched them traverse into the valley to a grassy prominence that dominated the pass.

Side by side they studied the tundra sprawling below them. They then split up, with one stationary on the point, the other descending to a nearby willow thicket where it searched for squirrels. After flushing some ptarmigan, the wolf limped from the willows and headed east, its companion darting down to catch up. Although the lead wolf favored its left foreleg as if from a shoulder injury, both wolves moved fast. On the rocky hillside, their coloration had blended in; on the lower slopes, they were conspicuous against the green.

Half a mile to the east of the wolves, two bull caribou, one with enormous antlers, grazed in an open swale. The wolves picked up their pace, fast closing

on the caribou. Their route was happenstance, neither predator nor prey aware of each other. When the wolves trotted to the edge of the swale, they stopped to watch the unsuspecting caribou now just two hundred yards away. Its limp gone, the lead wolf crept forward catlike with its companion following slightly behind. Ten . . . twenty . . . thirty yards closer . . . and the wolves charged. The small bull saw them almost at once and bolted, but the wolves veered away to pursue the larger bull. The chase entered a gorge, and they were hidden from view behind a rocky ridge.

Suddenly the big bull dashed into sight and plunged straight down the rocky slope, the wolves less than thirty feet behind. One slip or misstep and the wolves would have him. Running downhill, the bull picked up speed, widening the gap. Once he reached level ground, the wolves stopped to watch him race away.

After a brief pause, the wolves turned and ran back uphill. As soon as they regained the ridgeline, the second bull, which had stopped a few hundred yards away, saw them and took off. The light-colored wolf put on an incredible burst of speed, leaving its partner behind. On the sidehill, the gap between hunter and prey narrowed. When the wolves had closed to within twenty yards, the bull cut sharply downhill and, at the base of the slope, swerved down the drainage toward Bergh Lake. Here the trailing wolf stopped, but the leader continued the pursuit.

After changing my position to regain the view, I spotted the bull racing along the lakeshore, both wolves nearly on him. Without hesitation the bull jumped into the windswept lake, one wolf at his heels. The turbulent water quickly forced the wolf back to dry ground. The caribou breasted the waves and swam to the far shore, where he stopped in the shallows. After a long rest, the wolves trotted off down the canyon and out of sight. For over an hour the bull studied the far shore for pursuit, content to stand knee-deep in the lake, conserving energy for the next challenge.

## VIII

Late one evening, with fresh snow on the ground from the second September storm, eight moose—three bulls and five cows—milled about near the south end of a small lake fringed with timber. The antlers of the largest bull were

well over four feet wide, the next about three feet, while the smallest was just a forked horn.

Even though the rut had peaked, the bulls capered about, sparring with each other and harassing the cows. All of them browsed periodically, an indication that the mating season was almost over. (Bulls eat little during the rut and live off their body fat.) Just at sunset I got a good photo of the two largest bulls crashing headlong into each other, the battle lasting until dark.

The next morning I returned to the lake with my friend, wildlife biologist Derek Stonorov. Hiking in through fresh snow, we crossed the tracks of several wolves. As silently as possible, we followed their trail to a cutbank above the lake. Here the tracks separated, five wolves fanning out from the trail. We were in luck; the herd of moose was still in the marsh at the south end of the lake and active. The wolves hadn't chased them off as we'd feared. Glassing the opposite end of the lake, we spotted a bull moose sprawled flat, the churned snow around it splashed with red. A dozen magpies perched nearby or pecked at the crimson splashes. Derek and I edged away to a more distant vantage point and settled down to watch.

After twenty minutes, the "dead" moose raised his head and struggled to his feet. Both rear legs were torn and bloody. A wound inside his right knee hemorrhaged blood. The bull wobbled and sagged back to the ground. We held our breath, expecting at any minute for hidden wolves to attack from the brush.

Just before noon a wolf crept from the snow-draped willows and paused to study the prostrate bull a few yards away. The wolf then turned and looked toward us, well over a football field distant. (So much for our attempted stealth, silence, and concealment.) The wolf sauntered back into the timber but in minutes came out again and beelined for the moose. The bull thrashed to his feet as the wolf closed to within ten feet.

The wolf dodged a clumsy antler thrust and circled, judging the moose's mobility and weakness. Twice the wolf snapped up mouthfuls of bloody snow. A magpie landed on the moose and pecked at his wounds; another settled nearby.

I marveled at the size disparity, the moose easily ten times the size of the wolf. Moose are the wolf's most formidable prey, and it seemed incredible that a single wolf could have inflicted such wounds on this huge animal.

The wolf turned away then and padded along the lakeshore directly toward us, stopping ten yards away. We sat motionless and silent—the wolf's yellow

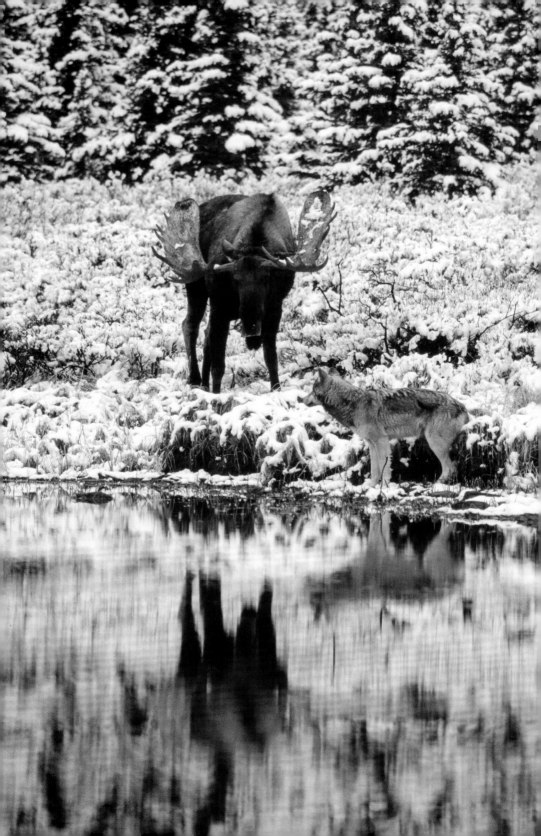

eyes burning incandescent. Though the wolf eyed us intently, it showed neither fear nor aggression. This was the closest either of us had ever been to a wild wolf.

After a long pause, the wolf climbed the low bank and circled into the surrounding brush. The chittering of a red squirrel marked its passage around and beyond us.

The wolf stepped into view on the shoreline behind us. Downwind now, it again approached to within a few yards. With flaring nostrils, it studied our scent. With its curiosity satisfied, the wolf regained the bank and looped back to the moose, upright with lowered antlers. From a few scant feet, the bull lunged forward, but the wolf dodged away. That one clumsy thrust was enough; the wolf, tail between its legs, abandoned its hobbled but still dangerous prey.

Over the next few hours, the wolf ambled in and out of cover to check on the moose. Each time, the bull got up to face the wolf with lowered tines. Between bouts, the bull sprawled flat, motionless as death. At such moments, Derek and I expected the wolf to charge to the attack, but nothing. We both knew that wolves, after inflicting grievous wounds on dangerous prey, often break contact, content to wait for the wounds to take effect. Better to make the final assault on a weakened moose than one full of fight.

In late afternoon the sun broke through, melting some of the snow. The wolf no longer paid any attention to us. We could move or talk quietly without even drawing a glance. At one point, with the wolf and moose head to head, the wolf suddenly backed off to stare at the far end of the lake. We looked too, but saw nothing. The wolf, excited now, began to run, dodging past the bull and into the brush. From somewhere in the timber close behind us, the wolf howled, loud and crisp. A brief reply echoed from down the lake.

When the voices stilled, we heard the wolf running through the brush and saw in the meadow near the south end of the lake the herd of moose motionless, watching something in the timber. Closer, on our side of the lake, a cow moose crashed from hiding and plunged into the lake where she pushed hard into chest-deep water. There she turned about to face an unseen threat. With raised hackles and flattened ears, she uttered a deep growl. (A moose can growl, deep and menacing like a Rottweiler, when confronting a mortal threat.)

In late September, a bull moose, wounded in an earlier encounter with a wolf pack, faces down a lone female wolf.

Then we heard a stampede in the thicket behind us. We leaped to our feet, bear repellents out and ready. Gray and white shapes zipped through the understory. Then, through a gap in the willows just ten feet away, we saw two wolves stop to stare at us. One quick look and they were gone. We watched three wolves sprint into the meadow near the wounded bull but race past without pause. We could hear others passing in the trees and willows.

As quickly as it began, it was over. The wolves had gone. Even though it seemed the wolves could have easily finished off the bull, they had left it.

At the opposite end of the lake, the cow stood in the water silent and motionless. The group of rutting moose slowly wandered off into the timber, leaving the injured bull and the cow the only moose in view. At twilight we abandoned our vigil.

On the hike back to the road, a commotion in the alders stopped us in our tracks. Another bull lurched out of the willows and hobbled by us toward the lake, his right front leg broken below the knee.

At first light the next day, we again approached the lake, assuming that overnight the wolves had made their kill. Closing in from the south end, we blundered through tall willows near the lakeshore and into the bull with the broken leg. Judging by the fractured skim ice, he had been in the lake earlier but was now unable to walk. We detoured well around him and cut the trails of several wolves.

The wolves were nowhere in sight, but the injured bull was still alive. He browsed and moved about with far more agility that he had displayed yesterday. The bleeding had stopped and he was able to put weight on his rear legs, a remarkable comeback.

We soon saw two wolves pulse through the timber northwest of the lake, but they never left their cover; the bull was unaware.

Hours later, a wolf howled from the trees where we'd seen the two wolves. From somewhere to the west, their song was answered by several voices. The injured bull struggled to stand. The howling lasted ten minutes and then silence. A bit later the wolves howled again but much farther away. Somewhere to the north, other voices chimed in, the howls volleying back and forth.

Derek and I kept watch for two more days, waiting for the wolves to return. Each day the injured bull grew stronger, but the bull with the broken leg weakened, never hobbling more than a few steps from the thickets by the lakeshore.

Each day we arrived at first light and left at dark. Nights brought additional snow. We neither saw fresh wolf tracks nor heard howling. We abandoned our vigil each evening, wondering if the moose would survive the night.

On the fifth night, a storm dumped heavy snow, closing the road for the winter. Without access we were unable to follow the drama. Three days later, at my request, a biologist flew over the lake but was unable to locate either bull. On a rocky stream a half mile east of the lake, he spotted a single wolf crouched next to a freshly killed caribou. He saw the wolf raise its head and howl. A mile to the north, he spotted a pack of twelve wolves running toward the kill.

The following April when the road again opened to traffic, I drove out to within five miles of the lake and hiked in to try to piece together the story. Just fifty feet from where I last saw the bull with the broken leg, I found his bones and skull, the ground littered with desiccated wolf scat. On the lakeshore less than a hundred yards away, I discovered the skeleton of a cow moose. It took a search, but I finally located the remains of the wounded bull. At some point the previous fall he had made his last stand in a swale a quarter of a mile from the lake. I photographed his antlered skull amid a great circle of moose hair, gnawed bones, and wolf droppings.

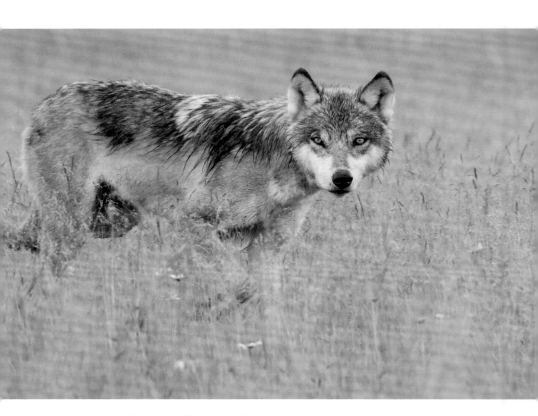

A large male wolf, the alpha of its pack, warily circles the motionless photographer.

# *Making Contact*

**ACROSS THE MEADOW,** in an alder thicket skirting tall cottonwoods, the wolves were talking. The barks, yips, and brief howls of excited pups welcomed the returning hunter. With wagging tails and lolling tongues, the pups and two adults greeted the homecoming male, the bringer of food and comfort.

My friend Alice and I watched the reunion from our vantage point a quarter of a mile away. Excited, almost discordant, howling had drawn us here the day before. Through binoculars we watched the male cross the vast sedge meadow, accept the pack's greeting, and regurgitate food for the pups. We made no attempt to hide but sat in the open, certain the wolves knew we were there.

After feeding, the wolves faded into the dense alders like wisps of smoke. We yearned for the pups to tumble into the open and play as they had the night before. Long minutes dragged by. Clouds of mosquitoes, white socks, and no-see-ums hammered us as we kept our motionless vigil. Then . . . *there!* The gray wolf stalked from the brush and came our way. We crouched low, silent, and motionless.

The wolf looked neither left nor right but strode directly to us. Without hesitation he approached with the confidence of primacy. Sixteen feet away he stopped and regarded us with his searing, amber eyes. He was big, powerful, and fully furred. Like all wolves he had huge feet, long legs, and a broad, deep chest. For us, there was no wind, no hordes of hungry insects, just those inquisitive eyes. He took two steps closer. When I rose to my knees for photos, he flinched, prepared to jump back. I froze, and he relaxed, scanned the meadow behind us and the distant river, then looked back toward the rendezvous site. He gazed at us again, his head cocked to one side, then, as if satisfied, turned to lope back home.

When the wolf was gone, the sound turned back on; I felt and heard the wind in the grass, the squabbling gulls on the tidal flats, the incessant drone

of the ravenous insects. In the meadow to the north, I spotted two brown bears grazing the spring sedges, a bald eagle circling above them. For precious moments, those golden eyes were my only awareness.

Some resource managers would condemn Alice and me for being too close to the wolf, for failing to ward off its approach. They would cite the risk, say we were conditioning the wolf to lose its fear of people, creating an unsafe situation. Maybe.

Are wolves dangerous? Absolutely. An estimated fifty to sixty thousand wolves live in North America, the bulk in Canada, and are expanding their range. In 2002 biologist Mark McNay published a study of eighty case histories of human-wolf interactions in North America. He reported no evidence to date of wild wolves killing a human since 1900, though there had been attacks. Twelve attacks were by rabid wolves, and nonrabid wolves bit sixteen people. Some cases involved small children or dogs, whereas wolves being fed— intentionally (food conditioning) or otherwise—played a role in many others. McNay concluded that "wild wolves present little threat to people."

McNay's study was not all-inclusive. He edited out undocumented incidents and undoubtedly missed others. Some Alaska Natives believe that wolves killed many of the people who have gone missing in the wilderness. It would be arrogant to dismiss their beliefs. In 1940, near Klawock, a village on Prince of Wales Island in Southeast Alaska, a one-armed Tlingit, William Barney, fought off two wolves that stalked and attacked him. The wolves inflicted severe head wounds before he was able to shoot one and wound the other. He staggered home under his own power. Without a gun he might have become one of the disappeared. This attack was not in McNay's report.

In 2000, Ludwig Carbyn, a Canadian wolf expert, was asked for his prediction on the biggest wolf story of the new millennium: "I think in the new century, you will find a situation where a wolf or a pack of wolves is going to kill someone."

Dr. Carbyn's analysis correlated wolf population expansion with a change of public attitudes toward wolves. He cited human encroachment into remote and rural zones. With wildlife habitat sliced up by roads, powerlines, pipelines, mines, and subdivisions, he said, ever greater numbers of people would come into contact with wolves.

Carbyn's prophecy came horribly true. Just five years later, four wolves, with their natural prey scarce, began feeding on camp refuse at Points North Landing, Saskatchewan. On November 8, 2005, twenty-two-year-old Kenton Carnegie went on a solo hike despite a warning about bold and aggressive wolves in the area. Searchers later found his partially consumed body. Subsequent investigation concluded that he'd been killed by wolves.

Then, in Alaska on March 8, 2010, near Chignik Lake, Alaska, wolves killed schoolteacher Candice Berner, thirty-two, as she was jogging and wearing headphones on the road outside of town. The Alaska medical examiner ruled that her death was caused by "multiple injuries due to animal mauling." Necropsies of the wolves killed by authorities gave no indication of rabies, sickness, or wolf-dog hybridization as causation.

Just five months earlier, on October 27, 2009, Taylor Mitchell, a nineteen-year-old Canadian folk singer on break from a concert tour in Nova Scotia, had died from injuries and blood loss sustained in an attack by *coyotes* while hiking Skyline Trail in Cape Breton Highlands National Park. Food conditioning may have played a part. She, like Berner, was wearing headphones at the time of the attack. The Mitchell incident did not make headlines in Alaska, but the Berner tragedy sparked a firestorm of controversy. Alaska was then hotly debating the issue of state-sponsored wolf killing, done to increase the numbers of moose and caribou available to hunters. News of a wolf attack in Yakutat in 2000 was dredged up, the two incidents reverberating for months.

Had Alice and I placed ourselves in harm's way? Did we create an unsafe situation? I think not. It was a remote area. There were no reports of wolves eating human food or garbage. An abundant supply of salmon provided a limitless source of protein for the wolves; we had photographed them chasing salmon. There is always risk with wild animals, and I never put myself in harm's way without personal protection—a firearm or some bear spray. I judged the situation both safe and exceptional.

## II

Rollie Ostermick came north in 1971 to work for the Alaska Department of Fish and Game. He'd spent the previous winter in the Army in Vietnam. In comparison, Alaska felt like paradise.

Rollie saw his first wolf in the autumn of 1972 within fifty feet of his vehicle idling on the Parks Highway north of Cantwell. He and his friends were thrilled. (Someone shot the wolf the next day.)

Earlier that summer he had worked for the National Park Service on Isle Royale in Lake Superior. Even though Isle Royale was well-known for its wolf-moose interactions, he had neither heard nor seen a wolf, despite numerous explorations and conversations with Rolf Peterson, the well-known wolf biologist. Rollie's friend Phil Burns had worked at Katmai in 1969 and shared tales of his sightings of wolves. While Rollie was still in Vietnam, Burns had sent him a close-up of a sleeping wolf. Inspired by wild Alaska, Rollie spent most of the 1970s employed as a ranger in Glacier Bay, Katmai, and Denali.

In Katmai in 1974, Rollie had a "life-altering" experience. Park visitors had seen wolves several times that spring, as well as the previous summer, on the road to the Valley of Ten Thousand Smokes. One night after work, Rollie and four friends borrowed a truck and drove out the road. Somewhere near milepost 4, a wolf sprinted from the brush to chase the truck. The driver slowed and stopped. Unafraid, the wolf trotted right up to the tailgate, stopping within twenty feet of the passengers. Rollie deemed the wolf curious and nonaggressive.

Then the extraordinary happened. Rollie had seen a television program where a biologist had lain down in front of a captive wolf, exposing his neck in submission, in order to establish a bond. Rollie decided to do the same thing. "I got out of the truck, laid flat on the road and tilted my head back. The wolf circled me, just two feet away," he told me. "I remember thinking, *This is the coolest thing I've ever done*, and at the same time, *This is the stupidest thing I've ever done*."

Two people, one of them Rollie's boss, also lay on the road with the same result. "Never once a threat or any whiff of danger," Rollie said. "Not a growl or any hint of aggression." That event was the first of Rollie's fifteen prolonged encounters with wolves at close range. On two separate occasions he assumed the submissive pose with the same result. Other times he and some friends sat, or knelt down, to entice the wolves closer. "No one ever said, 'Don't do it. Don't approach the wolves. Don't get close,'" he said. "Never, not once, did anyone object, and I didn't keep it a secret from my supervisors. The wolves always displayed a tolerance and curiosity greater than anyone's dog."

Rollie Ostermick investigating a grizzly bear den (Photo by Mary Ostermick)

Want proof of his story? Check out the October 1977 *National Geographic* to see his photographs of wolves and people, one wolf sniffing the boot of a seated woman.

Later, in Denali in 1980, Rollie had another close encounter with a wolf, an adult that came onto the porch of his cabin. The wolf did not linger. One of Rollie's friends who had shared one of his Katmai encounters had a different experience. While on a solo hike on the Savage River, the friend spotted a wolf crossing a gravel bar. "I wanted to see if the trick would work," he said, "so I laid down. Sure enough, the wolf came right up to me, same as at Katmai." Again, there was no threat or aggressive behavior.

Rollie theorizes that the wolves in Katmai were initially habituated to

In the early 1970s Rollie photographed this inquisitive wolf in Katmai. His photos appeared in numerous magazines and on book covers. (Photo courtesy of Rollie Ostermick)

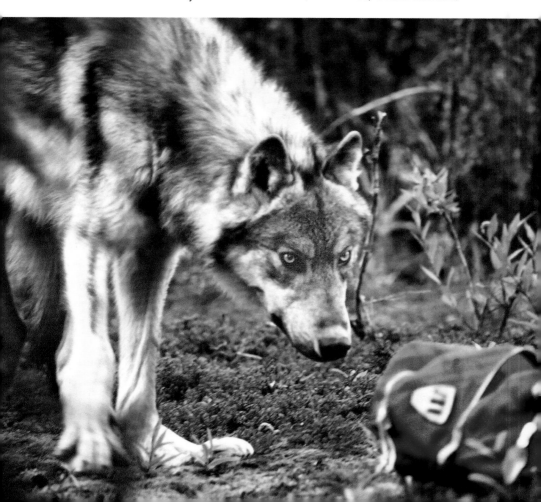

people in 1966 during construction of the road to the Valley of Ten Thousand Smokes. He'd heard stories of wolves approaching the workers on break and eventually being fed lunch scraps. "They learned that humans were a benefit not a danger or detriment." The primitive dump at Katmai was not closed until 1975. The wolves could have fed there as well and on fish scraps from the lakeside fish-cleaning table.

Shortly after Rollie transferred from Katmai, colleagues on a winter ski trip saw a pack of seventeen wolves on the ice near the Naknek Lake moraine. The following winter, the skinned carcasses of eleven wolves were discovered on nearby Brooks Lake, illegally gunned from the air. The benign wolf-human encounters were over.

"I feel blessed to have had these experiences," Rollie said. "High points of my life, never to be repeated. Times have changed. Everyone tells you to stay back,

don't approach wildlife. A whole paranoia that wolves are dangerous. It was OK to howl to the wolves back then. Not now. People see it as unethical—fooling the wolves into thinking other wolves are in their territory. A lot of fear, as if they want us to be afraid of the wolves."

### III

Bud Rice called it the night he would never forget.

It was a clear, calm day in early April when Bud and his wife, Anne "Lulie" Williams, set out from their cabin near milepost 127 on the Parks Highway bound for the upper Tokositna River. Bud skijored behind his two dogs, Doc and Casper, the three pulling sixty pounds of gear in a pulk tethered to Bud's waist. Behind four dogs, Lulie steered a sled loaded with another hundred pounds of camp supplies. The trail meandered through a mixed forest of birch and spruce, over open meadows, and across Swan Lake. On a hard-packed trail atop a five-foot snowpack, the pair covered the first seven and a half miles in about forty minutes. Their first stop was

Bunco Lake, about eleven miles out, and from there they turned to follow the Tokositna River. At about one o'clock they stopped for lunch, soaking in the beauty of the mountains on a clear, cold spring day. They saw the tracks of moose and ptarmigan; they watched a beaver slither from a hole in the river ice and had to restrain the dogs from giving chase.

As they continued upstream after lunch, they lost sight of Denali behind the serrated Tokosha Mountains. Two hours later, and about two miles short of Home Lake, they stopped in the last timber along the river to pitch camp. Alder and willow crowded the spruce and birch lining their chosen campsite. Once the tent was up, the dogs unharnessed, and a pile of firewood stockpiled for the night, they set out on a snowshoe hike with the dogs. They saw more moose tracks, beaver trails and cuttings, and skeins of ptarmigan tracks. In the stillness they heard an owl and moments later a wolf howling in the distance. More wolves chimed in, maybe as many as a dozen, Bud estimated. The dogs howled back.

Bud and Lulie returned to camp, built a fire, and started dinner, enthralled by the silence and wild beauty around them. As night fell and the temperature dropped, they got comfortable in their small tent and brought their German short-haired pointer, Lillehammer, in with them. The others dogs were securely staked nearby.

The wolves began to howl again, this time closer and with more intensity. Outside the tent, the dogs fidgeted and pulled at their chains. When the dogs began to bark and growl, Bud and Lulie got up. Lulie spotted the eye-shine of a wolf in the glow of her headlamp. "The wolves had us half-surrounded, and their howls reverberated through the hills and our hearts," Bud told me. "Though eerily beautiful, the howling was ominous." The howling was so loud that Bud felt the vibration in his chest. "There were at least ten of them at first," he said. Then the woods exploded with howling, far more than a dozen. Bud described the sound as a tremolo, an excited celebration, reminiscent of Indian war whoops in the movies.

The couple had heard stories of wolves killing and devouring dogs near Eagle River, a suburb of Anchorage, and they feared for their dogs, especially after they joined in the howling, a direct challenge to the wolves. Quickly, they heaped on dry wood to build up the fire. They shouted to let the wolves know humans were present and not just loose dogs. The wolves faded back

from the fire, going silent. Once the dogs relaxed a bit, Bud and Lulie crawled back in their tent. Almost at once, the howling resumed. Three times the scenario repeated. Finally Bud got up, this time to remain out all night, tending the fire. "It was the smartest thing I could have done. We felt we were being watched," he said. "It was uncanny, a surreal story of siege, like in an old movie."

Bud stripped one dead spruce of its branches and cut down another to feed the fire. The northern lights came out with big green sheets rippling across the sky. By the fire, Bud saw intermittent movement in the timber and the glow of eyes. "Almost like a dream," Bud said, "like a Jack London story. Unreal."

Around five o'clock, the dawn light began to grow. "We were both worn out from a sleepless night and all the work," Bud recalled. As he built up the fire, the howling began again, intense and powerful. An hour later, when the sun finally topped the distant mountains, the wolves backed off and went silent. "We decided without much discussion to cut our trip short," Bud said. "The dogs wanted to leave. We wanted to leave. The wolves wanted us to leave their territory. In broad daylight we packed up and got the hell out of there as fast as we could go." Once on the river, the dogs needed no encouragement and took off at full speed. Back at Bunco Lake, the dogs collapsed, exhausted from the traumatic night. It took the rest of the day to reach the trailhead.

When Bud and Lulie got back to town, they made some calls and discovered that they had been in the territory of the Tokosha Mountain Pack, twenty-four wolves strong. "We felt safe as long as the fire was going," Bud said. "If the fire would have gone out, I think the wolves would have come in and killed the dogs, and then we would have been at great risk."

Bud didn't do as much winter camping after that, citing age and the effect of this wolf encounter. "My gut feeling is that wolves are a tremendous force of nature," he said. "They are to be respected, and not to be trifled with. This powerful force, when organized, can structure nature. Take a wolf out of the biome, and it changes everything."

## IV

Jerre Wills, a respected friend of mine, described a close encounter with wolves that changed his life. Wills is a true Alaskan renaissance man: homesteader,

mechanic, builder, pilot, commercial fisherman. He once ran a trapline from his cabin on Twin Lakes in what is now Lake Clark National Park. Years of bush life honed his strength, made him capable of running a long trapline on snowshoes through rugged, brutally cold wilderness.

One winter, while snowshoeing back to his cabin, Wills sensed something behind him. Looking back, he saw wolves to his left and right, trying to flank him. At first, he kept calm, unerring in pace or direction. When the wolves maneuvered to cut him off, he began to run, the wolves giving chase. He reached his cabin just as the wolves closed in. "I have no doubt they were hunting me," he said. "No doubt at all. I think they would have taken me if I had been further from the cabin."

Wills is unshaken in his belief that for a short time he was prey. He is thoughtful and experienced, with a high regard for wildlife. "If the populations are healthy, I don't have any problem with trapping or hunting," he told me. "But it's hard to walk up and look a trapped wolf in the eye and not see the intelligence burning there. You just can't miss it, or shrug it off. I always felt bad." He stopped trapping wolves because of that disquiet, which changed his attitude toward them.

Humans, in part, may fear or loathe wolves out of a primordial dread of being eaten. Sometimes, I wonder, do wolves fear us for the same reason?

V

Through autumn-bright aspen and birch, I walked up the trail from the river to the cabin on the ridge. I was in the region to photograph caribou and wanted to stop in to see my acquaintances Seth Kanter and his wife Stacey. It was hunting season, and a blood-red caribou backbone leaned against the outside of the cabin's entryway. A log cache stood high behind the cabin, a dogsled suspended from its joists. The ribs and hindquarters of a caribou hung below the sled. A family of gray jays busily ferried away scraps of meat and fat. The outhouse, I would discover, had a door and window but no seat. As in many bush privies, the toilet paper was kept in a plastic-lidded coffee can.

I shouted my arrival and was welcomed. The entryway, its floor askew from buckled permafrost, sheltered the cabin door. Inside the entry was a row of 16-penny nails bent upward to form hooks. An old GI parka dangled

from one, a rusted double-spring trap on another, and between them was skewered a softball-sized caribou heart, a single drop of blood congealed on the tip. The bleached lower jaw of a wolf hung from one hook, the skull of a black bear on another, and a broken Coleman lantern on yet another. A bolt-action rifle with open sights dangled by its sling. On shelves above the hooks were rusty cans and bottles that contained nails and various mechanical parts. The floor was muddy and leaf-strewn.

Inside the cabin I was asked to remove my shoes, the familiar Alaskan custom. The cabin floor was level, and the plywood gleamed with many coats of finish. The room was orderly and spotless, warm and ripe with the smell of fresh bread and fried meat. To the left was a barrel stove and behind it a wood cookstove that shared the one chimney. Over each was a pole drying rack, hung with socks and gloves. Open shelves beyond held canned goods, boxes of rice, and other dried food.

Pegs in the wall behind and beside the door bulged with coats and outerwear. In the middle of the cabin and under the big window was a table hewn from rough-cut spruce. Two log-slab benches and a chair made of peeled spruce poles embraced the light from this, the cabin's only window. Next to the table was a bookshelf: Bradford Angier. Michener. Nietzsche. Brautigan. Grisham. Twain. Tolstoy. Wolfe. Kafka.

There was a workbench in the far-right corner, a bed in the left, a privacy curtain drawn back next to it. Against the wall there was a spruce pole couch covered with a black bear skin. Electric lights, powered by a wind charger and generator, were fixed to the walls next to propane light fixtures.

We settled in over tea. Stacey had come to Alaska from the East Coast with a girlfriend for a two-month visit to "real" Alaska. With barely a pause in Anchorage, they flew to their destination, a bush village north of the Arctic Circle. One look around and they were ready to leave. "Sorry," they were told, "only one flight a day." Vexed to learn that the village had no available accommodations, they spent the night in an old cabin with a leaky roof. The next morning, waiting for the plane, Stacey met the man who would become her husband. That was five years ago.

Seth was born in this cabin, the second of two boys, and grew up thirty miles downriver from an Inupiat village. His parents had come here in the early 1960s to subsist from the land, to make a "life—not a living."

His parents, like many others in the early '60s sought self-sufficiency in bush Alaska. Most lasted one winter or less; his parents stayed over two decades before being drawn away by other dreams.

Over a plate of boiled potatoes and caribou ribs, we talked a variety of subjects. Seth spoke of things he liked to eat, and had eaten, or would like to try. He rated some items this way: Beaver: "Great." Black Bear: "The best." Lynx: "Good." Caribou: "Fat bulls—primo." Fox: "Not bad."

"I have eaten everything," he said. "Seals, whale, musk ox, grouse, ptarmigan, fish, of course—everything. But I want to try wolf."

"Wolf?" I asked.

"Sure, why not? I'll bet it's good. It looks like good meat, pale and lean. Hey! It has to be good. Look what it eats. The very best stuff—moose, caribou, sheep, hares."

"I couldn't eat it," his wife said.

"Sure you would," he said.

"No, I wouldn't."

"Yes, you would. I'd say, 'Here try this. One small bite,' and you'd say, 'Do I have to?' and I'd say, 'Yes, you do,' and so you would. One bite, two bites, then three bites and pretty soon you'd find it good just like everything else you've learned to eat."

"I've never heard of anybody eating fox or wolf before," I said.

"Yeah well, I'm not everybody," he said. "Caribou's my favorite, and I'd choose that over everything else. I just believe that no matter what it is, if you're going to kill it, you should eat it."

## VI

In the evening of September 23, 1983, William E. Ruth, forty-one, died in an auto crash at milepost 232 on the Parks Highway in Denali National Park. Wet snow and icy roads had made driving hazardous, but there was no excuse for what happened.

At the time of his death Bill Ruth was my closest friend. We had a lot in common: carpentry, wildlife photography, and a quirky sense of humor. Bill was a self-described "moose freak." He avidly observed and photographed their every behavior. He said he admired their "strength, power, self-possession, and

ability to survive the winter" but laughed at the things he thought similar to humans, especially the bluster of breeding season. He spent the week before his death photographing moose and grizzlies in the park.

To find moose in the autumn, we would leave his cabin in the dark and be in position to photograph at first light. After the activity slowed and the moose bedded down, we'd often perch on a tundra knoll to wait them out. Invariably Bill would produce a bag of chocolate chip cookies that he'd baked and then strike up his pipe. Soon clouds of smoke from what he said was a blend called Irish Whiskey would swirl around us. I called the stench "Irish Warfare."

Sometimes he'd tell stories of journeys to Asia or Africa, but he rarely spoke of his time as a park ranger. More often he'd rant about the latest area construction project that he'd worked on. He fretted over the cost of the house he was building for himself and his partner, Linda, and how the expense stifled their travel plans.

Some details of the fatal auto accident are unclear; weather is not the whole story. It wasn't snowing when Bill left home to drive the eight miles to the park for a movie. On a curve at mile 232 an oncoming car crossed the centerline and, like that, he was gone.

Friends carried Bill's ashes to one of his favorite places, a hill above a small lake in the heart of the best moose country in Denali Park. He and I had photographed there many times: in spring looking for moose calves, in autumn shadowing feisty bulls resplendent in their outsized antlers. We once tracked a bull ghosting through dense fog, only to find it posing in the road for a busload of visitors.

One year after Bill's death, I hiked to the knoll above the lake to honor his memory. Clouds lurched on the wind and carried squalls of hail and icy rain. Moose tracks laced the snowy woods, and hares bounded through the brush. I crossed the saucer-sized tracks of two lynx. I was pleased because I knew my friend, who was alive in my thoughts, would have been excited to see them. I wanted to find some moose, follow them for a while, and remember the old times, the good times. But as the day wore on, a brittle wind forced me to shelter in the dense timber lining the lake. Through swirling snow the hill looked lifeless and inhospitable. My thoughts cried out that this was wrong. That Bill was warm and vital, not like this, not like this at all.

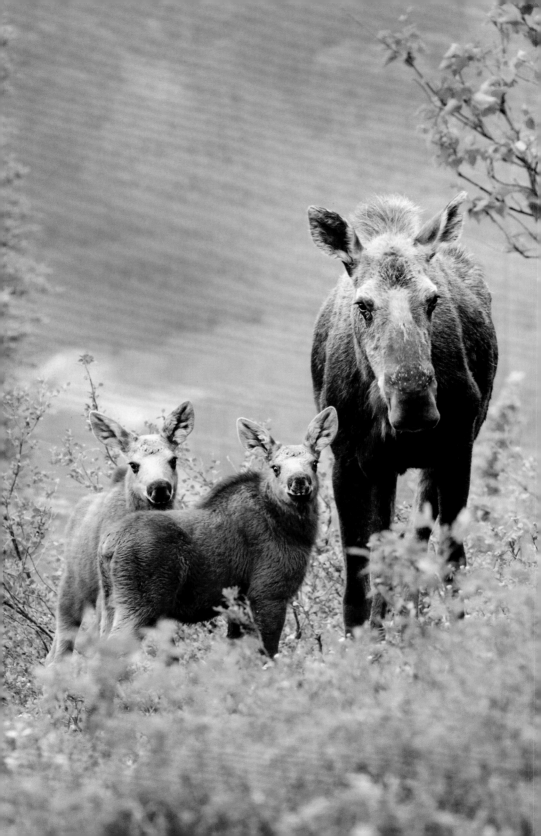

Over the years I've come to believe that the knoll is the perfect place for my friend. Like me, Bill took spiritual and intellectual well-being from nature, wildlife in particular. I realized he would be comfortable with the seasonal fluctuations, find peace in it. On subsequent visits there I have seen things that would have brought him joy: autumn vistas resplendent in yellow and red, radiant dawn reflections of Cathedral Mountain in a nearby lake, a lynx posed in the shadows, wolves howling in the distance, bull moose slamming together, golden-horned Dall sheep on Igloo Mountain, a smoke-colored grizzly bear gorging on blueberries. Any of these events are memorable, but one borders on the surreal.

On a crisp fall day, I climbed a ridge to watch for moose. A few wispy clouds drifted over the snow-tinged mountains and glowing mosaic of taiga and tundra. The vivid colors seized my full attention, and I was slow to spot the wolves. Four of them were resting on the slope just below the summit of Bill's knoll. On the top, a fifth wolf, nearly all white, reclined precisely where Bill's ashes had been spread. Twice I saw the wolf get up, turn a circle, then sprawl back down again.

As the morning wore on, the wolves grew restless, roused themselves, and headed west. The white wolf was the last to leave the knoll, content to trail some distance behind the pack. In short order the wolves traversed the willow and spruce thickets, the boggy muskeg, and the lake filling the pass to Big Creek. One by one the wolves filed into the timber at the far end of the pass and out of sight. At the last point, the white wolf stopped, looked back for one brief moment, and, like that, was gone.

Cow moose are very protective of their calves, defending them from bears and wolves alike. Depending somewhat on the quality of their range, a cow can produce one to three calves each year.

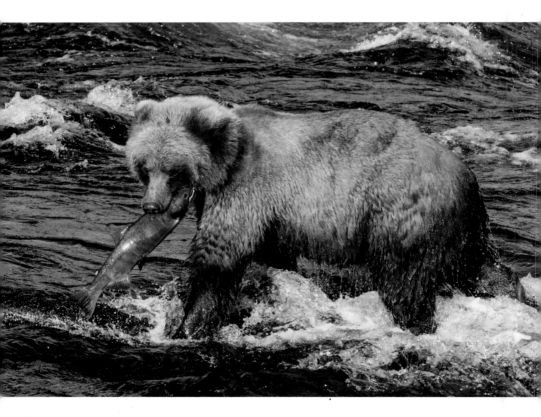

A brown bear wades from the rapids, a late-run silver salmon clamped in its jaws.

# Bears and Salmon

<center>I</center>

**I ANCHORED THE BOAT IN A BAY** at the mouth of a pristine coastal stream in Prince William Sound. Leaden clouds covered the valley, masking the serrated, glacier-clad peaks of the coastal range. Under the lichen-draped spruce and hemlock canopy skirting the slopes lay a carpet of moss and thickets of spiny devil's club, alder, ferns, and blueberry bushes. Rufous hummingbirds flitted through the trees while high overhead, marbled murrelets, a small seabird, nested on the mossy limbs of four-hundred-year-old evergreens, some with a basal diameter of nine feet. Tiny birds atop forest monarchs, a scene as if envisioned by Tolkien.

Ashore, standing on limpet- and barnacle-encrusted cobbles and the shards of countless clamshells, I inhaled the scents of the forest and a vibrant spawning stream. Damp salt air mingled with the smell of dead and dying pink salmon, a rich, pungent aroma more of life than death. Gulls feuded and fussed over fish scraps, their ubiquitous cries filling the air. Two bald eagles perched on the rocks at the stream's edge, another soared over the tidal flat, scattering the gulls, while just down the bay two juvenile eagles waited high in their enormous nest for a parent to bring food.

Mergansers, trailed by their broods, bobbed in the swift current searching for salmon eggs. Small numbers of silver salmon mixed with large schools of pink salmon now forcing their way upstream against the ebbing tide. Just offshore silvers jumped and twisted in the light, eluding harbor seals lurking below.

Every two years pink salmon return to these natal waters to spawn and die. Over the winter, their eggs, nurtured in the gravel by the nutrient-rich, icy water, mature and hatch. The young, called fry, pulse in spring downstream to continue their life cycle far at sea. A magnetic map and chemical clues will guide the mature fish back to this exact spot.

Abundant protein lures meat eaters of all kinds. Twice I had seen coyotes here, once a wolf, and river otters many times. Ravens and crows searched for scraps, stealing from the eagles and gulls alike. At times the stream seemed so packed with salmon that it looked as if I could have stepped across on their backs.

I'll never forget the first time I came here, by small rented skiff, motoring the calm, gray-green waters of the sound, the distant spouts of humpback whales on the horizon. My companion and I passed a luminous waterfall where a bald eagle perched on a nearby spruce, only the second I'd ever seen. "Look! A *bald eagle!*" I shouted. My companion scarcely looked. He'd lived here a long time, seen plenty of eagles.

On this day, years later, I came here for the bears. Both black and brown bears lived on this stream and gorged on salmon. A few feet up from the tideline, I saw the first tracks, huge brown bear prints engraved in the sand.

Salmon heads, tails, and bones littered the shore, leftovers of feasting carnivores. When I crossed the shallow stream, hordes of fish panicked and pushed ahead; some flipped right onto the bank. Each sandbar, every patch of mud, was engraved with tracks: gulls, crows, black bears, brown bears. In the upper part of the tidal flat, colored green and gold with moss and seaweed, and near what appeared to be a favored fishing site, I sat down to wait.

Within minutes, a shadow detached from the forest and sauntered into the creek. A brief lunge, a snap of jaws, and like that, the black bear waded out, a pink salmon struggling in its jaws. In a soft, feathery rain, the bear unhurriedly carried its catch into the timber.

Another black bear, smaller and more animated, rushed from the far tree line, ran across the flats, and plunged into the river, salmon escaping in all directions. The young bear charged, left and right, back and forth, pouncing and pawing at every fish but without success. Then, on the bank, it spied a salmon hurtled ashore by the initial panic. The bear charged forward and seized it with its teeth and front paws. Like a robber fleeing a bank, the bear raced off across the flats for the safety of the woods. I was reminded that not all bears are good fishers.

Over the next two hours, I watched the fishing techniques of a half dozen black bears of various sizes and ages. Some wandered in, grabbed a fish, and departed; others plunged in and bucked the current. All of them got fish; a

few settled for spawned-out carcasses. Once, near the head of the tidal flat, where the creek emerged from the forest, a female with a small cub made a brief foray from cover but retreated when another bear appeared close by. Not one single black bear ate its catch on the bank; they all carried their catch into the safety of the woods. It was telling behavior; something dominant and dangerous lurked there.

A lull in the action descended at midday. Hours dragged by without a single bear in view. Eagles wheeled and called; crows yammered from the stream bank; increasing rain beat a steady tattoo. I watched a pair of otters slide over the rocks and panic a shoal of fish. An uneasy tension pervaded the glowering mists, and I fidgeted with anticipation. Then, *there*, across the flats, stalked a giant—a brown bear, one of the undisputed masters of this realm.

The bear was deep chocolate brown, almost black. No mistaking this hulk for a black bear, for it was at least three times the size of any other bear I had seen that day. The big humped shoulders, the keg-sized head, the long whitish claws identified the species and signified its status: one thousand pounds of fur, muscle, and power. A thought ran through my head: *Yea, though I walk through the valley of the shadow of death, I will fear no evil since I'm the biggest, baddest bear in the valley.*

The brown bear ambled to the riverbank, scarcely glancing right or left, then wandered upstream, pausing to sniff at scraps and carcasses along the way. He was literally waddling fat, the beneficiary of nature's munificence. In a pool below a fast riffle that slowed the salmon's upstream struggle, he waded into massed fish, lowered his head, and in slow motion snapped up a big male pink salmon. He gave the humpbacked fish a slight shake, seemed to study it, and then dropped it back into the water, uninterested. He made another grab and pulled out a fresh, bright female.

Back on the bank the bear used its front paws to pin the salmon to the ground, then ripped the egg sack from the body, sending a scatter of bright-red eggs across the rocks. The bear lapped up the nutritious roe, stripped off the skin, then abandoned the rest to the gulls. In early summer it would have eaten the entire fish. Now, having gained tremendous bulk, the bear was picky, stripping the eggs, skin, eyes, and brain, leaving the rest. Others ignored live fish, preferring instead the putrid remains dredged up from the bottom. It

was disturbing to watch fish being torn apart, left twitching on the sand, their struggle to spawn ruined, a vivid reminder of the sometimes brutal cycle of life, a macabre dance of predator and prey.

I ended my vigil in late afternoon and walked back to the skiff in pounding rain. Before shoving off, I turned for one last look at the mists drifting across the slopes and over the flats. I listened to the birds and watched salmon forging their way upstream, pleased that this remote stream still supported an abundance and variety of life unmatched elsewhere. All of it harkened to a time when Alaska was wild and pure—solely the kingdom of the great bear, a place where all else gave way to its passage.

## II

It was never quiet on this Alaska Peninsula river. I heard boisterous gulls feud over spawned-out red salmon or remnants left by bears. Any lull in the dawn-to-dusk tumult was filled by the *hack-hack-hack* of magpies mocking fish carcasses. The bass notes in the overall cacophony came from brown bear cubs begging shares of their mother's catch or the guttural growls of competing adults.

Red salmon and brown bear is a relationship as old as time. Alaska has 6,640 miles of coastline, more than all the other states combined. If the distance around islands is added, the total rises to nearly 34,000 miles of shoreline, 9,000 miles more than the distance around Earth at the equator. Thousands of rivers and streams punctuate that total, and many of them support Pacific salmon, five species in all—king (chinook), red (sockeye), silver (coho), chum (dog), and pink (humpback). Lured by the abundant protein, bears utilize almost all of the salmon streams, even those cutting through Alaskan cities.

Red salmon return to watercourses draining from lake systems. Juveniles will spend one to two years in the lake before migrating to the sea. Adults will spend two to three years in the ocean before returning to their natal waters. Spawners become bright red with green heads; males develop massive hooked jaws armed with sharp teeth used in dominance battles. Over a period of several days, females spawn in three to five rocky nests, called redds, with the eggs hatching within six to nine weeks. All salmon die after spawning, their bodies enriching the natal waters.

Staring at the river, the water was rich with decaying flesh, I knew a million red salmon had returned there to spawn. The run had peaked; latecomers awaited their fate, an unpleasant one. The river's tiny feeder streams pulsed with fish, at times so thick, they plugged long stretches of shallows, their massed red bodies like blood capillaries wending through green meadows, the banks pounded flat by innumerable paws. The wealth of protein was astonishing. A five-pound salmon provides 4,500 calories (equal to nine cheeseburgers); adult bears eat up to ninety pounds per day. (One McNeil River bear caught one hundred fish in a single day, feasting on only the choice parts.)

On the Alaska Peninsula there are no black bears, only brown bears. The smallest adult bear on the river that year weighed in excess of 350 pounds. Two scarred, old males each would have tipped the scales at well over 1,200 pounds. From my perch I could see seven bears in a quarter-mile radius.

Small adolescent browns react to the approach of a dominant male in much the same manner as a coastal black bear would—race to safety in nearby thickets. They know how the big males acquired their scars and jagged wounds. A single blow or bite can kill.

Just below my viewing stand, one big bear swam, every now and then pausing to examine the dead fish it scraped from the bottom. On the surface, it shook its head to clear its ears. Twice it delicately inserted one long claw into its right ear to clear the water—amazing gentle dexterity for such a huge animal.

A flotilla of gulls bobbed behind the bear, chorusing for scraps. Some of the immature gulls displayed in the same way as nestlings begging from their parents. (I once saw an immature eagle begging from a bear in much the same manner.) The bear paid the birds no heed, but they got scraps all the same.

The trail from my camp to the stand, erected long ago for fish counting, passed through heavy brush and was laced with tracks. (Oddly, tracks always seemed menacing, perhaps because they were an undeniable stamp of weaponry.) Bear piles of undigested cranberries littered the muddy path. Each hike along that trail was an adrenaline rush.

Resource managers teach people to make noise when hiking through brush: "Hey, bear. Hello, bear." Over and over. It seems strange to me. Does a bear know a greeting? Or even know it's a bear? Maybe it thinks it is something else. In general, I just yell, "Hello. Hello." Or sing—any loud racket will

do. (Making noise doesn't always work. The wind, rain, rushing water, or terrain type can mask even the loudest racket. Plus, an animal trainer told me that some older bears are almost deaf.)

A male grizzly, fresh from hibernation, digs willow roots from the spring snow.

Although I yelled and made loud noises on that trail, every day I met at least one bear, which gave way and pushed off into the brush. But I never surprised one either. In fact, the bears I saw appeared to be waiting to see who, or what, was making all the racket.

I hoped no one would discover the giant rainbow trout in this river. Too many fishermen think they own the water, and likely their presence would displace the bears, or worse.

Nights were the hardest part of camping there. Although my camp was well away from the river, on a section of lakeshore seldom trod by bears, several passed within two hundred yards. I kept my food secured in a container high in a tree, and I cooked well away from camp, with caution. I knew I'd done well, for mealtimes had been uneventful.

It was the darkness that played tricks on me. Every sound turned into a bear. In the daytime I enjoyed the bears and felt comfortable watching them, but at night I lost my assurance. Each evening at twilight I walked out to the beach and never failed to see a dark shape ambling along the shore. By ten I was in my sleeping bag, my shotgun by my shoulder. It was little comfort.

At night, the serene forest came alive, ominous with shadows and rustlings. Why did the dark change things? Why did shadows hold such menace? Why did small sounds morph into dangerous omens?

I had slept through the night only two nights out of the last ten. Both nights the wind had blown hard enough to mask the movement of elephants, let alone bears, so I didn't bother listening. There was a moral in that, I knew, but it didn't balance out the disgust I felt for my wild imagination. Most nights there was only silence, but once I heard something heavy lumber away—and I thought I heard a growl. For at least an hour afterward I lay tense and expectant, and like the Paleo hunters of ages ago, I cursed the darkness and longed for the dawn that never seemed to come.

On my last day I was up at first light rekindling the fire. Then I strolled to the lakeshore, seeking the open, placid vista. By light of day, everything

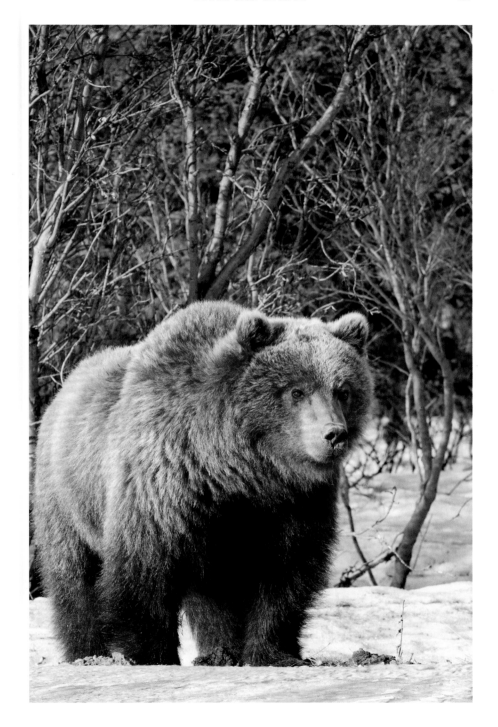

appeared serene. Down the beach a female and her three cubs wandered in a relentless quest for salmon in the warm, benign morning light.

### III

Under the earth, great beasts are stirring. They shrug and stretch and try to ease the cramp in gut and limbs. The biggest, the strongest, claw at the loosened soil, shoulder up through the damp, cold earth, and lever themselves out through the receding snow and into the nascent spring. They come squinting in the bright spring sunlight and take their first steps into the day, into their world and into ours.

Emergence from hibernation is gradual—not all bears, not all ages and sexes, come out all at once like a mosquito hatch. Over the course of many days, the big males crawl from their shelters first, followed by smaller bears that wintered alone, then females with older cubs, and finally females with new cubs, the segment most vulnerable away from the den. The adults are hungry after the long winter nap.

Hibernation begins in mid-October in central Alaska and ends in mid-April. In the far north, the sleep can be weeks longer, and in the south much less. On Kodiak Island, with its mild maritime climate, some bears do not hibernate at all. (Scientists debate the nuances of the terms *hibernation* and *torpor*. For the layman it is enough to know that in response to food scarcity, bears sleep through the frigid winter, their systems shutting down in order to survive, and emerge in spring hungry and some soon ready to breed.)

Few bears den in natural caves. Some dig burrows, some crawl into boulder piles, others den in hollow logs, and a few curl up under a deadfall. In a typical scenario, a female, fat from gorging on a bumper crop of blueberries, digs her den into a south-facing slope. Protected by her thick fur and heavy fat layer, she spends her last few days aboveground napping by the excavation, heedless of the sleet, snow, and frigid wind. Diminishing sunlight triggers abundant melatonin that brings lethargy and then hibernation. In midwinter, the female stirs only slightly when birthing. After licking her cubs clean and eating the afterbirths, the drowsy mother snuggles the cubs close to her and drifts back to sleep. The cubs instinctively begin to suckle.

Outside, in darkness and subzero cold, howling winds shriek down the slopes and over the snug den.

Until spring green-up, foraging will be difficult. Coastal bears wander the beaches for edible flotsam and then congregate on meadows of intertidal protein-rich sedges where they might graze twelve hours a day. The all-plant diet ends when the first salmon appear.

Spring forage farther north is limited: dried berries and shoots and roots are important staples. Carrion is particularly prized. A few catch and eat moose or caribou calves. Spring is a special challenge for a mother of small, vulnerable cubs. She must guard them and keep them close. Natural hazards abound: river crossings, avalanches, rockslides—all manner of risk. Large males pose serious threat and will kill small cubs. Females ferociously defend their young, yet many cubs do not survive to adulthood, nearly half dying in their first year of life. At Pack Creek in Southeast Alaska, a bear that researchers named Pest bore eleven cubs over her life span but successfully raised only five, a not uncommon rate.

Spring breeding season brings powerful males into contact with wary females. Nonbreeding females with cubs flee at the sight of another bear; even receptive females remain cautious of their suitors. For females, courtship can be fraught, lasting a period of days. Fertilized eggs, in a phenomenon known as delayed implantation, remain dormant until denning time when they attach to the uterine wall and begin normal gestation. If a female has failed to store enough fat to see her through hibernation, the eggs will spontaneously resorb, a natural mechanism geared to the female's survival at times of unfavorable environmental conditions.

The bond of mother with cubs is powerful, and the cubs follow her closely. For three years she gives them her knowledge and fierce protection. Each of those winters, she shares her den with them until the third spring, when she again comes into season and drives them away, the bond forever broken.

## IV

The outer coast of Katmai National Park and Preserve bordering Shelikof Strait, with Kodiak Island in the distance, is home to a large unhunted

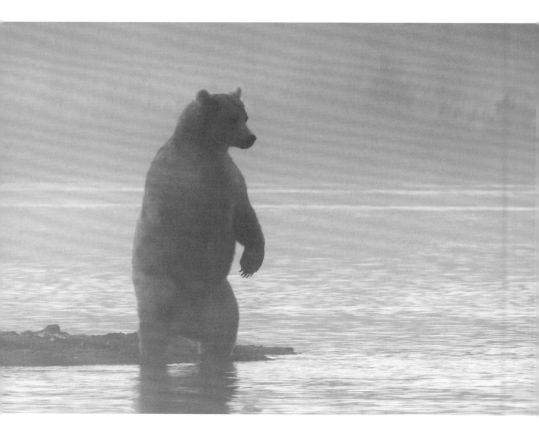

population of brown bears. Vast mud-flats are available at low tide, skirting a long stretch of coastline, a place where bears dig clams hidden in the

Bears rear up on their hind legs to get a better view of anything of interest. On a foggy dawn on the Alaska Peninsula, this brown bear stood to view another bear obscured in the mist.

sediment. Beyond the tidal flats, a sharply tilted cobblestone beach rises to a dense fringe of tall beach grass amid a jumble of driftwood logs, some three feet across.

Beyond the beach terraces the terrain slants down to a vast sedge flat laced by the river and sloughs. A half mile across the meadows, a line of dense alders mingles with cottonwood trees, backed by emerald-green slopes rising to serrated mountains and glaciered volcanoes. These jagged, broken spires are ramparts of a chain of volcanoes, one of which—Mount Katmai—erupted in 1912, reshaping the land for miles around. Some slopes are still buried in deep ash.

Could a more dynamic coastline exist? One molded by tectonic tremors and volcanic upheaval, freeze and thaw, wind and wave, tide and torrent? A place where bears stalk the beaches, as they have for millennia?

In the spring of 2005, I took some friends on a boat excursion along the coast to photograph bears. North and south of our anchorage near Ninagiak Island, the mountains reach to the shoreline, two giant arms embracing the estuary, sedge, and tidal flats of Hallo Bay, a place I have visited many times. I once saw over fifty-five bears here in a single day, everything from family groups to huge males, grazing the sedge flats or digging for clams. Red foxes, a wolf, and two bull moose also made brief appearances that singular day.

Another day, in an island-studded inlet hemmed close by mountains, I spotted in the fine wash of dawn light a female with four tiny spring cubs, the only quadruplets I'd ever seen. I studied the mother's every move as she brought her cubs from the timber and into the open. Her tenuous, halting movement signaled hypervigilance for her cubs. I watched from the boat, careful not to make any noise or movement that might disturb them.

On the tidal flats, the female searched for clams. Unlike other bears that dig slowly and deliberately, she dug like a fox digging a cache, pausing often to look around. When she pulled the first clam from the sand, the cubs crowded in. With her claws she pressed one edge of the three-inch-wide clam into the mud and, with the other paw, using just the tips of two claws, deftly pulled back the top half of the shell, revealing the meat inside. She turned her body to block the cubs, while neatly inhaling the tender morsel. Hungry, she did not share the first few clams. But as she worked across the flats, her rowdy cubs got more and more of the take. At times the cubs were sidetracked by empty shells, unable to understand why they smelled so good but offered nothing to eat.

Just as the bear family reached the middle of the tidal flats, another bear emerged from the forest and wandered toward the beach. Then a second bear appeared, both bears converging on the female and cubs. One of the two bears was a giant, maybe twice the size of the female; the other was a juvenile, smaller than the female. When the small bear spotted the big male, it reared to his hind legs for a good look, then turned and raced back into the timber. The big male homed in on the sow and cubs.

The flight of the small bear caught the female's attention, and she spotted the big male just fifty yards away. She called to her cubs, which cowered against her legs and under her belly.

The bear approached head-on, faster now. The female wrenched left and right, looking for an escape route. To her left was the river, behind her the bay. She had nowhere to go. If she bolted, the boar would nail a cub in seconds. When just thirty yards apart, she charged.

With gaping jaws the bears met head on, rearing to hind legs, the male dwarfing the female. Fur flew, blows crashed down, with action so intense, it could not be followed. The fury of the attack pushed the male back, but he countered with powerful blows and snapping jaws. He ripped into the female's neck, pulling her off the ground. Three of the terrified cubs were trampled as their mother gave way. The fourth cub panicked and ran. The boar broke from the battle and lunged for the cub. The frantic mother launched herself into his side with such force, he stumbled and went down. He was up in an instant, fighting again but backing away.

Then the bears separated, stopped. The female stood her ground, head lowered, jaws agape, roaring, all four cubs beneath her. The male backed toward the timber. When sufficient space opened between them, the female led her cubs to a shallow point in the river, crossed, then fled into the timber.

## V

The best place in the world to see a large gathering of brown bears is McNeil River State Game Sanctuary and Refuge, located in Kamishak Bay on the Alaska Peninsula 250 miles southwest of Anchorage. At a mile upstream from the river mouth, a falls impedes a run of chum salmon, the big schools collected below the falls attracting numerous bears—as many as 75 observed at one time. More than 140 individual bears fish the river each summer. Large males dominate the best fishing spots, but all ages and sexes are present. A gravel pad above the falls provides unparalleled viewing and a photography site without negative impact on the bears.

In an ironic twist, McNeil River is named after Charles H. McNeil, who lived and prospected there in the early twentieth century, supplementing his

income by fur trapping and killing brown bears for their hides. Skulls of two bears he killed are in the Smithsonian National Museum of Natural History.

Commercial fishermen in the 1930s shot bears on sight simply because they ate fish. There is indication that as late as the 1940s, maybe into the '50s, bears were poisoned with cyanide "getters." (Not long ago, on Kodiak, a few people illegally poisoned unwanted bears with a brew of rat poison, brake fluid, and antifreeze.) The McNeil congregation of bears also attracted sport hunters. Slim Moore, a venerated pioneer guide, once took hunters there but never went back because he thought it unsporting. In the 1950s the unique situation attracted two photographers, who soon pushed for protection. Cecil Rhode was one of them—he first visited the river in 1952 and instantly recognized its significance. In his August 1954 *National Geographic* article, "When Giant Bears Go Fishing," Cecil wrote that "the bear alive is worth infinitely more to the photographer and nature enthusiast [than a dead bear is to a hunter]."

In 1955, thanks to Slim Moore and photographers Steve McCutcheon and Cecil Rhode, and his cousin Clarence Rhode of the U.S. Fish and Wildlife Service, McNeil River was set aside as a protected reserve. On his second visit in 1955, Rhode counted thirty-two bears gathered at the falls. He also described the bears' amazing tolerance for people as well as their overall lack of aggressive behavior. In eighty-five days of observation, over two summers, he encountered over two hundred bears, many at close range, with only one of them exhibiting limited aggression.

Because of the abundance of protein available, coastal brown bears appear more tolerant of humans than interior grizzlies, which makes McNeil River and Katmai's Brooks Falls both unparalleled opportunities to photograph and view bears at close proximity. No one has ever been harmed by a bear at McNeil River and only rarely in nearby Katmai National Park, with one notable exception. On the flip side, only three bears have been killed by people at McNeil since its establishment in 1967 and an unknown number within the boundaries of Katmai.

Early wildlife managers saw McNeil River as a grand experiment to answer the question: Can people and bears coexist in peace and safety? Decades of interactions provide a resounding *yes.* Bears go about their daily lives uninhibited by the presence of people. It is not unusual to see bears pass very close to

groups of viewers without threat or notice. Bears often seem to ignore people altogether, regarding us as merely part of the scenery with no special interest or attraction. In spring, visitors are sometimes treated to very close observations of mating bears, a situation once considered hazardous. Females nurse their cubs in proximity to viewers without apparent stress. During salmon season one female deposited her cubs near the viewing pad while she went fishing, as if the people on the pad provided a cub-sitting service. Subordinate bears on occasion hide behind viewers, using them as a shield from a dominant bear. The level of trust demonstrated by both species is remarkable.

These, and other benign interactions, have developed largely because human behavior is rigidly controlled. Because access is limited and by permit only, with all forays conducted by trained personnel, McNeil bears have been conditioned to ignore people. Generations of bears have grown up around people. Bears respect the main viewing pad at the falls as "people country."

Years ago, Maureen "Mo" Ramsey, a free-spirited Aussie then married to the longtime sanctuary manager Larry Aumiller, hiked to the falls alone to check on the tardy salmon run. From the gravel pad above the falls, she saw no salmon and, of course, no bears. The day was hot and sunny, with a breeze strong enough to keep the mosquitoes at bay; she took the rare chance to sunbathe. She pulled off her top and pants and stretched out on the gravel pad. She dozed off. When she awoke sometime later, a large male brown bear was asleep on the pad nearby. "At first I thought, *Oh, my god! What do I do now?*" she told me. "Then, I thought, *What the hell?* He could have eaten me a long time ago. When he opened his eyes and looked at me, I closed mine." Incredibly Ramsey fell back asleep, and when she opened her eyes again later the bear was gone.

For over two decades I visited McNeil River each spring or summer, until the number of visitors had to be controlled through a lottery system. When I first went there, no permit was necessary and the majority of visitors were professional photographers, replaced today by tourists with permits. The permit system has successfully protected and preserved McNeil River's unique concentration of bears.

Another bear sanctuary in Alaska owes its fame to the audacity and courage of one man, Stan Price, the "Bear Man of Pack Creek," one-time logger, prospector, and miner. He and Edna, his first wife, came to Alaska in 1929

dreaming of a life close to the land and personal freedom. In 1952, Stan and Edna, who were planning to celebrate their fiftieth wedding anniversary, towed a small floating cabin to Admiralty Island, known to the Tlingit people as Kootznoowoo, "Fortress of the Bears." They anchored their float house where Pack Creek spills into Seymour Canal, thirty miles south of Juneau, and lived there for decades, developing a unique relationship with brown bears on the island. "Bears are no menace to us," Edna wrote in her unpublished partial memoir, *Nuggets from Thirty Five Years in Alaska.* "One of our friends says we are going to trust one bear too many. He is mistaken. We don't trust any at all . . . we have learned to get along with them peacefully."

As Price learned about the bears, he realized that fear of them was exaggerated. Throughout his decades among the bears, Price never carried a gun and disparaged those who did, including the state and federal managers who oversaw the area. Instead, Price carried a stout walking stick with which he sometimes "thumped" unruly bears on the nose. Retired Admiralty ranger K.J. Metcalf wrote this: "More than once I walked through Stan's woodshed, which was the only path when the tide was in, and saw a large bear asleep in the corner. Stan's reply was, 'Oh, don't worry, she won't bother you. She's one of my regulars.'"

In his later years Price became an advocate for bears by speaking to groups throughout the Pacific Northwest. As a result of the publicity, Pack Creek attracted growing numbers of people, leading to the establishment of the permit system to control access.

Stan Price died in 1989, at ninety years old, but his legacy persists. Descendants of cubs that he raised after their mothers had been killed by hunters still frequent the creek's tidal flats and sedge meadows. "Over the past forty-five years, we've had eighty-two cubs born here," he told writer and filmmaker Joel Bennett before his death. Hunters killed about a third of those bears.

The Stan Price State Wildlife Sanctuary, part of the larger Pack Creek Wildlife Viewing Area, protects habitat for brown bears and important spawning streams for salmon. The seasonal pulse of salmon—and the myriad predators dependent on it—is an ages-old rhythm of the wild, enthralling in its complexity and importance to humans and wildlife.

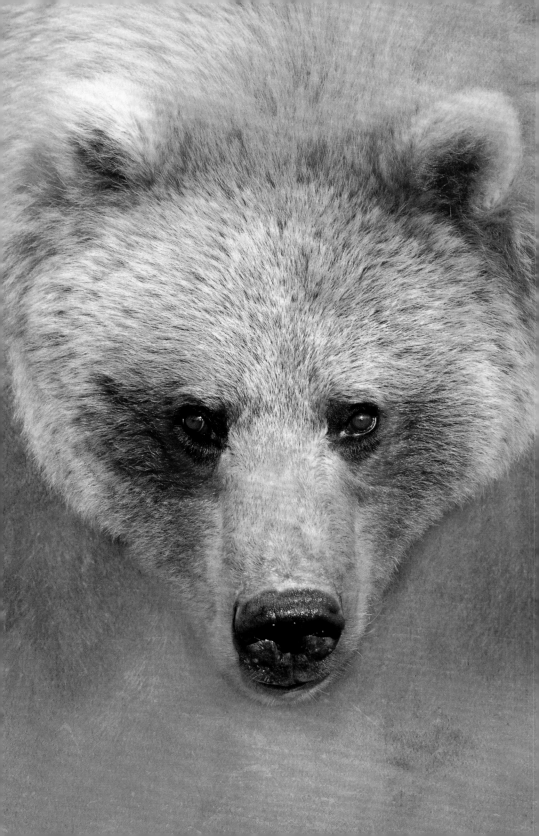

# On the Edge

## I

**BEAR VIEWING IN ALASKA** is booming. When I first came to Alaska, Brooks River, McNeil River, Pack Creek, Anan Creek—a black bear viewing area in Southeast Alaska—and Mount McKinley National Park were the only protected areas available to bear watchers or photographers. Now there are a dozen or more sites hosting bear viewers.

Protected areas provide the best opportunity for observation and photography because resident bears are habituated to people. Bears outside such preserves are more elusive, often intolerant of people. Wildlife managers heatedly debate the issue of wildlife habituation. Here's one definition of the term: "A decline in an animal's response to repeated exposure of an inconsequential stimulus." In short, bears lose their fear of us after frequent innocuous contact. Resource managers, as well as many members of the public, worry that bears that have lost their fear of people become dangerous. In some circumstances the opposite is true. Research has shown that habituation can lessen the risk of human injury through a reduction in fear-induced aggression. Habituated female grizzlies with cubs are less likely to react violently in a sudden, close encounter with people because they perceive no risk. The McNeil River experiment demonstrates clearly that habituated bears can be safe—if people behave themselves.

As one bear expert has said, habituation is not necessarily good or bad; it is simply an adaptation a bear makes to survive. Because we station ourselves within their prime feeding zones or travel areas, bears experience recurrent benign contact, and so they tend to overcome their natural wariness in order to graze on sedges or catch salmon. If people are well controlled around habituated bears, it can be a positive experience for viewers and promote conservation of bear populations and habitats. Others argue that animals habituated

The intense stare of a brown bear is unsettling.

to people become unwary targets for hunters when they wander out of their protected zones.

Why then does the conception persist that "wild" bears are safer to humans than "habituated" bears? (All bears, in my view, are wild and should be treated with respect.) The problem, I think, is confusion in terms. A food-conditioned bear, which often exhibits a lack of fear, is very different from a habituated bear. Bears can be found almost anywhere in Alaska, even within the largest cities. Urban food sources abound and, if unsecured, lure bears into contact with people. Repeated food rewards create nuisance or problem bears, which destroy personal property, threaten pets, or in the worst cases, turn aggressive. Food conditioning is a threat to both bears and humans.

Habituation *may* be problematic because bears that tolerate people in close proximity are more likely to be rewarded with human food or garbage, thus associating people with food. Bears, like us, are omnivorous, wide-ranging, and adaptable. They are intelligent and learn quickly. It takes only one success-ful raid of a camp or garbage can, or an intentional feeding (the latter especially dangerous), to ruin a bear. Bears possess keen memories for food sources and will repeatedly revisit places where they have found food. I have one hard-and-fast rule when camping in bear country. If I see any indication that bears have obtained human food or garbage, as evidenced by torn trash or shredded litter, I will move on and not camp there. I believe this to be a critical safety rule when floating or boating fishing streams.

Bears are often described as "unpredictable." That adjective is almost always used in every public announcement or publication related to bears. But is it accurate? I've had the good fortune to work with two professional outdoors-people with a combined ninety years' experience working in bush Alaska. From them I learned that the label "unpredictable" refers primarily to a bear's fight-or-flight response. Surprise a caribou or Dall sheep at close range and the animal will bolt; a bear, on the other hand, may defend itself. The experts taught me that bears signal their intentions by body language; that in defiance of the conventional wisdom, bears are actually quite predictable; and that sim-ple precautions, like secure food storage, can prevent conflict.

If anything, people, not bears, deserve the label "unpredictable." Where one person might run off, another might move in for a photograph or try for a sel-fie with junior. Another might fall to the ground and roll into a ball, scream for

help, or climb a tree, while yet another might try to feed the bear a sandwich or doughnut.

Each year, people are attacked and injured by bears, with nine fatalities between 2000 and 2017. (More than four hundred grizzly attacks on humans have been documented in Alaska since 1900; many of the incidents were avoidable.) Lurid headlines engender fear—and gunfire. It is legal to kill a bear in defense of life and property (DLP). In 2016, a hiker was injured by a food-conditioned bear in Denali. A short time later, a different bear, in an innocuous encounter, was killed just north of the park simply out of fear. In Anchorage, in 2017, thirty-four bears were killed under the DLP rule, four times the previous year's total. Biologist Claude Grandpey offered this simplified explanation: "After the fatal mauling of a 16-year-old on Bird Ridge [that spring], some people just became less tolerant of bears."

On the flip side, thousands of human-and-bear interactions, many at close range, occur each summer with no harm or injury. I have watched groups of viewers meander across open sedge flats, passing within yards of numerous bears, without the slightest hint of interest from the bears. In my experience, bears are way more tolerant of people than we are of them.

The expansion of bear viewing has another critical downside: displacement—animals abandoning prime habitat because of their stress related to human use. The first time I visited Hallo Bay on the Katmai coast, I counted forty or more bears daily on the sedge flats and intertidal zone. Sometime in the 1990s when bear viewing began to boom, air services from Kenai, Homer, and Kodiak began offering day trips to that remote location. Each year as the numbers of visitors went up, the numbers of bears declined, likely because the bears did not tolerate expanding human activity. In 2016, a friend counted ninety-two people on the sedge flats and just one bear. Fewer than a dozen bears gathered for the autumn salmon run, a sad shadow of past abundance.

Humans are drawn to bears more than almost any other animal. Their behaviors both delight and terrify us. Their size, strength, and at times ferocity fascinate us but also sometimes lead us into harm's way. The desire for close contact, coupled with limited knowledge of bears, is a potentially deadly mix. Sometimes it takes study, experience, and a modicum of luck to acquire the skills to live safely with wild bears. People can forget or underestimate—or misjudge—the risk posed by any large animal. I once did.

## II

In my twenties, because of my own stupidity, I was almost a statistic. The headline could have read: "Man Mauled by Grizzly." It is a hard story for me to tell. I've told it one other time, and I tell it again now because it is cautionary. It's a story of naiveté, ignorance, and a monumental error in judgment.

In the early 1970s, I met a Fairbanks teacher and cinematographer who showed me a grizzly film he'd shot in Mount McKinley National Park. His footage was rapturous, with a superb sequence of a blond grizzly grazing wildflowers by a sparkling stream. The tight shot of its eyes mesmerized me.

The wildlife imagery, however, was not the most powerful sequence. The photographer's son had filmed his father not *thirty feet* from the grizzly. Stunning. Everything I had ever heard, read, or imagined called this insanity. Later, and over the course of several visits, my new friend insisted that the danger from bears was exaggerated. Time and again he told me that park bears were harmless. "If they don't run away first, just walk right up and take their picture."

What did I know? I was still a cheechako. I remember thinking at the time, *Oh, so that's how they get those pictures.* I'd seen lots of great bear shots, and I wanted my own.

The next July, I visited McKinley Park with a friend, a novice filmmaker. In stark contrast to today, there were few people in the park and wildlife was plentiful. In that week we took stills and movies of moose, caribou, and sheep, but what we really wanted were bear pictures. My friend also believed that the danger from bears was overblown, and he was eager for some close-ups. On three occasions we approached lone bears, but as predicted they ran off as soon as they saw us.

Late one morning near the Toklat River we spotted a female with two cubs grazing amid lush summer grass, a tempting subject. Partway to the bears, we separated—I went east to use a willow thicket as cover, and my friend went west.

When I finally got into position behind some waist-high brush seventy-five yards from the bears, my buddy was already set up and filming from the opposite side. The bears seemed to ignore us. While making the stalk, I'd had misgivings, but now they appeared groundless.

I took one picture, advanced the film, and moved two steps to reposition my tripod. When I looked up, one of the cubs was on its hind legs peering

in my direction. When I released the shutter a second time, both cubs began to mill around. Their mother looked up from grazing, first at them, then at me. All at once I felt vulnerable and exposed. The sow hesitated briefly then charged, bowling over a cub.

Grabbing my camera, I ducked low behind the bushes and ran, thinking I was out of sight. I aimed for the gully behind me so that when, or if, the bear saw me again, I'd be far enough away to not represent a threat to her cubs. *You idiot! You idiot!* pounded through my brain as I ran.

In four or five strides I was in the gully and racing downhill. Halfway down I looked over my shoulder and saw the bear charging over the top, never hesitating. I panicked into full flight. Ten yards downhill I gained control, stopped, and whirled around to face her. No way was I going to be pulled down from behind. I braced myself, my tripod gripped like a rifle with bayonet.

In a flash the grizzly covered the intervening space. I heard the grunt each time her front paws hit the ground. I stood bolt upright, and at the last moment lunged at her with all my strength, jabbing the tripod and camera toward her snout. We were so close, it seemed I couldn't miss, but with remarkable agility the bear swerved away, and I flailed thin air. She stopped not five feet from me. I thrust a second time, but again missed as she dodged away. For what seemed like minutes but was only a few seconds, we exchanged stares. As abruptly as she had charged, the grizzly broke off and raced toward her cubs waiting at the top of the gully. With a few backward glances, the bears disappeared over the crest.

Breathless and trembling, I stood there. Until the very last second I'd done everything wrong that a person can do around bears, yet I had escaped unharmed.

Due to the anesthesia of youth, the full impact of my razor-thin escape did not hit for several days. About a month later I awoke yelling in the night. In a vivid dream, I had remembered two things I'd blocked. Every time the bear's front paws struck the ground, her jaws snapped closed with a loud pop. What haunted me more, then as now, was the image of her paws clearing the tundra, the long white claws clicking together, scything the air like ten giant razors.

Through the clarity of experience and age, I look back and am damn grateful for my incredible luck. Novices might see a wondrous bear photograph and want one just like it. What a photograph does not reveal, however, is the story

of *how* it was made. Most bear photos are shot from the safety of a vehicle or in a bear sanctuary. A few images are of captive, trained bears.

Over the past fifty years I've learned a few lessons the hard way and have also been tutored by top wildlife mentors. I've learned that bears are individual and behave differently in diverse places and situations. I never assume that a bear on the Arctic Coast will behave like a bear in Katmai, and I act accordingly. I encourage others to learn as much as they can about bear behavior from authoritative sources before entering bear country. I am always guarded when I'm asked questions about bears. I never forget that a mix of inexperience and bad advice can carry serious consequences.

## III

The sudden close encounter, a whirr of fur and bared teeth, charging full on, is the stuff of nightmares. Experts admonish hikers in bear country to make noise in areas with restricted visibility to avoid a surprise encounter. However, bears may respond to sounds in the brush that they otherwise would ignore or avoid.

In the autumn of 1992, my friend Dr. Cindy Zabel, a field biologist who was then head of the Redwood Sciences Lab in Arcata, California, and I hiked into a timbered valley in the Alaska Range where I had recently seen and heard wolves. Our route led downhill through open muskeg and scattered black spruce skirted with scarlet dwarf birch. Red squirrels chattered at us from the trees. A slight wind ruffled the canopy and carried the heady scent of rutting moose. A warm light highlighted the few golden willows fluttering in the breeze. We kept a sharp eye for moose but made no particular effort to be quiet, talking as we went. Our goal was to reach a high knoll where we could sit and maybe see and hear wolves on the far side of the valley.

Less than a half mile from our destination, we saw a cock spruce grouse courting a hen crouched at the base of a tall spruce. I told Cindy that I thought his display, which closely mimicked spring courtship, was the result of diminishing daylight, the trigger for many behaviors.

Taking advantage of the opportunity, I hurriedly shrugged out of my pack to fumble for my camera and telephoto lens. I took a couple of quick

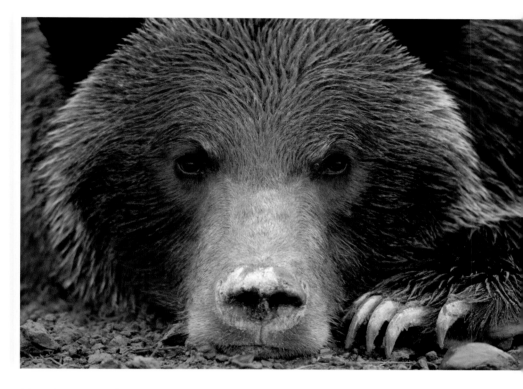

A bear that appears asleep on the tidal flats edging the Alaska Peninsula is almost always more alert than its posture suggests.

shots before the grouse strutted under the tree. Bending down I wriggled under the branches to get a few more shots of the puffed-up grouse. There was no need for stealth; the cock paid no attention to the limbs scraping against my windbreaker or my chatter as I provided Cindy with commentary on grouse behavior. Out from beneath the tree, we shared a joke and laughed about male behavior.

A sudden, convulsive crashing in the brush spun us around. I expected a moose, but instead a grizzly burst into view, hurtling through the willows straight at us. Without forethought—just reacting—I charged straight for it, shouting and waving my arms. Within two steps, the bear veered right and blasted straight downhill, flattening brush in its wild dash to escape. In milliseconds it was gone. For a moment we stood motionless in the sudden stillness. The whole thing happened so fast, I'd had no time for fear, but the look on Cindy's face said it all. We grabbed our packs and got the hell out of there.

## IV

Snow had been falling for about two hours—not hard but steadily, adding a thick coating of wet flakes to the tundra shrubs. Fresh tracks of fox, wolf, and ptarmigan made the hike to the head of the pass more interesting than expected. On the edge of a marsh, etched with countless caribou tracks, I hunkered down behind the only cover available, a small, scraggly willow.

Caribou had been passing my camp since midmorning the previous day, which had passed in a drizzle and low fog with poor light for photography. Today, with better light, I could photograph the migration in fresh snow. The spring movement to the North Slope calving grounds had slowed somewhat, yet hundreds of animals still trudged through. Bulls, cows, and calves trooped by in small bunches or large groups.

My hiding place had restricted visibility because of the low ridge rising on the opposite side of the marsh. Numerous caribou traipsed the ridge and the slopes beyond. The crisp, cold air carried the talking of cows and calves and the grunting of bulls laboring up the slope.

I had a limited view back toward camp and of the approach to the pass, but on the treeless alpine tundra I made do with what I had. I wanted only to remain immobile and photograph the caribou streaming by. The illusion of invisibility—the ability to observe animals without disturbance—for me, is joy. *The rock on the tundra.* In the last week, playing the part of the rock, I'd watched a peregrine swoop down on a ptarmigan, a grizzly chase caribou for two hours before finally killing a calf, and a golden plover tending its eggs in a lichen nest.

As time wore on, I stiffened from the cold. Except for slight adjustments of position, I didn't dare move. The photographs were coming to me.

Just as the far slope filled with caribou and a long string of them began to fan out in the foreground—the very scene I'd been waiting to photograph—the entire herd stampeded. I cursed under my breath. *Did they see me? Scent me?* My spirits sank. I scanned the higher slopes. Nothing. The valley swiftly emptied of caribou.

On balky knees I struggled to my feet. I stretched the tightness in my back and shoulders, flailed my arms to warm up. *Why did the herd bolt? What spooked them?* Without mosquitos to torment them, there had to be a reason. *Wolves*

*perhaps?* I thought it would be fantastic to see and photograph a chase through the snow. I spun a circle but saw nothing as I rotated.

I spotted the grizzly as soon as I turned back. It was on the ridge and close, *very* close. The low ridgeline had shielded its approach.

Just as I saw it, the bear saw me and stopped stone still. I was partially hidden and somewhat downhill in a shallow depression, a very bad position. The closest trees were hundreds of miles away; climbable cliffs were too far to offer haven. There was literally nowhere to go. This was the moment I had long dreaded: unarmed, face-to-face with a grizzly on the open tundra.

Seldom have I felt more vulnerable. My mind raced through my options. I knew that *size* matters to bears and is an important factor in dominance. I didn't want to look small and perhaps helpless. I wanted to trade places with the bear, be on the ridge looking down on it.

Complicating the matter, the wind blew from the bear to me. Without my scent, it could not identify me with certainty. Bears have good vision, but they don't trust their eyesight. Also, I wasn't making any sound that the bear could fix on and ponder. Bears need the assurance of their sense of smell. Perhaps *my* scent alone would determine the outcome.

After a long, wrenching pause, the grizzly shuffled to its right, my left. It came down from the ridge and into the depression, its gaze locked on me. With less than ninety feet between us, I started toward the ridge—slowly, *very* slowly. I circled like a wary prizefighter, acutely aware of the mismatch, the flyweight versus the heavyweight champion.

Within a dozen steps I was on the ridge, pleased to have gained the high ground. Even though still in the open, I felt better off. Now that the grizzly was somewhat below me it looked smaller, and I hoped that I looked larger and more intimidating. We had traded positions almost exactly, with the wind straight from me to him. The bear sniffed my tracks and hiding place behind the willow. With quivering nostrils he scented the breeze, twisting his head to catch every nuance. I heard a low grumble, a mutter.

As the bear evaluated the scent and situation, I dared not move. With only three good jumps, the bear could be on me. Seconds, which seemed minutes, ticked away. The moment expanded, dragged by. Then, deliberately, the grizzly turned and padded away, every few steps peering back, perhaps to see if I

was pulling a sneak attack. *Fat chance.* He yawned and piddled as he walked, the body language of stress, giving me no comfort to know that I wasn't the only one on edge.

As I relaxed, my field of view widened, and the world came into focus: the snowy tundra, the marsh, the mountains, the filtering snow. I was again aware of the smell of the rich, wet earth. And of sounds: the wind, the creek dashing over the rocks, my own breathing, a distant raven, my own hammering heart.

I waited until the bear was well into the distance before I retrieved my pack, grateful I'd had no food in it. Two steps from my pack, I stopped to peer at the tracks seared through the snow, the imprint of claws and pads sharply outlined. I shouldered my pack and backtracked toward camp, done with photography for the day.

V

The one bear encounter that aged me the most occurred on a trip with three friends to Martin Lake about forty miles east of Cordova.

We were surprised that John Pecel and his son Ron, then twenty-three, were not in camp when Brad, fourteen, and I returned at dusk. At daybreak we'd split into pairs to search for mountain goats. Although Brad and I saw several goats and one black bear, we never got close because the cliffs were steep, wet, and treacherous. The day had dawned clear, but afternoon winds ushered in clouds and drizzle. Long before we were ready to turn back, Brad and I were forced off the slopes by a downpour. Despite the rain, we had enjoyed the climbing and views of Ragged Mountain and forested slopes around the lake. In midafternoon we thought we heard two or three distant rifle shots.

By seven o'clock at the camp, it was pitch dark. Without a flashlight I could not see Brad sitting within feet of me. Despite being sheltered by dense spruce, rain and wind buffeted the camp. Dry firewood was nonexistent, and what we had would not burn. I feared for my friends, and Brad for his brother and father. Perhaps one of them had fallen and been injured, or had been attacked by a bear; maybe they'd gotten lost. The temperature was in the forties, and my friends, equipped with light raingear, would have a hard time surviving the night without shelter.

Well after dark, a rifle shot echoed from the far end of the lake, followed quickly by another. I answered with a shot into the air. In a few minutes we heard another blast, but closer.

Over the next two and a half hours we traded periodic signal shots. I dared not move lest I mislead the two men regarding our position. Maybe the echoes were deceptive but every other shot seemed closer, the next farther off or coming from the wrong direction. One sounded as if it had come from the middle of the lake.

At precisely eleven o'clock I fired twice, but there was no response. Despite shooting perhaps twenty rounds, we'd failed to lead the lost men into camp. By then we had only a few rounds left.

A half hour later I fired one shot but again without answer. Brad was upset and wanted to search for his father and brother. I held him back, convinced that we had no alternative except to signal and wait.

Sometime after midnight the rain stopped, the silence an opportunity. I fired a shot into the air. Immediately it was answered, and from nearby.

"They're alive!" Brad shouted. "What do we do now?"

We heard another shot, but with only two rounds left, I couldn't reply. The second shot seemed to come from the same direction as the first. I thought I knew where they were. Our camp was located near the mouth of a salmon stream where it flowed into the lake. It sounded to me as if the shots had come from a peninsula on the far side of the creek.

Leaving Brad in camp, I stumbled out to the beach. It would be easy to miss camp in the dark, so I dragged a fallen limb out onto the rocks as a marker.

When I clicked off my dimming flashlight, total darkness enveloped me. I felt blind, helpless, exposed. My eyes soon adjusted enough to stagger down the beach toward the creek, which seemed farther away than I remembered. With the weak light, I picked out what I hoped was a manageable ford. The beam quickly faded, and I switched the light off. In eerie darkness, the rain again pelting down, I started across, feeling around the rocks for each tenuous step. Several times I stumbled, and each time a salmon slapped the water or brushed against my legs I nearly fell.

A sudden enormous splashing just upstream staggered me—the unmistakable sound of a charging bear. I couldn't see a thing. In complete darkness I fought panic, battling weak legs that begged to run.

The bear could be on me at any second. I clawed to get the gun off my shoulder. Dozens of salmon fleeing from upstream struck my legs, and I fell to one knee, icy water pouring over the top of my hipboot. I fought to regain my footing.

The splashing seemed to intensify. Small waves sloshed against my legs. Any moment a terror would envelop me from the darkness.

Then, silence—utter, complete silence. I thought I heard something pound off across the sphagnum but was confused. All that was left was the gentle swirl of water over the riffles. Uncontrolled shaking gripped me, and I gulped huge breaths.

It took minutes and incredible force of will to step forward into the night. One step, two steps, and then three. My flashlight barely caught the far bank just six feet ahead.

Crawling out on the bank, I rolled down my one boot and drained the water as best as I could. Firm ground provided no sense of safety or extra courage. I kept my rifle at the ready, my mind full of horrifying visions. I began to hurry. From the top of the bluff above the creek, I hollered aloud. "*Here! Over here!*" Immediately someone yelled back. I yelled again and flicked the light on and off.

"We see you! We see the light! Don't move," John shouted from somewhere below.

The beam rapidly dimmed, and I clicked it off. I yelled again but there was no answer. Again and again, my call went unanswered. But finally I heard voices coming up the hill. I blinked the light on and off. In moments we were together, yelling and slapping each other on the back.

Both men were plainly exhausted, and John's speech slurred. His first concern was for his youngest son. Ron explained that they'd gotten off the mountainside at nightfall and were immediately disoriented. My signal shots seemed to them to be moving, never coming from one direction; both said they never would have found camp in the dark.

I warned them of the bear as I led the way back to camp. We waded the stream and were soon safely to the tent. Brad was fast asleep, and I felt a hundred years older.

These four jolting events are a few of my dozens of encounters with bears spread over the course of the past five decades, the only ones of grave danger. All have left a mark. To this day I am uncomfortable with darkness when camping and unnerved by unexplained sounds in the night, often coming when I'm wide awake with pulsing breath.

Peers have chided me for being cautious around bears, something I do not deny. Because of my lack of boldness, I have few great bear pictures, and I consider documentation of their natural history one of my weaker subjects. I have several reasons and not just because of that one particular incident years ago in McKinley Park.

Yet I am one of those people who do not want a world without wolves and bears, animals that define and create wilderness. There is no wilderness without them; without wilderness they cease to exist. A grizzly is the very manifestation of wilderness, in every sense of the word.

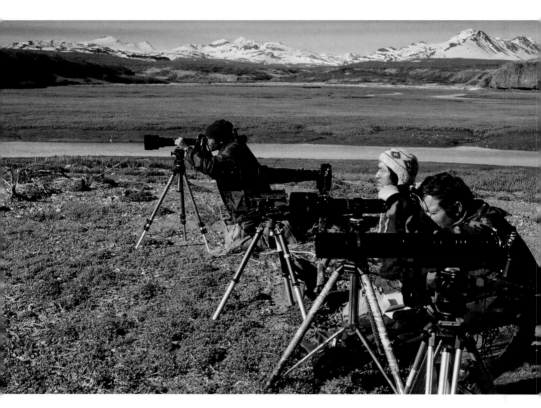

Michio Hoshino, center, flanked by friends Mark Newman, left, and Grant Klotz, photographing a McNeil River brown bear.

# *Grizzly Tragedy*

## I

**FOUR O'CLOCK IN THE MORNING.** The rattle of the telephone shattered the silence. I lurched out of a deep sleep and fumbled for the phone. "Tom, this is Tom Mangelsen. Something awful has happened. Michio is dead. Killed by a bear in Kamchatka. I just got word from Japan. It happened yesterday."

I could not speak, or even think. A sharp buzzing filled my head.

"Hello? Tom, are you there?" Mangelsen prodded. I mumbled a response.

"Sorry to be the one to wake you with this," he said. "I know how close you two were, but I thought you'd want to hear it from a friend. I just got a call from Frans Lanting in Japan. It's big news there. Turns out he was some kind of national treasure. I can only guess what his family is going through."

Other than ask for further details, I had little to say. Tom recited a sketchy story: Michio had been in Kamchatka to photograph brown bears with a Japanese television crew. One night a bear had dragged him from his tent and killed him. As Mangelsen spoke, he became emotional and hung up.

I staggered back to bed, staring into the darkness. At six the phone rang again, a friend from Montana with the same news. He had little new information, but we listened to each other babble. Throughout the day the calls came one after another. By late afternoon the tragedy was national news, and the calls multiplied until I had to unplug the phone.

I'd first met Michio Hoshino in 1980 in Igloo Campground in Denali National Park. On my fall foray there, I found someone camped at my favorite site. By nightfall, the occupant had a fire going, so I walked over to say hello. I was greeted with a broad smile and slight bow. Michio said his name; I said mine. He offered tea, and I accepted. Even though Michio struggled with his English and I knew zero Japanese, we sat by the fire, chatting for hours. It was the beginning of a friendship that lasted sixteen years.

Michio Hoshino was born in Japan in 1952, and although he studied economics, tales of Alaska pulled at him. The lifestyles of Alaska Natives intrigued him, and when he was eighteen he wrote letters to various villages looking for a host family. In 1971, he traveled to the tiny village of Shishmaref on an island on the northern Bering Sea coast, where he lived for a time with an Inupiat family. Despite rudimentary English, he made lifetime friends and developed an enduring affinity for Alaska. He returned to Japan to complete his college degree and to apprentice with Japan's master nature photographer, Kojo Tanaka. Michio came back to Alaska in 1976.

When we met, Michio was taking wildlife classes at the University of Alaska Fairbanks. Here, I thought, was a kindred spirit who not only wanted to photograph wildlife but also learn all that he could. His thirst for knowledge, respect for wildlife and wild places, combined with his ingrained sense of humor and humility, captivated everyone who met him.

Often alone, he traveled all over the state, photographing everything from squirrels to whales but especially mothers with young. He made strong ties in Native villages, where he was often accepted as a family member. Denali Park remained a favorite haunt, and he was present at seemingly every unique wildlife sighting. Michio persevered in his quest for photographs with obsessive dedication, which the Japanese call *doryoku*, meaning "great effort, exertion."

My friend possessed a childlike glee with Alaska—a joy in the land, wildlife, and people, even the weather. Instead of the jaded Alaskans who bitched about the cold, storms, and mosquitoes, he persevered, usually in silence, finding inspiration in the frigid displays of northern lights, the miracle of spring renewal, and the ability of wildlife to endure the harsh conditions. Over the years, his appreciation for the far north seemed only to strengthen. No matter how cold, wet, or tired, Michio almost always had a smile on his face.

He started with little money and struggled to get by. His financial support remained a mystery to the rest of us photographers, but he always had the latest Nikon cameras and lenses, the rest of his equipment marginal. He drove a series of beaters that seemed to break down at the most inopportune times. Once I saw him coming down the Denali park road in a sedan that leaned precariously to the left. Both tires on the driver's side were flat. When he rattled to a stop next to me, he said, "Do you have a spare tire? Mine is flat."

"Michio, you have two flat tires. Why don't you get out and look?"

"Tom, I can't," he said. "The door is wired on, and if I do, it will fall off." And with that he slowly continued east, driving thirty miles on two flats and ruining the rims.

His absentmindedness provided never-ending amusement. He forever was misplacing things—gloves, blocks of film, lenses, but almost never food. One colleague went on a "Nikon Easter egg hunt" after Michio had left a pond where the two had been photographing a moose—he picked up two lenses that Michio had left behind. Later the other photographer flagged Michio down on the road. "Can't stop now," Michio said. "I forgot a lens at the pond." Our friend smiled, "Oh, you mean these two?"

Michio had a sort of babe-in-the-woods air about him. He was either naïve or simply too trusting. One autumn he drove to the village of Northway to photograph a traditional Athabascan chief, then one hundred years old. As a thank-you for this show of respect, the chief gave Michio an exquisite pair of beaded, smoke-tanned moosehide mittens. On his drive back to Fairbanks, Michio stopped in a lodge for coffee and took the mittens in to savor their beauty. At one point he got up to use the restroom, leaving the mittens on the table. When he returned, they were gone. No one, of course, knew anything.

Michio produced unique pictures, teaching us Alaskans a thing or two. In the days before the advent of autofocus and digital technology, wildlife photography was a challenge. Action was difficult to capture because of the inherent limitations of the medium. The few fast films available back then, such as Kodak's Ektachrome, which we all called "Ektacrummy" and refused to use, produced terrible photos. Many old-timers waited for the best light and seldom photographed in bad weather; Michio photographed in all conditions. While some of his pictures lacked lighting and color, the subject matter was always compelling. Michio's best photographs revealed animals in the context of their habitat.

After his death some people cloaked Michio in mystical terms, using phrases like "communion with animals," "kindred spirits." I thought differently. His total immersion and commitment presented him opportunities denied dilettantes. As the great Branch Rickey once said, "Luck is the residue of design." For example, late one night while Michio was photographing alpenglow on Mount Denali, a wolf trotted up to Michio's vehicle. As usual he'd left his camera gear on the ground. The wolf grabbed his new Nikon

camera by the strap and ran some distance before dropping and breaking it. While Michio couldn't afford to lose a new camera, he described the moment as "a gift." In one of his books there is a photograph of the wolf with Denali in the distance.

When Michio's book *Grizzly* was published, he wowed viewers with his broad array of intimate portraits of bears in all phases of their lives. One reviewer said that to get such photographs, Michio was "either invisible, or takes crazy chances." He was neither reckless nor fearless. Like he did with any other subject, Michio obtained singular, often dramatic, bear pictures simply by putting in vast amounts of time in the best viewing and photography locations in Alaska. He was a regular at Katmai and McNeil River, often accompanied by trained staff.

Initially Michio was afraid of bears, as are most people when camping in the wilderness for the first time. On his first trip into the Arctic National Wildlife Refuge, he flew into an airstrip where two other photographers were already camped. Steve Kaufman remembers seeing the chartered plane and lamenting the unwanted intrusion.

"We'd never met," Steve said, "and the next thing I know, this guy comes up and asks if he can pitch his tent next to ours. He said he was scared of the bears."

As he developed into one of the world's foremost wildlife photographers, Michio began to journey farther afield, especially to Churchill on Hudson Bay, where he photographed polar bears. Together we photographed Dall sheep in Yukon's Kluane National Park with morning temperatures at minus 30 degrees. Each evening, after a frigid day in the high country, Michio would say, "Have we worked hard enough today to buy a soup?" Later, he'd cook rice in the motel room on a Coleman stove.

Over time Michio published several books and won the 1989 Kimura Ihei Award, the highest recognition given for a Japanese photography book. A 1994 solo exhibition at Pittsburgh's Carnegie Museum of Natural History brought Michio's work to the forefront of nature photography. His work was and still is published in noted publications such as *National Geographic.* Michio didn't talk about his accomplishments, and if we heard about them at all, it was via the rumor mill. Most Alaskans were unaware of his growing fame in Japan. I only guessed at his increasing prosperity because he started driving a new Toyota

4Runner. In Fairbanks he hired a renowned local craftsman to build him a log home. Another sign of success were the Japanese television crews that accompanied him into the field.

All of this recognition didn't seem to change him. He remained humble and ablaze with good humor. He loved to try out American sayings. When I teased him the first time we met, at Igloo Campground, he looked truly perplexed. I'd said, "It's OK, Michio. I'm just pulling your leg." Despite my hurried explanation, the phrase baffled him. A few weeks later, when he teased me back and I didn't get it, he said, "It's OK, Tom. I'm just pulling your foot." On our last trip together he had just learned the phrase, "His elevator don't go all the way to the top," and used it over and over.

Michio was a great camp cook and turned out amazing meals of salmon, berries, or whatever. He knew Americans were obsessed with health issues and worried about things like cholesterol and saturated fats. After eating breakfast, Michio once asked, "Do you think nine eggs for breakfast is too much cholesterol?"

At a time when supersaturated film and digital creations were beginning to subvert nature photography, Michio clung to his vision, and his standby Kodachrome, which rendered colors in a realistic way. His photographs were accurate and reliable. I have no idea how much he philosophized about his rigid traditional approach. Some things he just didn't talk about except in a humorous way. Michio often told colleagues, "You know you are getting old when three things happen: You use a zoom lens, an autofocus camera, and drive a Volkswagen camper."

Michio did not find complete happiness in his work. He longed to marry and start a family, a difficult challenge for a person married to work. When he was thirty-eight he said, "I am too old to get married now. Maybe I should have spent more time in Japan when I was younger."

"I want a son, so bad," he once told me. "My dream would be to carry him in a backpack while photographing a bear."

In the early 1990s Michio met the love of his life and married Naoko, with whom he had the son of his dreams, Shoma. When he spoke of his son, his face lit up like an arctic sunset.

Michio loved bears, and except for caribou, they were his favorite subject. Over the years he lost his fear of them. From his national park experience

he'd come to believe that bears were not dan-
gerous. More than once I saw him hold his
ground when he should have moved away. He
wasn't reckless, just too trusting.

A mature male bear seeking human food or garbage can be extremely dangerous, vastly more so than a female defending cubs.

The details of Michio's death emerged slowly. The attack occurred August 8, 1996, at Grassy Point on Kurilskoye Lake on the Kamchatka Peninsula. On July 25, Michio and three members of TBS television (Tokyo Broadcasting System) had arrived in the Southern Kamchatka Reserve with two Russian biologist-guides, brothers Andrei and Igor Revenko, for a three-week stay. Three days later an aspiring Alaskan photographer, Curtis Hight, flew in to the same campsite. According to Igor, Michio decided to sleep outside in his tent instead of in the cabin, which had space for him. On the second night a bear came to the cabin but failed to break into the food storage shed.

"The bear had unusual habit," Igor said. "He didn't react to human smell, voice, and movement. I had a hard time trying to drive him away that night." The bear returned the next day, and it took the efforts of six people to run him off. According to Igor this bear had broken into the cabin before and may have been fed by other visitors. Clearly the bear had learned that people meant food.

Several times Igor urged Michio to move into the cabin, but he refused. Michio told Igor that bears weren't dangerous when they had lots of salmon to eat. (I thought it typical for Michio to prefer his tent to a crowded cabin. Even as sociable as he was, he definitely sought his own space.) The party soon learned that the salmon had yet to arrive in large numbers. They had bear spray for self-defense but no guns.

Hight, who had expected to share the cabin, also camped out but in a small, inadequate bivouac tent pitched behind the cabin. On his first night in camp, he witnessed the bear's assault on the food shed and decided he needed safer accommodations. The next day he moved to a twenty-foot-tall observation tower at the mouth of the river. Igor warned him that a large bear slept under the cache at night and to climb the ladder before dark. Hight later credited divine intervention for his move to the tower.

With salmon scarce, the television crew was not getting the wildlife shots they wanted. The aggressive bear approached the camp several times, each time more difficult to drive off. Finally, the number of fish increased enough to

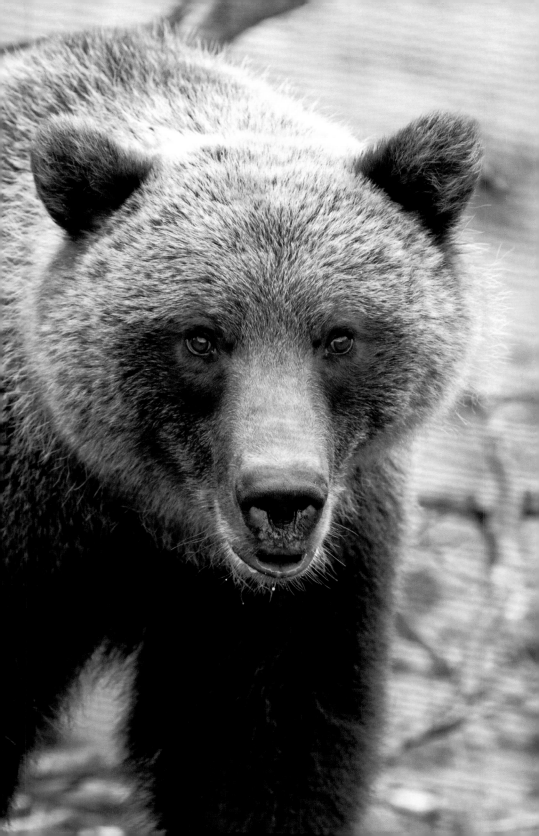

attract several bears, rewarding the TV crew for their persistence. On August 7, the last full day of Michio's life, the salmon arrived en masse.

At four o'clock the next morning, horrendous screams woke all in the cabin. The men rushed onto the porch and raised a raucous din. By flashlight they saw Michio's destroyed tent and a bear bent over something in the grass thirty feet behind it. "I found a shovel and metal bucket and started to bang it three to five meters from the bear," Igor said. "The bear raised its head once but very shortly took Michio's body by its teeth and disappeared in the darkness. We were shocked. It was a horrible nightmare."

The guides rushed the film crew into a boat and raced to a science station nine kilometers away where there was a radio. An American researcher and the two guides, now armed, returned and searched the immediate area. They followed a drag mark to the edge of a dense forest thicket but decided against pursuing further. Later, a professional hunter and a Special Forces officer flew in by helicopter. From the air they spotted the bear, drove it into the open, and killed it. In their report they described the bear as a mature, battle-scarred male weighing about seven hundred pounds.

"We found Michio's remains," Igor said. "It was a very terrible picture. I couldn't believe what happened. But every time I close my eyes, I see the bear carrying Michio into the darkness."

The TBS film crew helicoptered back to Petropavlovsk-Kamchatsky, where they spread the news of the tragedy. Michio's wife, parents, and relatives soon arrived and visited the lake, then flew home with his remains.

One disturbing note and perhaps an important element in the tragedy: Prior to the attack a floatplane had landed, and the pilot was seen standing on the pontoon filming the killer bear eating food from a can—that he had likely given it. (The pilot was reportedly a member of the Russian mafia later responsible for the illegal slaughter of the local bears for their gallbladders, sold in Asia as medicine.)

"Despite the short time I knew Michio, I liked him very much and feel like he was a good friend," Igor Revenko said. "It was a big loss for myself and for my brother. I am sharing the sadness of relatives and friends of Michio."

Ten years after the publication of his award-winning *Grizzly*, Michio Hoshino, forty-four, who "breathed with the bears," was killed by one. It seemed a betrayal. An Inupiat elder who had befriended Michio tearfully said,

"It is my fault. I never teach him that not all bears are good. A few are bad. Very bad spirits. One got him. I never tell him that."

The program printed for a memorial in Fairbanks, attended by hundreds, provided this translation of a piece of Michio's writing:

*If there wasn't a single bear in all of Alaska, I could hike through the mountains with complete peace of mind. I could camp without worry. But what a dull place Alaska would be!*

*Here people share the land with bears. There is a certain wariness between people and bears. And that wariness forces upon us a valuable sense of humility.*

*People continue to tame and subjugate nature. But when we visit the few remaining scraps of wilderness where bears roam free, we can still feel an instinctive fear. How precious that feeling is. And how precious these places, and these bears, are.*

## II

In the years after Michio's passing, some of my friends backed away from bear photography; one quit entirely. But for me, Alaska is bear country, and if you want to be outdoors in summer, then you live with the reality of bears.

I've never been one of the "bear people," a substantial and almost fanatical group who live, breathe, sleep, and dream *bear* almost to the exclusion of all other wildlife. I'm enthralled with bears, but every wild animal inspires me. I celebrate each animal's separateness as a living being. For me, wildlife behavior suggests a broader and richer world beyond my own. Humans, cursed by a misplaced sense of superiority, will never fully understand what goes on in the mind of an animal. I never think of a wild animal as a friend, nor do I think I possess any special connection. Forefront in my mind is Cecil Rhode's admonition: "Be the rock on the tundra." Watch, observe, record, but never insert yourself.

Timothy Treadwell and I were friends once, but we drifted apart when he, in my opinion, started engaging in increasingly bizarre behavior in his attitude toward bears. His work also seemed to be more about celebrity than education. I'd first met him in Southeast Alaska in 1995 when we were both working independently on a *National Geographic* bear film.

I didn't initially like Timothy. He wore his baseball cap backward over a blond Beatles haircut and spoke with a phony Aussie accent. He projected a loopy, surfer-dude air. For an adult, it seemed childish. (When he relaxed, or let down his guard, his accent disappeared.) His penchant for naming bears—Cupcake, Booble, Snowflake—was off-putting.

He seemed to want to be considered an authority on bears and sprinkled his conversation with biology terms. (For example, he once told me he wanted to meet a woman in estrus.) He said he had no formal training and wasn't a scientist. Yet with minimal experience around bears, he'd developed a lecture circuit. Schoolkids loved him; he had a shtick, and the kids ate it up.

Once you got past Timothy's affectations, his enthusiasm was infectious. I admired his apparent sense of wonder with the natural world. Timothy was one of the few people willing to challenge the conventional wisdom of bears as demonic, bloodthirsty predators. (In North America in 2015, one person died in a bear attack; thirty-five people were killed by dogs.) We agreed that sharing the world in harmony with other animals has not been our species' defining quality.

When we first met, Timothy had been summering in Alaska since 1989 or 1990. On his first visit to Kodiak Island, he said he'd come face to face with a bear, meeting a "kindred soul," the contact changing his life. He told me that he was going to put an end to Kodiak Island's entrenched hunting industry. He abhorred hunting and was on a mission, he said, to "save the bears." He wanted to confront people who viewed animals merely as targets or sources of food. Not surprisingly, he made few friends on Kodiak but many more enemies. After a couple of contentious seasons he moved on to Hallo Bay on the Katmai coast.

Treadwell found a summer home in Hallo Bay, a remote, storm-tossed seaside landscape. He lived out of a tent and made his way among the bears unarmed, as park regulations stipulated. He claimed to be "protecting the bears from poachers." From my own experience, I thought it fanciful. He seemed to be styling himself as the Dian Fossey of Alaska's big bears. He once said that he worried more about being shot by a poacher than he feared a bear attack.

Contrary to Treadwell's implied narrative, he was not the first person to roam those sedge flats. In truth, people and Hallo Bay bears had enjoyed a long peaceable association, favored by a few photographers at least as far back as the mid-1960s.

Some of his techniques of getting close to bears seemed to me downright absurd—and risky. He dressed in dark colors to mimic bear color and imitated bear postures in order to elicit responses. He rolled in bear daybeds to "experience what they experience." Timothy never wore hip boots but clomped around in perpetually sodden footwear and pants cut short at the calves. He approached bears with chants of love and said the bears sensed he meant them no harm. Also, Timothy failed to secure his food and camp, something rangers repeatedly warned him about.

He confronted some people; others he avoided, even shying from benign contact. I thought some of it was needless posturing for tour groups that sometimes watched him approach bears. I once called it an act, angering him. "It's not an act," he fired back. "I'm trying to join their society, not merely get close. We have a special connection."

We never photographed together, but our paths crossed in Hallo Bay. On one occasion I saw him repeatedly approach a female and her tiny cub until they fled. Steve Kaufman, a nature photographer and former park ranger, also encountered Timothy there. "I saw Treadwell photographing a young bear that was pawing at his tent," he said. "A girlfriend was there, in the tent. Treadwell was lying down within four feet of the bear, almost underneath it, shooting video. I thought he was crazy and wondered why the park service never took action."

Bear viewing in Hallo Bay boomed in the 1990s with at least two boat operators and several flying services providing day trips. Timothy viewed these groups as trespassers among "his" bears. He ranted to me about Will Troyer, a retired biologist and group leader, as "one of the worst when it comes to bothering and pushing the bears."

In time, Treadwell became a celebrity, sort of a flamboyant Dr. Dolittle of bears. He starred in television specials, appeared with David Letterman, and enjoyed the support of Hollywood celebrities like Leonardo DiCaprio. *People* magazine profiled him in 1994. He spoke to almost ten thousand schoolchildren a year. He founded a group called Grizzly People, "devoted to preserving bears and their wilderness habitat. Our goal is to elevate the grizzly to the kindred state of the whale and dolphin through supportive education in the hopes that humans will learn to live in peace with the bear, wilderness and fellow humans." His book, *Among Grizzlies: Living with Wild Bears in Alaska*, written

with Jewel Palovak, was immediately controversial: "The grizzly bear is one of a very few animals remaining on earth that can kill a human in physical combat," he said. "It can decapitate with a single swipe, or grotesquely disfigure a person in rapid order. Within the last wilderness areas where they dwell, they are the undisputed king of all beasts. I know this all very well. My name is Timothy Treadwell, and I live with the wild grizzly."

In the book he tells tales of close encounters with bears, benign as well as threatening. He tells of swimming with them, trying to kiss one on the nose, and facing down dominant thousand-pound males. As one reviewer wrote in 1997, "*Among Grizzlies* is a book about one of my favorite subjects: bears. . . . But it isn't long . . . before one realizes that just beneath the surface this is actually a book about a man with a death wish and all the talk about bears . . . is really a series of descriptions of this sad individual's numerous attempts to force a horrible death upon himself."

One summer my friend Chuck Keim and I hiked up Kaflia Creek to a lake where Timothy camped during the late autumn salmon run. I wanted to see the place Timothy had described to me as the "Grizzly Maze." The hike along the creek from tidewater followed a series of well-worn bear trails through dense alders and was more intense than I expected. At times we had to duck down and scoot through brushy tunnels. We made plenty of noise, thankful that the salmon were yet to arrive. We saw just one bear that wandered past us seeking fish.

We followed a muddy trail to a tiny clearing on a little rise near the lake's outlet. The grassy clearing was the hub of intersecting bear trails. Despite Timothy's positive description of the spot, I was appalled. In my estimation you couldn't pick a worse place to camp—any contact here would be sudden and at close range. I also thought it a place where bears unfamiliar with people, or worse, those *intolerant* of people, would gather. It seemed to me an invasion of a sanctuary.

My friendship with Timothy grew strained over the years. More than once I told him I thought he was acting inappropriately and not doing the bears any favors. Once I slammed him for flouting park rules and for his not infrequent run-ins with park rangers. I told him he was only making life harder for other people and perhaps creating an unsafe situation. And that if he got hurt, or killed, bears would die as a result. He countered that there was always that

chance but wanted no retaliation because it would be his own fault. What disturbed me most about Timothy was not the disregard for his own safety but the implied disregard for others. Too, I considered his behavior disrespectful to his subjects. No wild bear can be our "friend" or "love" us.

When a bear killed Timothy Treadwell, the tragedy made national news. In midday on October 5, 2003, Timothy Treadwell and his girlfriend Amie Huguenard were killed and partially consumed by a bear or bears at his Grizzly Maze campsite. They were the first people killed by bears in the eighty-five-year history of Katmai National Park, home to the highest density of brown bears worldwide. Sadly, Timothy's death came just as he predicted, but Amie's death seemed especially tragic to me. She died because of trust and faith in her friend.

On Monday, October 6, bush pilot Willy Fulton landed his floatplane near Treadwell's camp for a scheduled flight out. Instead of two waiting passengers, he discovered a flattened tent and what appeared to be a bear feeding on a person. Fulton radioed for help. Park rangers and Alaska State Troopers responded. Near the campsite, rangers shot and killed a bear at close range. They located the gruesome remains of both victims. The officers killed a second, smaller bear in the act of stalking them. What had started out as a rescue mission ended as a grim dance with death.

A subsequent necropsy described the first dead bear as a large, adult male, at least twenty-five years old and weighing a thousand pounds, in apparent good condition with no signs of injury other than the wounds that killed it. Its stomach contained human parts and bits of clothing. A lip tattoo revealed that the bear had been captured in 1990 in nearby Kukak Bay as part of a research project. The second dead bear was a much smaller three-year-old. Because the carcass of the smaller bear had been mostly consumed by other bears before collection, it provided no other evidence.

Investigators recovered a video camera that contained only a recording of the fatal attack. "*Get out here. I'm getting killed,*" Treadwell shouted to Huguenard, who was in the tent at the outset. "*Play dead,*" she yelled back, but as the attack continued, she left the tent to help her friend. Blood-curdling sounds dominate the six minutes of tape. "Believe me, it is something you don't ever want to listen to," investigating biologist Larry Van Daele told me. "Horrendous."

In their official report, park rangers wrote that the camp was clean, food was stored properly, and Treadwell had been in compliance with applicable

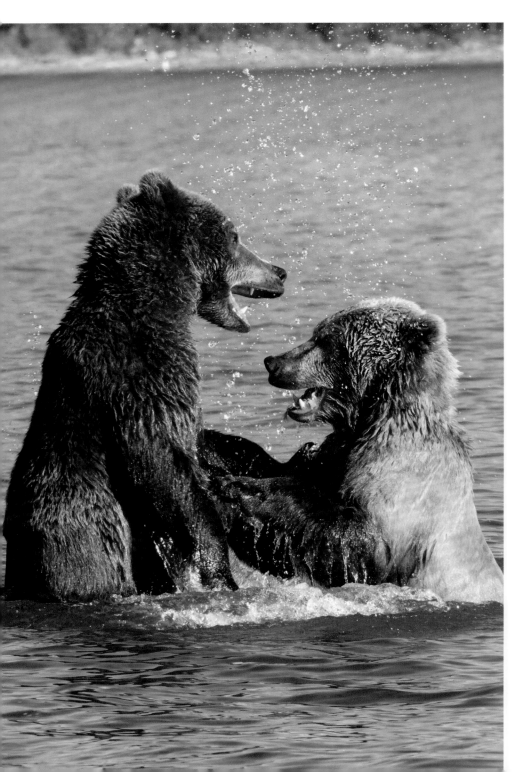

Even when bears are play-fighting, their teeth and claws can inflict serious wounds.

park regulations. A search turned up no defensive tools—no bear spray, electric fencing, flares, or firearms. In Van Daele's assessment, "Mr. Treadwell's actions leading up to the incident, including his behavior around bears, his choice of a campsite and his decision not to have any defensive methods or bear deterrents in the camp, were directly responsible for this catastrophic event." The National Park Service investigation concluded, "The location of the campsite was a primary factor that led to the . . . deaths of Treadwell and Huguenard." The reports cited Treadwell's well-documented questionable behavior around bears, based on his belief that he had a "special relationship" with them, as another significant factor.

Several surprising details emerged in the aftermath. Timothy's tales of being Australian or an English orphan were false. Timothy William Dexter, his real name, grew up on Long Island, where he earned a swimming scholarship to Bradley University. In 1978, he relocated to Long Beach, California, then Malibu. In California he legally changed his name to Treadwell, a stage name.

In Alaska, the tragedy ignited a firestorm of news stories, rumors, and commentary. Much of it was sensational, woefully little of it respectful. Initial news accounts were inaccurate or speculative. Second-guessers wrote columns based on little but opinion. Treadwell never seemed to grasp, or didn't care, that Alaskan values were different from those of mainstream America, that celebrity was a two-edged sword. The "we don't give a damn how they do it Outside" crowd lit into Treadwell with a macabre gloating over his ghastly death, an obvious undercurrent of "I told you so." Venomous spewing filled online chatter and letters to the editor. Two people died in one of the most horrific ways imaginable, but that didn't slow the cruel and vicious attacks.

Helicopter pilot Sam Egli of Egli Air Haul, the charter service that assisted in recovery of the victims' remains, was interviewed afterward. "Treadwell was, I think, meaning well," said Egli. "Those bears are big and ferocious, and they come equipped to kill ya and eat ya. . . . He got what he was asking for. He got what he deserved. . . . The tragedy of it was taking the girl with him."

Timothy "deserved" no such fate. Sadly, Egli's comments, and worse, were echoed by many others.

Only a few people spoke in Timothy's defense, praising his conservation work and asking for compassion for the victims' families and friends. Juneau-based cinematographer Joel Bennett, who had worked on five films with Treadwell, said that he "never once saw [Treadwell] behave in what I considered an inappropriate or dangerous manner. He didn't get any closer to bears than most wildlife photographers do. Bear-viewing guides and tourists get close every day." Bennett, one of the few to camp with Treadwell and with years of experience working with Alaska's bears, summed up his view this way: "When all is said and done, Timothy Treadwell will be remembered by those who knew him as caring for the future of bears. At least he did *something* when most people won't or are too busy to bother."

"Treadwell did not represent, by any stretch of the imagination, responsible bear viewing, and certainly not that of any professional wildlife photographer," countered Joe McDonald, another prominent wildlife photographer. "Frankly, the general feeling is that Treadwell should have been policed and restricted to prevent the predictable. . . ."

Larry Van Daele, the state biologist who investigated the attack, said, "I am trying to find some good out of this tragedy and to divert the animosity that is developing between the Grizzly People and many Alaskans. If we can get past the personality and actions that Treadwell exemplified we can work toward the common goal of bear conservation. Their group reaches an entirely different segment of our society than we do, and it is important to deliver an unbiased message to them."

The tragedy spawned numerous articles and opinion pieces and at least two books, the best being the one by Nick Jans, *The Grizzly Maze: Timothy Treadwell's Fatal Obsession with Alaskan Bears*. A documentary by Werner Herzog, *Grizzly Man*, included video shot by Treadwell. The film is provocative, cringe inducing, and often bizarre—in sum, a disturbing legacy.

Timothy Treadwell, in my opinion, was too complex a personality to interpret. He lived out a self-absorbed passion that cost him and an innocent friend their lives—and the lives of more than the two bears killed at Kaflia. In the aftermath, a biologist estimated that as many as twenty-four more bears were killed statewide in "defense of life and property" as a result of the fear generated by this horrific incident.

Too, I wonder about all those children he addressed, their reaction and thoughts. And what of the agony of Amie Huguenard's family? In the end, Timothy did more harm than good.

## III

Some second-guessers declared the tragic deaths of Timothy Treadwell and Michio Hoshino as similar and predictable. Nothing could be further from the truth, the two men sharing almost nothing in common except a passion for nature. Michio used experienced guides for some of his photography and never behaved like Timothy. Michio made a tragic error in judgment when he chose to camp out. I can see absolutely no other connection.

The Treadwell tragedy, however, did contain striking similarities with another horrific incident. Two days after Christmas 2003, and just weeks after Treadwell's death, I received an email from Kamchatka. "Vitaly is dead, killed by a bear." In an eerie replay, Vitaly Nikolayenko, sixty-six, a man who had spent the better part of thirty years studying and photographing bears on the Kamchatka Peninsula, was found dead at a lake near his hut on the Tikhaya River, site of a late salmon run. His remains were found in the snow amid fresh bear tracks. A swath of orange-colored pepper spray evidenced an attempt at self-defense. A flare gun found by his body was unfired.

We had met just once, but I knew his work and admired this self-educated researcher. According to his friends, he walked as much as six hundred miles a year through the wilderness of the Kronotsky State Reserve, logging eight hundred bear contacts annually. His journals documented behavioral ecology that professional biologists found invaluable. His major goal was thwarting the region's billion-dollar poaching industry, fish for their roe and bears for their gallbladders. After the fall of the Soviet Union, poaching was rampant, protected by corrupt but powerful people. Unlike Treadwell, the danger Vitaly faced from poachers was real; he limped as a result of a poacher's bullet.

Not unexpectedly, Vitaly was reviled by some but respected by others. As a ranger and guide, he resisted the urge to assign human emotions to bears. He believed bears, like a large male he studied for twenty-two years, only tolerated him. "A bear thinks only of himself, his own needs," he said. Vitaly possessed

an intimate knowledge of bears, and colleagues looked to him for advice. He helped investigate Michio Hoshino's death.

Nikolayenko's journal revealed the last days of his life. He was camped near a stream plugged with a late salmon run. In December, a large aggressive brown bear male arrived and quickly established dominance over other bears. In the days prior to the fatal attack, Vitaly experienced several close calls, apparently of his own initiation. He crowded the bear one too many times.

"Everything looks as if Vitaly lost his good sense and believed that nothing bad could happen to him," one Russian expert said. "In his last interview . . . Vitaly said, 'A Lord still protects me. Nobody is able to predict his future.'" Vitaly went on to say that humans are invaders in the bear's world. He believed that in the case of bear attacks, only man is to blame, not the bear. "A more generous way to look at what happened is that Vitaly most likely had more experience living with [wild] bears than anyone in the world," said the expert, "maybe twice that of Timothy Treadwell. Perhaps like Timothy and Michio Hoshino, Vitaly simply ran out of luck. In all three deaths, if each of these people were able to comment on what happened, they would all probably admit they had made a mistake."

Vitaly's death was a severe blow to the conservation and protection of Kamchatka's bears. Poachers continued to exact a terrible toll on the region's wildlife. That he—and for that matter, Treadwell—lasted as long as they did around bears, speaks less about their skill and more about the tolerance of bears.

## IV

Rich and Kathy Huffman, my neighbors at Denali, were merely in the wrong place at the wrong time. They were on a dream trip, a float down the Hulahula River in the Arctic National Wildlife Refuge. Both were experienced outdoorspeople and loved wildlife and nature.

The fatal attack came at night, though not in full darkness. No one knows the complete details. The couple kept their food in bear-proof containers and made a practice to cook and do dishes well away from camp. The bear that killed them was a typical arctic grizzly, seven years old, and three hundred

pounds, with no apparent physical anomalies. Investigators found an unfired rifle in their ravaged tent. The attack seemed predatory in nature.

In the search for meaning in the face of tragedy, Rich's daughter, Shannon Huffman Polson, later floated the Hulahula to the site of the attack. Her book, *North of Hope: A Daughter's Arctic Journey*, details her difficult quest. We all asked, as she initially did, *Why? Why them? They did nothing wrong.*

Trying to make some sense of this tragedy, I recalled my own float trip on that river and remembered seeing several Inupiat subsistence shelters that had been broken into by bears and the crude dumps nearby. Clearly, a bear or bears had obtained food or garbage from human shelters. The bear that killed Michio had done the same.

I consulted Steve Herrero, an authority on bear attacks. "The common denominator in the fatalities was gender of the bear," he said. "Adult or sub-adult males were involved in ninety-two percent of fatal predatory incidents, which reflects biological and behavioral differences between male and female bears. Females with cubs are not the most dangerous." He said that, prior to 1987, "of nine people killed by grizzlies south of Canada in the past two decades, *all* were at campsites, and seven were in their sleeping bags."

Science explains but does not offer solace. Five people I have known have been killed by grizzlies, a fact profoundly disturbing. I've found little commonality or understanding. If, in the end, we can't explain aberrant behavior in our own species, how then do we expect to understand it in other animals?

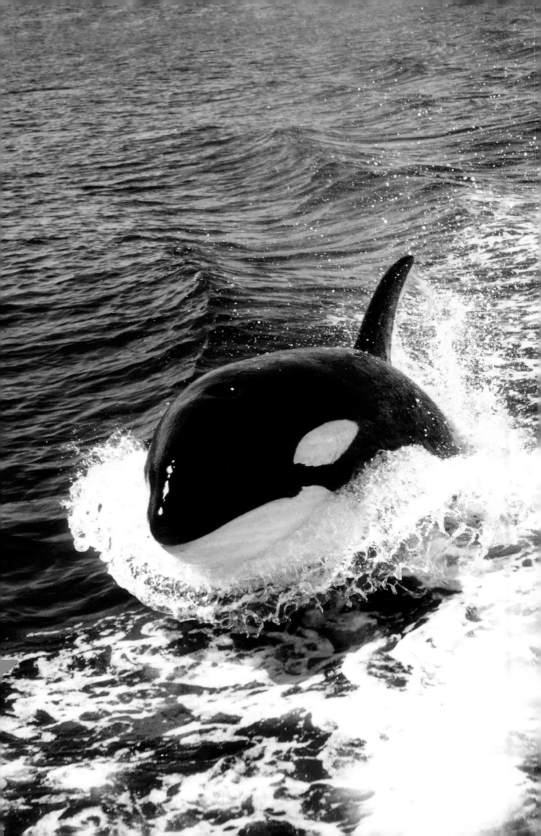

# *Tumultuous Shores*

## I

**EARLY ON A SUN-SPLASHED JULY** day, aboard a forty-foot workboat, *Provider*, we motored south out of a secluded bay on Admiralty Island's southeast coast. Each year for several years I chartered the *Provider* for a two-week, or longer, jaunt in Southeast Alaska to photograph marine mammals, inviting other photographers to join me to help defray costs.

Just offshore, dozens of black-and-white Dall's porpoises surfaced in slow rolls, traveling in a loose aggregation the captain estimated numbered three hundred. Normally they travel in groups of two to twenty, with two hundred not uncommon. At our speed of eight knots, it appeared we would pass well to starboard of the porpoises, but they surprised us.

"*Here they come!*" shouted the captain, throttling the boat up to its maximum fifteen knots. I looked where he pointed and saw four or five porpoises angling in at us. Three times they surfaced for a quick breath, each time creating their distinctive "rooster tail."

"*Bow riders!*" he yelled again, and we all stampeded to the bow. The crystalline water revealed every subtle movement of porpoises playing off the bow. Dozens of them joined in the sport. Whenever one peeled away from the wake, another swooped in to take its place. When they surfaced for breath I watched their blowholes snap open, then slam shut before submerging. Each breath sounded like a pistol shot, and more than once their spray painted my face.

Porpoises veered in and out with wondrous agility. Several times they crossed from side to side in one swift pass. Once a porpoise zoomed across the bow only to reverse its direction with a 180-degree flip with no apparent loss of speed. One porpoise lined up directly in front of the bow, its tail just eight to ten inches away, in essence breaking trail for the boat. On occasion it dropped back slightly until its fluke almost touched the boat. With

After killing a porpoise and feeding a calf, a female orca plays in the bow wake of our boat.

only a slight and rhythmic undulation, it hung in place for minutes, position-
ing itself by the bow pressure.

Finally, the porpoises veered off and the captain throttled back. For
long minutes we had enjoyed a close look at this unique North Pacific por-
poise. Colored much like an orca whale, these eight-foot-long, 450-pound,
thick-bodied, Dall's porpoises can swim at 35 miles per hour but rarely breach
like other porpoises. Their relationship to their larger cousins, orcas, can be
either playful or deadly.

A day or two later in Chatham Strait, off Admiralty Island's west coast, we
spotted five orcas—two cows, two calves, and a bull—traveling parallel with
us off the port side. We watched the orcas close to within a hundred yards,
where they maintained a steady course, swimming with a series of rhythmic
surfacings. The tip of a fin breaking the water was the first indicator of their
direction of travel. A bugle-note sounded with each breath, a small rainbow
forming in the spray.

An hour later, lulled by the orcas' leisurely pace, I was startled to see them
rocket ahead. The male, with half his dorsal exposed, torpedoed forward at
double speed. The cows and calves dove and did not resurface.

"It's a chase! Porpoises ahead!" barked the skipper, gunning the throttle.
From the bow, I watched dozens of porpoises scattering in the distance. Even
at 15 knots we couldn't keep up with the bull orca. When he finally dove, I
lost all sign of the pod, the surface broken only by the rooster tails of fleeing
porpoises.

Then our captain shouted: "*Breach!*" A quarter mile ahead, the bull leaped
out of the water in a tremendous arc. Where he landed sixty feet away, two
porpoises jetted out of the water at right angles. Several more circled back
away from the splash, and we saw two orcas racing to intercept them.

Again the bull breached, landing on a single porpoise that narrowly squirted
away. A hundred yards to his left, a cow shot upward in a breathtaking leap,
apparently driving several porpoises toward the bull.

Just as our vessel drifted to a stop, the water off the port side erupted with
a resounding tail slap, sending up a colossal splash and whirl of foam. I caught
a glimpse of an orca cow, a calf at her side, yanking something underwater.
Moments later she surfaced with part of a porpoise in her jaws, the calf slashing

at her catch. Slowly the two submerged, only the tip of the cow's dorsal waving above the bloody sea.

Suddenly, off the port bow, the tip of the bull's tall dorsal appeared, boring in on the cow and calf. Just short of them, he stopped, submerged briefly, and then reared out of the water in a spy-hop, his eye fixed on us. For long seconds he held our gaze before submerging again. Seconds, then minutes, ticked by, but the bull, cow, and calf were gone, the roiled water turning calm and still. Later we spotted all five orcas headed north in Chatham Strait.

From his perch on the flying bridge, our captain had seen the bull pass under the boat and glide off into the depths. He didn't see the cow and calf again until quite distant. He called their attack strategy and tactics "stealth mode."

Later that same afternoon we spotted a larger pod of orcas, perhaps twenty or more, including two mature bulls. Dozens of porpoises broke the surface some distance in front of them. "*Orca food dead ahead*," shouted the captain as he throttled back to watch the chase and hunt. What happened next was inexplicable.

These porpoises did not panic or race off but rather allowed the orcas to close in. Astonished, I watched the porpoises swim without panic amid the orcas. It looked suicidal, but one porpoise passed across the head of the biggest bull. Again and again the two animals crossed paths, increasing their speed with each passage. *The porpoise was playing in the bull's bow wake!* Others did the same.

Here was the interaction of porpoises with a *resident* pod of orcas. The hunt we had witnessed earlier was the work of a *transient* pod. Residents feed exclusively on fish; transients hunt marine mammals such as seals and dolphins. Transients and residents may live in the same coastal areas but generally avoid contact and do not share the same calls. Transients also tend to range farther offshore than resident pods. In one experiment, harbor seals fled from the recorded calls of transients but ignored those of residents. Our captain's term "stealth mode" was accurate because hunting orcas go silent in the stalk.

Orcas, also known as killer whales or blackfish, inhabit Alaska's coastal waters out to five hundred miles offshore. The scientific name, *Orcinus orca*, means "from the underworld of the dead." They are not whales but the world's largest, brawniest dolphins and live in every ocean. Orcas weigh up

to eight tons, measure up to twenty-six feet long, and are capable of speeds up to 48 knots (30 miles per hour), ranking them nearly the fastest marine mammal, second only to the speedy common dolphin. They regularly dive one to two hundred feet deep, with the deepest dive recorded at nine hundred feet. They live together in matriarchal groups, called pods. Females live longest, on average twenty-nine years; one lived to one hundred. Super pods, totaling fifty animals or more, form when resident pods mingle for mating and socialization.

Seals, seabirds, sea otters, and other cetaceans are prime prey for transients. Speedy Dall's porpoises are an abundant prey species. Harbor porpoises, Alaska's smallest cetacean, are another. In recent years transient pods of orcas have taken a toll on sea otter populations in the Aleutian Islands. Recent estimates place the island chain's otter population at about six thousand, down from nineteen thousand in 1992.

Orcas consume two hundred pounds of prey per day, but their food chain is badly polluted. These predators have the highest concentrations of industrial chemicals found in any living mammal. Extremely high levels of PCBs (polychlorinated biphenyls) disrupt immune systems and reproduction, perhaps accounting for recent accelerated mortality.

Transient orcas hunt a variety of prey. Several times I've seen them catch white-winged scoters, a small sea duck that bobs along on the surface alone or in small groups. On one trip I saw a scoter suddenly disappear into an orca's gaping maw. Minutes later the injured scoter popped to the surface but was dragged down again as it tried to escape. The bird vanished for good after multiple attacks. Once I saw a female orca catch a *ten-ounce* marbled murrelet and turn it over to her calf, which repeatedly mimicked the attack, much the way a lynx sometimes plays with voles or mice.

Other Alaskan observers have reported orca pods attacking humpback, gray, and minke whales, and once, a rare northern right whale. In 2000, onlookers along Turnagain Arm near Anchorage saw four orcas cut a female beluga whale out of a pod and, with what one person described as "the coordination of roving wolves and the patience of creeping tigers," attack and kill it. The next day the mutilated carcass of the twelve-foot cow floated up on a sandbar.

## II

Alaskan summers are brief, a time to be on the saltwater, sharing space with giants. In Southeast Alaska, humpback whales are ubiquitous. More than half the North Pacific's eighteen to twenty thousand humpbacks migrate here to feed in the rich inshore waters, sometimes literally within feet of the shoreline. Many species of marine mammals, as well as seabirds, migrate into Alaskan waters each year to avail themselves of its rich feeding grounds.

In spring, humpback females and calves migrate from their breeding grounds off Hawaii to critical feeding areas in Southeast Alaska. On arrival most humpbacks have lost 25 percent of their body weight.

The return migration begins in September; a very few overwinter here. A humpback identified in Kenai Fjords was spotted thirty-six days later in Hawaii, a travel rate of 100 miles per day. Most make the journey in four to six weeks at a steady 3.5 miles per hour. In the warm tropical waters, they mate and calve. Calves are twelve feet long at birth and weigh three thousand pounds and are strong enough to begin the long journey north shortly after birth. Adult humpbacks weigh 25 tons and live forty to seventy years. Humpbacks derive their name from their rolling dive pattern and can submerge for up to forty-five minutes. Their fifteen-foot-long pectoral fins are unique identifiers.

Rather than teeth, humpbacks filter out their food through jaws lined with 270 to 400 hairy baleen plates. Pleats in the ventral pouch beneath their lower jaws unfold as the whales surge forward during feeding. A filled pouch can hold an estimated fifteen thousand gallons of water. Humpbacks employ several feeding strategies. Individuals swim through drifting clouds of tiny crustaceans called krill, gulping gallons of water, trapping as much as one hundred pounds of krill at a time. To capture fish, they may slap a fluke or fin to stun their prey, a technique called "flick feeding." Their unique strategy is "bubble-net feeding." Anywhere from five to nine whales gather in this cooperative hunt. (A friend once counted over twenty-five whales working together.) At depth, the whales circle and release a ring of bubbles that traps schools of herring or candlefish in the center of the rising cylinder. (The bubble-net may exceed one hundred feet in diameter.) With gaping mouths, the whales rise

under the fish and at the surface close on the massed prey. Group feeding is methodical and coordinated, a strategy that allows each whale to consume as much as two tons of food per day.

Male humpbacks are the famed "singing" whales. Researchers believe males use their vocalizations to establish dominance over other males or that females choose mates by song. Humpbacks also are notable for their acrobatic behaviors such as breaching and tail lobbing.

I've watched these impressive animals on many trips, but one in particular stands out. Early one day in Frederick Sound on the south end of Admiralty Island, our captain spotted a huge splash off in the distance. *"Breach,"* he shouted. *"There!"* He spun the helm and steered toward the action. "Sometimes they breach over and over again," he said. "Maybe we'll be lucky and get closer."

In the half hour it took to close the gap to the legal hundred-yard limit, we saw a series of breaches and two separate spouts, probably of a cow and calf. "Mostly the calf playing around its mother," said the captain. "I only saw her breach once." He idled to a stop and shut down the engine. The lull in the action didn't last long. The minute the captain went below for coffee, a whale breached behind us. I spun around but caught only the tremendous splash. No one saw the first breach, but minutes later we all caught the second full-bodied breach and the geyser of water as the whale slammed back into the sea.

For long anxious moments there was no sign of a whale, nothing, not even a ripple. Then, with an explosive trumpeting spout, a whale surfaced near the bow. For some moments it lolled on the surface, a fine mist rising from each shallow breath. The captain said the whale was resting as a likely prelude to further action. After a minute or two, the whale inhaled then rolled into a dive. I began a slow count.

Less than a minute later, and just a hundred yards from the silent boat, the adult whale rocketed straight up out of the calm sea, spinning as it cleared the surface, spray flying in all directions and white froth cascading from the winglike fins. An enormous belly flop produced an explosion of water. Our spontaneous cheer broke the silence. One of my friends leaped two feet off the deck, punching the air with her fist while two others slapped high fives. (A whale breach is the sea's game-winning touchdown, homerun, and overtime goal, rolled into one.)

Whale watching is not always exciting, and too often it is heart-wrenching. On three occasions I have seen humpback calves entangled in heavy nylon fishing lines, one towing the buoy and line of a crab pot. Rescuers who enter the water in an attempt to free enmeshed whales run great risk. Just one slap of a fin or fluke can kill. Many entangled whales die; few are rescued. Some stories are remarkable.

In 2005, a crab fisherman working east of the Farallon Islands near San Francisco reported a female humpback with hundreds of yards of rope wrapped through her mouth and around her body and tail, all weighted down by hundreds of pounds of crab traps. She fought hard just to keep her blowhole above water. A member of a rescue team told me the story. The team arrived within hours of a fisherman's radio call. They determined that the only chance to save the whale was to swim with her and cut the ensnaring ropes, an extremely dangerous move. Some of the lines were cinched so tight that they had cut deep into her skin and blubber. The swimmer who cut the rope from the whale's mouth said that the

Five humpback whales, mouths agape, break the surface of their bubble net, gulping a school of herring.

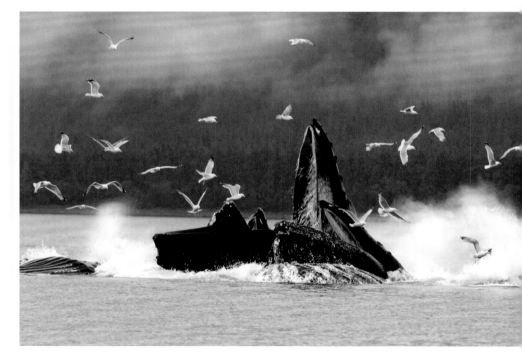

whale watched him the whole time and seemed to know that he was trying to help her. When finally freed, after four hours of dangerous work, the whale swam in what the rescuer described as "joyous circles," gently nuzzling each diver. "It felt like it was thanking us, knowing that it was free and that we had helped it," he said. "It stopped about a foot away from me, pushed me around a little bit, and had some fun. I never felt threatened. It was an amazing, unbelievable experience."

Whale watching in Southeast Alaska is as much about place as it is about whales. Massive tidewater glaciers tower over inlets choked with icebergs calved from their faces. Numerous islands and fjords along the wild coastlines provide rich habitat for brown bears and eagles. Thick conifer forests skirt mountains shouldering upward to glacial summits. Mountain goats edge across sheer cliffs, and wolves hunt the shorelines. Seals, sea lions, sea otters, and salmon sharks ply gray-green waters loaded with herring, candlefish, halibut, and schools of salmon. Puffins, murrelets, bald eagles, cormorants, and gulls search the sea to feed themselves and their young.

A crow or raven calling from silent, fog-draped woods is a reminder that this region was once solely the home of Tlingit and Haida clans, which claim these highly intelligent birds as totems. It takes very little imagination to conjure visions of paddlers in huge dugout cedar canoes hunting whales or fishing for salmon. Here, the word *wilderness* takes on a full and complete meaning, *bountiful* the only appropriate descriptor.

### III

As our floatplane approached from the east, Round Island emerged from the mists like some prehistoric marine beast. Our pilot stayed well offshore, and before landing, pointed out Sealion Cape at the southeast tip, the rugged sand spit at the opposite end, and the slab-sided cliffs between. He set the plane down in the tranquil water near Boat Cove, where we rendezvoused with a raft for transfer to the island.

As I packed gear up from the cobble beach to the campsite, the wind twisted and taunted the tall grass furring the island. Fields magenta with fireweed, monkshood, and geranium sprinkled with yarrow and coltsfoot finger up the steep, sheer flanks of the island. From previous trips I knew the summit was

seldom free of clouds, now it was barely visible through heavy mist. Steep cliffs east and west of camp supported a quarter million nesting seabirds—kittiwakes, murres, cormorants, puffins, auklets, and guillemots—their cries never-ending. Silence is an unknown on Round Island.

Perched on a rock shelf that evening, I watched the sun drift below the far horizon, reddening the clouds and sea, birds wheeling on the wind, the hordes of walrus asleep on the rocks below. I'd come here not just for walrus photographs but also for a journey on the back of the sea beast, to savor the wildlife, the sea, the weather.

Round Island is one of seven craggy islands in the northwest corner of salmon-rich Bristol Bay designated as the Walrus Islands State Game Sanctuary. This two-mile-long, thousand-foot-high rock was once one of only four major Pacific walrus haulouts in Alaska, with, at times, as many as fourteen thousand bull walrus crowded on its narrow rocky beaches. Haulouts also dot the Siberian coastline. Why some haulouts are solely male is unclear except perhaps a natural separation of genders to protect calves from the much larger bulls.

I'd first visited Round Island in the late 1970s as a guest of two friends, wildlife researchers, who had worked there for more than a decade. I made several visits since and was once stranded there for eight days because of storms. Camping there demands preparation; a windproof, waterproof tent; and the best quality waterproof raingear. I found the frequent storms invigorating. At night I'd drift asleep to the wind whispering in the grass, the cacophony of seabirds, and the lovely bell-like chiming of walrus. Some nights I heard only wind-driven rain and crashing waves. I fell in love with it all, walrus only part of the magic. On one trip, the three competent women on the island—in Carhartts, Xtratuf boots, and windbreakers with bandannas covering their hair—radiated an exotic, sensual charm. (A far cry from the tropical islanders of my youthful fantasies.)

Walrus feed mainly on bottom-dwelling invertebrates such as clams, snails, crabs, and shrimp found at depths less than three hundred feet. (Inupiat hunters tell of "rogue" walrus that attack, kill, and eat ringed and ribbon seals.) On the ocean floor they scull along with their hind flippers, rooting through the mud with their broad, flat muzzles that are covered with stiff, sensitive, whiskers called vibrissae. They use their lips to suction the meat from bivalves.

Pacific walrus number a little over two hundred thousand according to recent estimates. They look somewhat like sea lions but with a heavier neck and flat face. Walrus are the largest of the pinnipeds. Bulls can be eleven feet long and weigh more than a ton. (One bull weighed 3,432 pounds.) Cows weigh around 1400 pounds; newborn calves weigh 100 to 160 pounds. Their outsized canine teeth, or tusks, are a distinctive feature. In fact the genus name for walrus, *Odobenus*, means "tooth-walker." Both genders use their tusks for climbing onto both land and ice. Ferocious battles sometimes break out, with tusks used as stabbing weapons. An Inupiat elder told me that he once found a polar bear stabbed to death by a walrus—in his experience an unusual occurrence.

Each spring as the Bering Sea ice begins to recede, the majority of walrus follow the retreating ice edge north to the rich feeding grounds of the Bering and Chukchi Seas. For decades, twelve to sixteen thousand bull walrus did not migrate north in spring but remained in Bristol Bay from March through October. In late autumn they relocated northward to the ice edge near St. Lawrence Island. Today, as dramatic changes in ice cover have occurred, the once predictable patterns have been disrupted.

Gregarious but contentious, bull walruses spar frequently as they contend for resting places on crowded haulouts.

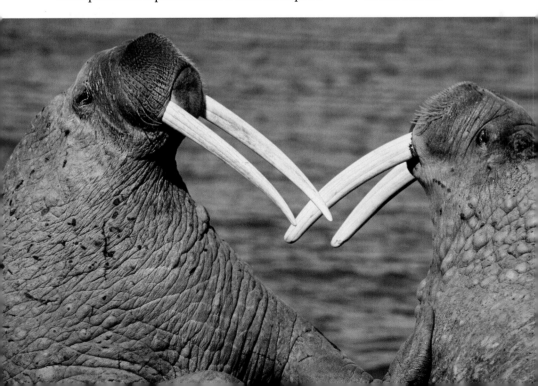

Walrus use the pack ice for resting and birthing. The ice at these haulouts must be thick enough, twenty-four inches or more, to support their weight and allow ready access to the water for foraging. Congregations develop on relatively flat ice near open leads, or near polynyas (open water formed by warm ocean upwellings). In early winter most walrus retreat southward along with the advancing sea ice, but some remain in the polynyas near St. Lawrence, sharing space with the world's overwintering population of spectacled eiders.

Haulouts are raucous places. Walrus roar and bellow as they vie for prime resting places. Stabbing tusks and indignant grunts welcome newcomers as they crawl up the beach and over other walrus. Tusks glitter in the sun as bulls spear and parry their outraged companions. These sites are critically important for thermoregulation. Immersion in cold water restricts blood flow to the skin, which turns pale pink, almost white. As a walrus warms up, the blood surges to the surface, the skin turning deep red or brown. More than one casual observer has described the scarlet color as sunburn.

Over the past decade climate change has created chaotic conditions for ice animals. With the ice pack ever more unpredictable, large herds of walrus have hauled out on land where they were never seen before, making them vulnerable to harassment, hunting, and predators. In some cases, these critical haulouts are long distances from the best feeding grounds, creating yet another challenge. Some usual haulouts have been abandoned because of human disturbance. Stampedes of frightened walrus leave a trail of dead or injured animals. Planes flying over Cape Peirce, north of Round Island, have stampeded herds over cliffs.

Since its establishment as a sanctuary in the 1950s, Round Island access has been tightly controlled. Poaching for ivory has been an infrequent problem. In recent years a limited subsistence hunt has been allowed in the late fall after most walrus have migrated north. Airplanes are restricted from flying low over or around Round Island; boats are permitted to approach only through a designated corridor outside Boat Cove. Frequent storms and rough seas keep visitation minimal.

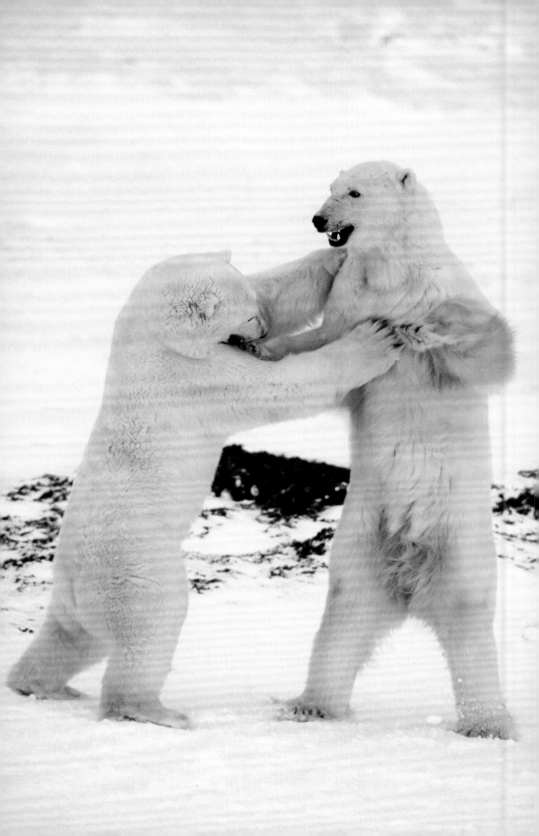

# *Ice Bears*

## I

**ON A LATE NOVEMBER DAY,** under clearing skies and plummeting temperatures, a female polar bear, trailed by two young cubs, approached our camp perched on the edge of the congealing arctic sea. First-year cubs dutifully follow their mother, rarely lagging behind, but something seemed wrong here. One cub trailed its mother, who paused often for it to catch up. At each pause the laggard dropped, exhausted, to the ice.

I was in the Canadian Arctic on a journey to photograph polar bears and arctic foxes. Periodically I would leave Alaska in winter on extended excursions, not for warmth and sun in Hawaii or Mexico like other Alaskans sought, but to cold regions to see and photograph polar animals. How creatures adapt to and cope with extreme weather fascinates me, and to learn more, I've traveled—often alone—to Antarctica, the Canadian Barrens, the Svalbard, and the Sea of Okhotsk.

On this day in the Arctic, the bears passed near us before meandering off into the pressure ridges. The next morning the bears were back, their wanderings curtailed by thin and broken ice. The cub had weakened overnight, its pace slow and uncertain. Several times the cub dropped in its tracks. Each time, its mother turned back to sniff and prod it. Throughout the morning we watched their progress. Once, the mother bear rolled on her back to nurse her cubs, but only the healthy cub suckled, its weak sibling sprawled nearby.

Over the next four days the cub continued to falter until it grew too weak to stand. Mother bear hovered anxiously over the small form, placing all three bears in jeopardy. For safety, a female with cubs must be mobile to avoid dangerous large males.

Mature polar bears spar on the coast while waiting for sea ice to form.

The female pushed and pawed her cub, urging it to move. Several times she tried to lure the cub to its feet by walking away. Twice the cub struggled upright, but each

173

time collapsed after a single step. Eventually the female abandoned the ploy and settled in to guard her cub. On the evening of the fourth day, two young male bears approached the huddled family. The mother's fierce open-mouthed charge drove them away.

The fifth day dawned under light snow. From our vantage point we quickly located the immobile bears, curled up in a depression as if asleep. An hour after we arrived, the mother stood up, stretched, and shook the snow off. Even at a distance we could hear the mewling of her healthy cub demanding to be nursed; she sprawled on her back to suckle it. Her second cub appeared dead.

After nursing, the female moved to the still form, touching it gently with her paw. All that morning she attempted to rouse her cub but with no response. We spotted several other polar bears in the vicinity, but none came near the female and cubs.

At midday the sick cub opened its eyes and rolled its head. Mother and cub crowded over it. With one final shudder, the cub died, the mist of its final breath lost on the wind.

The next morning a ground blizzard ripped across the ice, battering our camp. The three bears were still in the same place, the dead cub covered with snow. The survivor rolled and rubbed on the frozen carcass, its mother impassive.

During the night a number of polar bears had congregated nearby and along the shore ice. We watched the three bears throughout the morning, but little transpired. The family hung close together as if routine. My friends and I knew that it was only a matter of time before a large male homed in on the scent of the dead cub and attempted to claim it.

In late afternoon the mother bear appeared to abandon her dead cub. As she walked away she paused to look back, as if expecting the dead cub to follow. On a distant ridge she stopped for one last look. For the first time since giving birth eight months earlier, the mother bear left a cub behind.

At dark, just as we were leaving to go back to camp, the mother and cub sprinted back over the ridge, heading toward the dead cub. Once there, they pushed and nuzzled the lifeless and stiff form.

Although it may have been my imagination, I thought I saw disappointment settle on the mother as she peered down at her dead cub. In the gloaming, we watched the two bears curl up around it.

Our last day in camp dawned clear and very cold. We had just two hours before we had to break camp for the arduous cross-country trip to the village. We had just enough time for one last look at the bears. From the observation ridge we spotted *four* bears where there should have been only three. A huge male stood over the dead cub, glowering at the

A polar bear and her healthy cub stand guard over her second, dying cub. Their vigil lasted days.

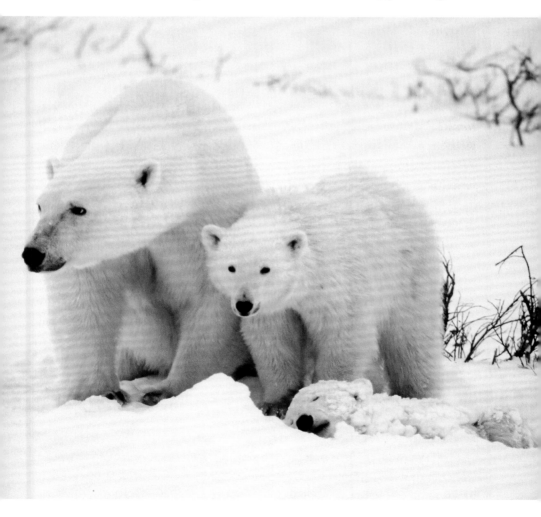

mother a few feet away. She faced him with lowered head and gaping maw, her surviving cub tucked between her legs. Thin but powerful, his keg-sized head scarred from fierce battles, the male dwarfed the female. Twice she charged him but slammed on the brakes when he refused to back away. Her second bluff charge seemed to unnerve her, and she fled into the pack ice, her remaining cub close behind.

The boar looked our way just once, then tore into the carcass. A smear of blood on his shoulder gave witness to what had transpired during the night. The mother had not abandoned her cub without a fight.

We watched in grim silence. In an hour all that remained of the cub were pieces of hide and stains in the snow.

## II

Known to scientists as *Ursus maritimus*—"bear of the sea"—polar bears are circumpolar and most abundant near coastlines and the southern edge of the northern permanent pack ice. They make extensive movements related to the seasonal position of the ice edge. In winter, polar bears off Alaska commonly range as far south as St. Lawrence Island in the Bering Sea and may even reach St. Matthew Island and the Kuskokwim Delta. A polar bear once washed up on Kodiak Island in the Gulf of Alaska. Rather than marine mammals—as they are officially designated—I think of polar bears as *maritime*, creatures of the arctic seas.

Studies of animals marked and recaptured by wildlife researchers indicate that there are twenty distinct populations of polar bears in the polar basin, with relatively little interchange. Off Alaska there are two distinct populations: the Beaufort and Chukchi. The Beaufort Sea population, along the North Slope of Alaska and northwestern Canada, appears to be in steady decline, as much as 50 percent in the past decade alone.

Preferred habitat is a mix of pack ice, open water, and land for denning and supplemental feeding when food is scarce. Polar bears prey on ice seals, primarily ringed seals and bearded seals, also called *oogruk*. Bears locate seals by smell and stalk them at breathing holes and open leads. Scientists say polar bears can find ice- and snow-covered breathing holes from almost three-quarters of a mile away. In spring they also catch young seals by smashing into natal

chambers carved in snow atop the ice. Bears sometimes prey on walrus, nar-whals, and beluga whales, and in rare cases will kill and eat caribou and musk oxen. Carrion, small mammals, bird eggs, and vegetation, including seaweed, complete their seasonal diet.

Polar bears, other than females and young, are solitary most of the year, but groups occasionally form around whale carcasses or other abundant food sources. "Bone yards"—places where subsistence hunters butcher bowhead whales—also attract congregations of bears, most notably at Kaktovik in the northeastern corner of Alaska. As ice conditions alter with climate change, such sites take on increasing importance.

Polar bears and brown bears evolved from a common ancestor and are closely related; mating across species produces fertile offspring. Recently a wild cross was killed on the Arctic Coast. A thick white coat, dense underfur, and heavy layers of fat are adaptations to the cold. Polar bear hair is translu-cent and reflects solar heat down to the base, where it is absorbed by the black skin. Short furred snouts and short ears radiate little heat. Long hair insulates their paws for warmth; small bumps and cavities on the pads provide traction on the ice. A large male may weigh fourteen hundred pounds, but most weigh between six and twelve hundred pounds; mature females are about half that. Polar bears are the world's largest land carnivores.

Although polar bears of both sexes and various ages may occupy dens during periods of cold or stormy weather, only pregnant females remain in dens throughout the winter. During the breeding season beginning in late March, males locate females by following their tracks and scent. In late October and November, pregnant females seek out denning areas both on land and on sea ice. Land-denning females excavate a depression in the snow, often on south-facing slopes, where prevailing winds pile up deep snowdrifts. Inside, the temperature can be 60 degrees warmer than outside. Cubs—normally two—are born hairless and defenseless, and weigh between one and two pounds. In much of the Arctic, family groups emerge from the den in late March or early April when cubs weigh about fifteen pounds, but emergence varies by latitude. Premature den abandonment guarantees cub death. Soon after emerging from the den, the female leads her cubs onto the ice to hunt seals. Cubs stay with their mother until they are about two and a half years old. A female first breeds at age five, and over her thirty-year lifespan may produce six or seven litters

with high mortality. This low reproductive rate explains why depleted populations are slow to recover.

Because of changing ice patterns, the eastern portion of the Arctic National Wildlife Refuge in northeast Alaska has become the most significant terrestrial polar bear denning area in Alaska. From 1985 to 1994, 62 percent of the female polar bears in a Beaufort Sea study denned on sea ice. By 2004, just 37 percent denned on the ice, the remainder on land. It appears likely that climate change has degraded the quality and availability of offshore denning habitat. "In my view, this makes the protection of the arctic refuge critical," my friend Jack Lentfer, a polar bear researcher, told me.

Since 1965, an international group of polar bear scientists has been coordinating research and management throughout the Arctic. Human activities, especially oil exploration, seismic testing, and drilling activities in denning areas, pose an immediate threat. An oil spill in arctic waters would be catastrophic for polar bears and other arctic species. Already, polar bears carry loads of pollutants like PCBs and DDT, with two to four hundred foreign compounds found in tested bears. These residues, from seal meat, accumulate in the body fat of these animals at the top of the food chain.

Global climate change poses the greatest threat to the survival of polar bears as a species. Over the past two decades arctic seas have thawed earlier and frozen later. Polar bears stalk their prey from ice, their essential hunting platform—and the ice is disappearing. Shrinking sea ice may result in the loss of roughly two-thirds of the world's twenty to twenty-five thousand polar bears in the next fifty years, scientists say. Changes in ice distribution also impact ice seals. The decreased availability of the critical prey species may doom polar bears. Already, the time available to hunt on ice has shortened by two weeks.

In the past, polar bears stayed with the ice pack as it advanced and receded in summer. That pattern has been broken. The summer ice pack might now be two hundred miles offshore. As arctic sea ice dwindles, polar bears are spending more time on land. Bears in the southern Beaufort Sea population are now three times as likely to come ashore in summer and fall as they were in the mid-1980s. Changing ice conditions in the Beaufort Sea also force polar bears in summer and fall to make a choice—swim north to the receding edge of the pack ice, or swim south to land, where they face months-long fasts, which might lead to starvation.

When polar bears swim, they use their large front paws as powerful oars, while their rear paws trail behind as rudders. They can remain underwater for over a minute. Polar bears are incredibly at home in the water. Using GPS tracking devices, scientists recently discovered that when sea ice is at its minimum, polar bears, in a desperate search for prey, were swimming farther and for longer periods of time than ever before. A collared female polar bear swam four hundred miles in nine days, never once hauling out on land or ice to rest. In the process she lost her only cub, unable to keep up, and 20 percent of her body weight. This research shed new light on how polar bears are struggling to cope with the rapidly changing arctic environment.

One bear radio-collared in Prudhoe Bay wandered nearly three thousand miles. In the two and a half months after tagging, the bear moved sixteen hundred miles and wintered off the northern tip of Greenland, an almost straight line across the polar ice. It then roamed to Ellesmere Island in eastern Canada.

In 2006, the U.S. Fish and Wildlife Service recommended listing polar bears as "threatened" under the Endangered Species Act. Two years later, the bears were the first vertebrate species to be listed by the Act as threatened by extinction primarily because of climate change.

Not long ago, I traveled north by boat into the ice-free Arctic Ocean and ultimately reached 82°N latitude before being turned back by drifting ice. Seldom do boats get that far north, and what I saw was revealing. I did not see the first bearded seal until north of 80°N. Until reaching the ice, the only polar bears I saw were six emaciated individuals roaming the tundra coast, all stained brown from feeding on bird nests and carcasses. The first bear I saw on floating ice was a large male feeding on a bearded seal. In all, I saw just ten bears, eight of which were bags of bones, a sobering sight.

Inupiat people tell tales of *Qupqugiaq*, the mystical and fierce ten-legged polar bear. Those emaciated bears were but a hint of a tragic fate, perhaps a harbinger of a time when ice bears live only in legend and myth.

### III

The search for food drives polar bears into some of the fiercest conditions on earth. In total darkness, in constant wind and stabbing cold, they stalk their primary prey, arctic seals. Fierce storms and tortured ice are obstacles that ice

bears must cope with to survive. I once witnessed a polar bear wander willingly into the most horrendous polar sea conditions imaginable.

Overnight, a gale-force wind rose in the north and slammed two miles of sea ice into shore. On a boulder-strewn promontory I took shelter from the bitter wind to glass a long spit of land thrust into the sea by a surging arctic river. Giant waves tossed huge ice slabs onto the spit as if mere ice cubes. Breakers flung sludge and ice blocks half the size of a car against the rocky cliffs. Crosscurrents flowing around the spit at the river mouth opened leads seething with spindrift and jumbled ice. An ominous, gray fog boiled above the open water beyond the churning ice. The grinding ice was loud even above the roar of wind and crashing waves.

Suddenly off to the east I spotted a polar bear swimming amid the pounding ice. I'd expected to see bears gathered on the spit but not out there. Only desperate hunger could drive a bear to press on in such conditions.

Several times the bear clawed his way atop a cake of ice, only to have it roll and toss him back into the tumult. A half mile from shore, faced with open water, the bear altered course and turned toward the base of the spit. Rather than a steady correction, his course veered west, south, then north, then west again. Always he tested the ice leading north.

At times I'd lose sight of him behind a wave of bucking ice. Near the spit, the wind-driven pack ice grew riotous, but he fought on, half swimming, half crawling. Several times he climbed out on huge, frozen, swaying blocks to study the route ahead. When he came to the maelstrom of river current and tide sluicing around the end of the point, he abandoned the floes and jumped into the icy waves battering the rocky shoreline. I feared that he'd be pulverized by the bludgeoning ice.

For agonizing moments the bear was lost to view. Just when I thought he had been killed, his head appeared at the top of an ice-jammed wave. I watched, breathless, as powerful surf hurled him against the ice-crusted boulders on the point. For desperate moments he fought to gain purchase, but a receding wave washed him away. Amid blocks of ice he was again hurled on the rocks, but this time he stuck, clinging with all four paws. A following wave slammed chunks of jagged ice against the rocks, narrowly missing him. In slow motion he climbed the boulders to the top of the spit. There, he paused long enough to

shake off the water, then hurried on. On the far side of the spit he dove again into the tumultuous sea. Before long he crested an icy roller and swam north into the roiling fog. I shivered in the bitter wind for an hour more but never saw him again.

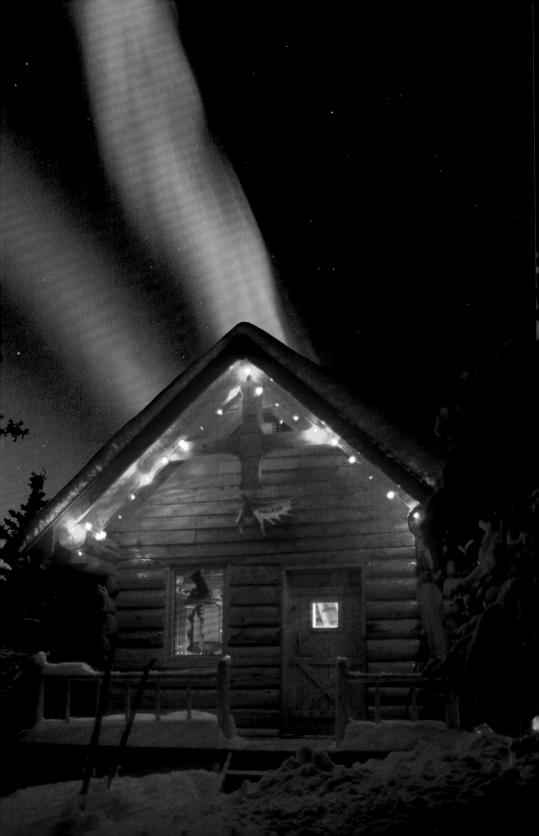

# The Goddess
# of the Dawn

## I

**MY CURRENT CABIN, BUILT IN** 1985, sits on a ridge in the heart of the Alaska Range mountains, just a raven's mile outside the Denali National Park boundary. At its nearest point, the Nenana River runs through a gorge beyond a nearby ridge, yet on calm late spring or fall nights, I can fall asleep to the rumbling water as loud as if perched on the riverbank. I can mark the passing seasons by sound, or the lack of it, of the comings and goings of robins, owls, coyotes, and people.

Multitudes tour the park in midsummer, at times a chaotic scene. But it is a summer spectacle only; in other seasons the area is left to a few year-round residents. Autumn, with its blizzard of leaves, morning frosts, and the cries of migrating swans and cranes, is somewhat melancholy, with the long winter close at hand.

Winter is my favorite season. Despite the probability of temperatures as low as minus 40 degrees, frigid winds, snowstorms, and daylight less than four hours long, I find tranquility. Gone are the crowds, the frenetic pace, the endless summer chores—and gone, too, are the wildfire smoke and droning mosquitoes. Perhaps it is the silence, a silence that you can almost feel, that inspires inner peace. Each sound, no matter how commonplace—the squeak of snow under my boots or a gray jay squawking in the timber—seems almost loud in the winter quiet. Some mornings I awaken in stillness to look out the window and see a moose bedded in the nearby willows or find a fox chomping sunflower seeds under the

Built in 1985, my cabin in the Alaska Range near Denali Park commands views of the peaks and brilliant winter skies.

birdfeeder. Once, simply by peering out the window, I frightened a wolf poised just outside.

Winter is not all gray and white either. There is color: pastel clouds of claret, gold, even jade; summits awash in crimson alpenglow; an orange moon tangled in the treetops; and scarlet grosbeaks in the timber. And the stars! Constellations so bright, they seem alive: Orion circling the horizon with his sparkling sword. And overhead, Ursa Major, the Big Dipper pointing to Polaris, the pole star. Far from urban light pollution, the sky shimmers with shards of bright points and light.

What transfix me, more than all else, are the northern lights, the aurora borealis, the phenomenon that at times overpowers the imagination. In the 1600s, astronomer Galileo Galilei bestowed the name aurora borealis, from two classic deities: Aurora, the Roman goddess of the morning, and Boreas, the Greek god of the north wind.

Some pioneer gold prospectors thought the aurora was the glow off a polar mineral jackpot. A few early Arctic explorers believed it might be moonlight or starlight reflecting off the ice. Another story held that the aurora was the light of some fantastic polar city. In bygone years, Alaska Natives saw the lights as dancing souls. In Finnish, the word for northern lights translates as "fire fox" from a belief that the lights were caused by the fire fox racing across the snow, the sparks from his tail creating the aurora.

The aurora is a light show caused by charged particles from the sun colliding with oxygen and nitrogen in Earth's atmosphere. These halos of light above the magnetic poles are collectively called the aurora polaris. Auroras that occur in the northern hemisphere are called aurora borealis, and those in the southern hemisphere, aurora australis or southern lights. They wax and wane on an eleven-year cycle of sunspot activity.

Green is the usual color of the aurora, and red is rarer. Green auroras form about sixty miles above Earth's surface; red auroras develop up to two hundred miles above Earth. Totally red auroras develop when fast-moving particles strike oxygen. Energized nitrogen produces purple and blue auroras. Scientists have recorded relatively few all-red auroras over the past fifty years, perhaps the biggest and most widely seen that of February 11, 1958, when millions of people across North America saw the sky turn crimson. The skies over Alaska that night glowed red all night long.

## II

Wataru Aihara wants to take a picture of the aurora borealis. One winter he spent four months living out of a small backpacker's tent on the banks of the Kobuk River near the village of Kiana, fifty miles north of the Arctic Circle. Temperatures often dipped below zero—*way* below zero—but each clear night he wandered the frozen tundra trying to get his photo.

In the far north the aurora is visible almost every clear winter night, and my friend *saw* the lights almost nightly. The photos he showed me were excellent, especially some taken with a fisheye lens that captured the entire arc, horizon to horizon. But none were what he wanted: a picture of the northern lights with a moose in the foreground.

His idea seemed preposterous, a matter more of luck than anything else. First, the aurora had to be low in the sky and stationary, or at best slow moving, with the mountains far in the distance so as not to block the light show. Then, most importantly—improbably—a moose would have to cooperate by posing motionless out in the open away from brush or timber, for up to twenty seconds. (Moose prefer willow thickets and forest to open tundra.) Wataru also wanted a full moon to illuminate the mountains and add detail to the moose. No dark blob that could be *explained* as a moose. He wanted detail. Photographs that need explanation don't work, he told me.

On his way home to Tokyo after his Kiana trip, Wataru visited me and showed me the digital images he'd taken. He'd used his digital camera infrequently, mostly shooting film. For four months' work, he had accumulated relatively few photographs: village kids, landscapes, the northern lights, and moose. Mostly moose. Moose in the timber, moose in the brush, moose eating, moose pooping, moose running, moose snoozing, moose alone, moose in groups, moose, moose, moose. Then, at last, he showed me his stunner: a night shot of a moose under the northern lights.

"This is amazing," I told him. "I thought you said you didn't get it."

"No, Tom, not what I want. I needed the moon. The moose not clear enough."

The moose was instantly identifiable, I objected—a very distinct silhouette against the snow. No concealing brush, just a cow moose stock-still on open snow, the aurora overhead. What's more, it wasn't a simple arc passing overhead;

rather the aurora dipped straight down above the moose and appeared to touch it. I would have been ecstatic with the shot.

"Not what I want. I need the moon." He concluded, "I must come back. The snow and moose must be clear as day."

Playing the devil's advocate, I told Wataru that he could just create the picture digitally by using Photoshop to combine images, as some other photographers do. I told him about a photo creation I'd seen of a humpback whale breaching under the northern lights. (I asked the photographer, an acquaintance, if he had any qualms about producing the image in that way. His response: "Well, it happens, doesn't it? That's the only way I could get it.") Wataru considered my comment, then replied, "Those are not photographs. They are something else. I want a photograph."

The lengths to which Wataru went to get his picture would dissuade the vast majority of photographers, including me. The return would be too dicey, too little benefit for the time invested. Now, in the age of digital photography, instead of enduring bone-chilling cold, isolation, poor food, and hard work, many photographers would just stay home and conjure an image on the computer.

Wataru's passionate pursuit of a singular image is a trait shared by a handful of his countrymen. Michio Hoshino worked for years to document the natural history of caribou but died before he finished his book. Norio Matsumoto has spent weeks at a time camped high on the slopes of Denali for the chance to get a magical photograph of the aurora caressing the summit. There are others, too, around the globe.

### III

My own experiences chasing the aurora pale in contrast to Wataru's efforts. The best aurora photographers are night owls. Night after night, week after week, all winter long, they chase the cosmic wonder. They are extraordinarily dedicated to the chase, undeterred by cold weather and

isolation. I am definitely a diurnal creature. I start yawning at nine o'clock, although insomnia in my later years has been a boon to my aurora photography. On the positive side, extreme cold doesn't bother me; I own plenty of heavy clothes and lined boots suitable for subzero weather. Standing around in the darkness isn't boring to me either. Satellites pass through the heavens, and meteors zip by. There are always stars to peer at and constellations to identify. (I often wonder what hallucinatory substances the ancient Greeks imbibed to inspire the shapes they saw in the sky.) Sometimes wolves and owls call, or the timber whispers late night fantasies. Chasing the aurora, for me, is merely a matter of staying awake at night, ignoring the cold.

Near my home, a dazzling auroral display looms over tiny Tonglen Lake.

During the winter of 2015, I photographed the aurora almost every clear night, including the incredible St. Patrick's Day solar storm, the sky awash in a rainbow of colors all night long. (Weeks of cloudy weather provided

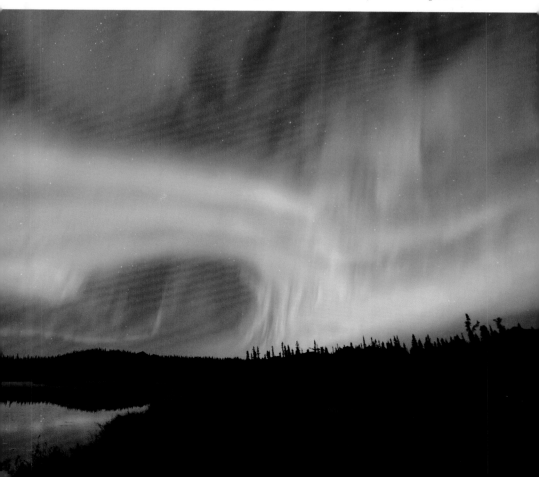

respite from nocturnal wanderings, yet I shot images on forty-five clear nights.) As amazing as that solar storm was, one superlative moment two decades earlier stands out in my memory, December 31, 1993.

New Year's Eve that year was the first clear, warm day in two weeks, the temperature at noon minus 4 degrees, almost balmy for midwinter in Interior Alaska. Three weeks before, it had been 40 below and colder. Availing myself of the warmth, that morning I photographed boreal chickadees at the bird feeder, marveling at those tiny birds' ability to withstand the cold.

Wildlife, even resident birds, had been scarce that winter. The annual Christmas Bird Count held on December 26 in my area tallied eleven different species. (In contrast, the same area in summer hosts up to 160 species.) Winter in the heart of Interior Alaska is not difficult solely because of the cold and darkness but rather in part because of the lack of life and sound. Near my cabin that winter I'd found tracks of ermine, snowshoe hares, red squirrels, red-backed voles, moose, and a red fox but had seen just one moose.

As the day faded, alpenglow turned the northern peaks amber, pink, then crimson; the first bright star winked from the eastern sky. By six, the night had cast a sea of crushed diamonds above the tops of the hoarfrosted trees. I saw the Great Bear and Cassiopeia. To the west, Orion guarded the approaches to Denali.

At eight o'clock I was reading by lamplight but wanting a break, so I went downstairs for tea. Reaching up to fire the propane light, I paused. The room was bright, yet moonrise was still two hours away. The snow outside was glowing green, lit by giant auroral arcs sweeping above the mountains.

I dressed hurriedly, layers upon layers, and stuffed my pack with camera, film, and tripod. On snowshoes I slogged around the back of the hill to a vantage point overlooking the confluence of the Yanert and Nenana Rivers. The display was so intense that no headlamp was needed to find my way.

From the lookout, the aurora was stunning. Four great bands pulsed across the sky, whipsawing colors of green, red, and purple. Here, a segment writhed and faded; there, another sparked and twisted. A red spot near Polaris grew bigger and bigger, rushing earthward at astonishing speed. Right overhead it exploded in a dazzle of light like some giant Fourth of July rocket.

The aurora whirled across the valley and peaks before finally fading away, the last color muted by the rising moon. In moonlight the landscape sparkled as bright as the stars, and I wandered home dazed.

The sound of a jet coming from the south, just beginning its descent toward Fairbanks, broke the magical spell. I followed the plane's blinking lights as it passed overhead, its vapor trail glowing with moonlight. Until then there had been no sound, just total, complete silence. Until the plane, nothing—not the drone of a distant car, truck, or train. Nearly midnight on New Year's Eve, and peace reigned in my part of the world.

On the cabin porch I dismantled my gear, wrapped my camera and film in a plastic bag to hinder condensation, and stuffed it all back in my pack. Just as I turned to the door, I stopped. *What was that? There!* Louder. *Wolves singing in the darkness.* No, not wolves. *Coyotes.* Several, raising their night anthem. They yodeled and yammered a lengthy tune, one worthy of an encore, even for this audience of one. When they stopped, the night was again glowing, cold, and silent, and the new year just minutes old.

## IV

I greeted the waning days of 2000 with anticipation, even excitement. This would be the winter of the flame-red sky of aurora, or so I hoped. To give myself the maximum opportunity to capture a crimson display, I planned to photograph every clear night that the temperature was warmer than minus 35 degrees, my cutoff point.

Storms dominated the early winter, clear nights few and far between. I missed one spectacular display because of a trip south. I passed up a chance at another display because it was minus 57 degrees. The cold kept me inside, watching from the window, the temperature a vivid reminder of the perils of subarctic winter. At 50 below it is almost impossible to wear enough layers to stay warm if inactive. Venturing outside at minus 40 degrees, or colder, in the wind, is an act of will—some say insanity.

That winter, I missed another red aurora while traveling *to find* clear skies. On the few cloudless nights at home either the aurora was the typical green, sometimes edged with pink, or the show fizzled out. When spring came I had few images out of the ordinary, just pictures of stationary arcs hanging above the mountains.

For three long winters I chased my dream of a red aurora. It seemed everybody in Alaska had seen or photographed one. When opportunities did present

themselves, something beyond my control—bad weather, illness, travel—got in the way. Time was running out; scientists announced the decline of the solar cycle. While multicolored auroras can appear at any time, the peak of the cycle offers the best opportunity for red ones. At the low end of the cycle I could wait endlessly and get nothing extraordinary.

By autumn 2003, I had about given up hope. The solar cycle was waning and entering a period of quiescence. September, which is usually a good month for aurora viewing, was relatively quiet. October was mostly cloudy. Early the evening of November 3, I got up from the table and went to the darkened kitchen for a glass of water. A pale-red light glowed through the north window. I gasped. The sky from the northeast to northwest was crimson, an unmoving blush of intense color. Flashes of lime and gold pulsed and disappeared.

In a panic I bolted downstairs and threw together my camera gear. I dressed haphazardly and raced to my truck. With a spray of gravel I sped for the highway pullout two miles to the north that offers an unhindered view of the surrounding peaks.

In northern Yukon Territory in 2014, I photographed an Inukshuk beneath a multihued aurora.

I slammed to a stop in the pullout and jumped out. The western sky pulsed with color; the sky above Mount Fellows, the dominant peak to the north, was blood red. The eastern quadrant had faded. It seemed forever before I finally got set up and positioned for the first shot. For the next fifteen minutes I watched and photographed the magic of the aurora's grandest spectacle. Here green, there gold, purple, and pink, a grand wash of rainbow color at times blotted out by an intense crimson blush. Overhead a corona of light rained colors straight down as if a celestial shower.

Cars are few and far between at night on the Parks Highway in midwinter. When I heard a vehicle approaching from the south and saw its lights turn off as it neared the pullout, I knew who it was—my neighbors Craig and Robin, both avid photographers, who then lived less than a mile from me. The doors popped open, and with a terrific commotion they leaped into action—but the red aurora had already begun to fade, and in brief minutes it disappeared altogether. It was eight thirty, and I'd shot for less than twenty minutes.

While waiting for renewed action, we stood chatting in the dark. They too had seen the aurora from home and had hustled to get ready. As the night wore on and the aurora stayed quiet, it became obvious my friends had missed the most intense display by brief minutes.

<div align="center">V</div>

On the last night of January 2003, I could not fall asleep. Maybe it was the weather. Ours had been a strange winter with moderate temperatures and almost no snow. It didn't seem like a real winter, and everyone acted a little off. No skiing, no mushing, none of the usual snow sports. I finally fell asleep around midnight but awoke a few minutes later, still unsettled.

At three in the morning I finally got up for a drink and, as usual, peered out the north window to check for the northern lights. Because of the persistent cloud cover, I'd missed, according to news accounts, several vivid light shows. Solar activity had begun to increase recently with nightly auroras of varying intensity. On successive occasions I captured evanescent green displays, but none that were polychromatic.

From the window I saw a luminous green band tinged with red swirling above Mount Fellows. A quick check of the thermometer: 40°F *above* zero,

in *February, at night*—and I was decided. A rare warm, winter night was not to be missed. Short minutes later I stormed out the door with my tripod and backpack.

Just a few hundred feet up the hill from my house, I started to overheat. The night was both warm and calm, and I'd overdressed. Aurora photography is a sedentary activity, and I'd prepared for the usual winter conditions. I shed layers as I walked.

I hiked to the top of the hill behind my cabin on almost bare ground, seeking an unrestricted 360-degree view of the Yanert and Nenana Rivers, Pyramid Mountain, and the distant peaks of the Alaska Range. By the time I reached the top, I was carrying an armload of clothes and was soaked with sweat, but the view was worth it. Two great auroral bands curved overhead and vaulted Mount Deborah in the east, Mount Healy in the west. The flow of light mirrored the winding, frozen river.

I got just a few shots before the aurora faded away to a diffuse patina. Even without the aurora, this night was preternatural. Stars like sapphire chips filled the sky and shepherded a sliver of golden moon. All was silent except for the murmur of the still-unfrozen lower Yanert and the distant hoot of an owl.

Even though I know the scientific explanation for the northern lights, they still evoke their own mystery and magic. I've never heard the crackling sounds that the pioneers described, but I do think the aurora speaks to us.

Over the next hour the aurora remained quiet. I bundled up in all my clothing and stretched out on the bare ground to stare at the luminous, ethereal sky. I picked out the Pleiades, Antares, Cassiopeia, Ursa Major, and the warrior Orion. Never before had I lain on the ground to watch the midwinter sky and been *warm*. I didn't mind in the least that the goddess of the dawn had turned coy, hiding her diaphanous gown. The sky pulsed with crystals of light, almost close enough to touch.

Just as the eastern sky imperceptibly lightened, a satellite coursed by on a north-south trajectory passing through the Big Dipper, its track visible all the way to the southern horizon.

Through all eternity, we humans have marveled at the night sky, its spectacle and dominion. We've longed to visit the heavens and unravel the mystery—perhaps find the meaning of our place in the universe. Only in the recent whisper of time have we achieved the impossible, brief forays into

space. Somewhere overhead this very moment, astronauts hurtled through the cosmos; how I envied them.

As the eastern sky brightened, the stars winked out one by one. Over the last few hours Orion had circled Polaris until vanishing in the west, his sentry duty done for the night. On the stroll home I savored the claret dawn and the silent forest.

As I opened the door of the darkened cabin, warm air rushed out its welcome. Inside, I filled the teakettle, set it on the stove, and flipped on the radio. It was six o'clock, time for NPR's *Morning Edition*. I added wood to the stove and silenced the kettle.

Something was wrong; a voice I didn't recognize was describing some tragedy. *Not again*, I thought—not another 9/11. Then I heard the words, "national disaster . . . *Columbia* . . . space shuttle . . . crash . . ."

Transfixed, I hovered over the radio. NASA's Mission Control announced that they had lost contact with the orbiter. The shuttle *Columbia*, en route to a landing in Florida, had broken up over Texas and Louisiana as it reentered Earth's atmosphere. Eyewitnesses in the American southwest and Mexico reported seeing streaks of fiery debris—fragments plunging to earth. All seven astronauts on board were presumed lost.

The *Columbia* disaster hit me hard, almost as if I'd been an eyewitness. In the hour of the disaster, I'd been watching a satellite streak through the heavens, had thought of the shuttle and wondered what the aurora looked like from space. That night, the spirits of the astronauts joined those legions already dancing in the light.

On the summer solstice, the midnight sun arcs across the Beaufort Sea marking another day without sunset.

# *Refuge*

**ON THE EDGE OF THE ARCTIC OCEAN** on the longest day of the year, I sat by a campfire with a group of Swiss travelers watching the summer sun graze the northwestern horizon. In an icy wind our solstice celebration began at ten o'clock at night. With tea, coffee, and schnapps, we drank toasts to our float trip and to summer. We traced the sun's trajectory to its low point (about three in the morning), when it again began to arc higher in the sky. The endless days of the midnight sun had peaked. Henceforth the days would grow shorter, the loss each day measured in seconds at first, then minutes in the headlong rush toward the perpetual darkness of arctic winter. On this day we almost felt the earth shift under our feet, the northern hemisphere minutely tilting back away from the sun.

Our float trip had begun in the Brooks Range at the headwaters of the Hulahula River, a north-flowing stream that bisects the coastal plain of the Arctic National Wildlife Refuge. Several flights spread over a day shuttled in our group—and hundreds of pounds of gear and rafts—from Barter Island to a gravel airstrip in the mountains. Once the last flight emptied, took off again, and faded into the distance, we were on our own.

For the chance to take pictures and explore more of the refuge, I had agreed to help my friend Chlaus Lötscher guide this group of Swiss clients. The two of us had arrived in Kaktovik, an Inupiat village of 250, the day before the rest of the group to prepare the gear and food for the trip. The Inupiat village was in fevered preparation for the visit of former president Jimmy Carter. "Lots of FBI coming too," one boy told me. "Maybe let me get his autograph?"

Jimmy and Rosalynn Carter. Two more names visiting the Arctic to oppose oil development. Carter was filming a Discovery Channel special on the tenth anniversary of the Alaska National Interest Lands Conservation Act of 1980 (ANILCA). Carter's five-day visit would take him into the refuge and then to the Prudhoe Bay oil fields. In Fairbanks prior to his flight north, Carter said

he opposed development in the refuge. In 1980, Alaskans had burned the then president in effigy for his support of ANILCA.

Just before noon the next day, people began to gather by the village airstrip. Small ATVs and pickups loaded with villagers parked by the hangar. Word had gotten out that Carter and his wife Rosalynn were on the scheduled flight. Michio Hoshino joined me, said he wanted to interview "the president." I told him I thought Carter would arrive by a private flight, not this one. We waited and watched. A murmur filled the cool air. "He gonna have secret agents with machine guns?" a boy asked another. "I want to see his face when he sees his room in the Waldo Arms," said an adult, referring to Kaktovik's worn modular hotel. Other than the school, the $150-a-night inn had the only flush toilets in town. A woman told her companion that Mrs. Carter would make everybody go to church before supper. The Carters, she said, were "Badists" and had made everybody in Washington go to church when they were "President and Mrs. President."

The Frontier Flying Service plane touched down just after one o'clock. The first passenger to deplane was one of Chlaus's clients. "Is that him?" an Inupiat boy asked. "No, too fat," said his father. To the assembly's vast disappointment, instead of Jimmy, or Rosalynn, or Secret Service agents, six Swiss tourists and a local couple climbed from the plane. Chlaus and I stepped forward to welcome the tourist group.

After introductions we hurriedly shuttled gear to our bush plane parked nearby, a Cessna 206. Within a half hour, two of the clients, Chlaus, and their gear were on their way. I was assigned the last flight to ensure nothing got left behind. By the time I landed at the mountain airstrip that evening, the tents were already up, the rafts inflated, and dinner over. After pitching my own tent and eating a warmed meal, I stood with the others gaping at the peaks awash in golden sunshine, the valley in deep shadow. In Kaktovik the temperature had been a seasonable but windy 45 degrees. At the headwaters it was calm and 70 degrees. We reveled in the lack of mosquitoes and hoped it was a trend, our head nets and repellent packed and ready for use.

Ours was an eclectic gathering of strangers: an engineer, a forester, a geologist, an ornithologist, a teacher and his wife, the guide, and me. The tents scattered widely over the river bar were emblematic of our individuality. A group

dynamic would take time to emerge, and I wondered how it would develop. Language would not be a factor. Everyone but the teacher and his wife spoke English and, except for me, German.

Alone, I strolled down to the river and found it clear, fast, and—in midchannel—more than waist deep. Over the cobbles its voice was soft and lyrical, but around the boulders, robust and raucous. Just as the wind wandering through a forest spins a tale, water running over the rocks also whispers a story—an ancient one of winter and summer, birth and death, and life so sweet and short, it must be lived at full tilt. Judging by the high-water mark, the river had its moods, some desperate and treacherous, others mild and languid.

I would be in charge of one of the rafts and the occupants' safety. Just now the river looked benign, but I knew the effect of summer storms. In much of the world a river this size and length would be segmented by roads, bridges, and private land, or perhaps be dammed, or polluted, but this one is whole and pristine. The river traverses wilderness in a sense beyond the common use of the word. In winter, this frozen watershed is one of the loneliest places on earth; in summer, it's remote and difficult to access, assistance uncertain and difficult. The nearest hospital is hundreds of miles away, communication and transportation weather-dependent.

About a mile upstream the river forks and leads into serrated, snow-dotted summits. These are the "magazine mountains," the postcard-beautiful northern slopes of the Brooks Range, the ones often pictured in articles about the proposed oil development. Such vistas, though stunning, are misleading in the media's portrayal. The mountains, the headwaters of the refuge's north-flowing rivers, are designated wilderness and closed to such development. Our trip would take us to the less scenic—but critical—coastal plain where development would occur if approved by the U.S. Congress. Already one person on the trip had said that he had come here to see the caribou herds before development rendered them a thing of the past.

Until recently only hunters, geologists, and biologists came here. The airstrip was hewn out years ago by Dall sheep hunters, and on a rise a short distance from the river, a headstone memorialized two of the youngest hunters, Forrest (ten) and Brett (thirteen) Boutang, killed in a wilderness accident in 1985. It is a sad legacy but a solemn testament to the value of place in the

human heart. The oil controversy had focused a spotlight on this remote corner of Alaska, and the river now saw a growing number of backpackers, campers, and floaters.

Other than the length of the airstrip, which had been extended, and a few rusty fifty-five-gallon fuel drums ("arctic poppies"), there was minimal human impact. Walking around I noted small things: trails, campfire rings, broken willows, bits of trash, boot tracks on the sandbars. Just in the past month two commercial raft trips and a private party of four had preceded us downriver. Some of them had been harder on the land than others, but all had left their mark. Another guided trip would follow ours. Conservation organizations sponsored two of the guided trips. Celebrities had made pilgrimages here, at least one honestly terming it the "world's largest mosquito refuge." If not for the high cost of access, the impact would be greater. I returned to camp at nearly two in the morning, the sun still bright on the peaks.

Just before noon the next day we launched our rafts, sturdy fourteen-foot Avon Inflatables, to begin our first day on the river. The first day of any river trip always seems to begin late. (But what difference does it really make when it's light 24/7?) We were a disparate group, and everyone needed to be told what to do. Our actions were not unlike those of the Three Stooges. What one person would pick up and load in a raft, another would unload. Loads were shifted from one raft to another, then back again. Through it all, Chlaus, as always, remained calm and self-possessed. This was nothing new to him. Once the gear was stowed and lashed down, we were ready to go.

The teacher and his wife stood next to my raft waiting impatiently. When I'd gotten up at eight, their tent had already been struck and packed. They were the only ones up, and they stood in the campsite like two people who had missed a bus. For them, *in the morning* did not mean "noon." I reminded myself that in Switzerland everything runs precisely on time. One minute late and you've missed your ride. In bush Alaska, *on time* usually means "in the same day." They, like all of us, would adapt and perhaps learn to relax.

By afternoon, after several hours of paddling, the palpable apprehension of the inexperienced participants began to ease. The rafts took the rapids well, providing exhilarating and safe transport—*safe* here, like the concept of time, being relative. Chlaus had briefed us that this was not a theme park or a

contrived diversion. Any foolishness or inattention, he said, could have serious consequences.

In late afternoon, with the temperature in the high 70s, cumulus clouds formed over the mountains. Thunder boomed through the valley, and lightning daggered the ridgetops. A hard wind drove frigid rain, and we pulled ashore in a sudden deluge. Chlaus and I struggled against the wind to string a tarp for temporary shelter. Some of the group hurried to set up their tents with slapstick results. Just when all the tents were up, the rain stopped and the sun broke through, warm and welcome.

Earlier that morning a handful of mosquitoes had buzzed us, but by evening they swarmed us. Our first day on the river coincided with the hatch. Chlaus handed out repellent, again with his serene, inscrutable smile. Each person dealt with the bugs differently. The geologist said he was "organic" and shunned bug dope, flailing his arms constantly to ward away the hordes. (Later his ankles, wrists, and forehead would be a welter of bites, and after two days of this he resorted to repellent.) The forester applied repellent and sat quietly under his head net, a deceptive serenity. "I don't enjoy it; it ruins the trip," he told me later. "For me there are only the mosquitoes." With or without a head net, the engineer remained calm and unruffled. The ornithologist used bug dope liberally and, despite the heat, wore both a heavy shirt and a hat to foil the attack. Over the course of the trip he seemed to enjoy the country and wildlife more than the others. As a genuine Alaskan, I rejected using a head net but applied bug dope liberally and withered the bugs with profanity, my vast vocabulary able to singe the hide of a moose. Each of us carried a squadron on our shoulders and back, one swat killing a dozen or more. We longed for a stout wind to scatter the bugs, but we unknowingly were just beginning five days of calm.

Later, after everyone turned in, I wandered upriver with my camera, lured by the amber light. From a high bluff, I sat surrounded by admiring insects, studying the course we had traveled. The river, located above 69°N latitude, wends beneath nine-thousand-foot peaks, home to Dall sheep and golden eagles, and through low hills that eventually flatten onto the arctic plain. That afternoon, on the ridge above camp, the geologist had found a layer of fossilized coral, evidence of the seabed origin of these mountains some 150 million

years old. From where I sat I spotted a sheep following a trail etched across the steep cliff above the fossil bed. *Mountain sheep on a coral reef!* I glassed the slopes well into the wee hours, hoping to spot one of the wolves that had left tracks in the sand near camp. In the distance I spied a grizzly bear grubbing for roots on the riverbank and jaegers winging in the soft light. Redpolls sang from the willows, and ptarmigan muttered on the slopes.

For photographers, the concepts of "morning light" and "evening light" lose meaning in the Arctic. The arctic light has a quality all its own, the low directional slant persisting for six hours or more. As the sun drifted toward the horizon, the light turned golden and more delicate. Everything became a photographic opportunity: lichen-covered rocks, louseworts erupting from the soil, the coruscating water, the interplay of light and shadow. With only a limited amount of film, I had to ration my shots, but these moments, alone in the alpenglow, were magic.

Our second day on the river began much like the first but with less comedy and minimal impatience. We pushed off an hour earlier, glad to be on the river and moving, leaving the mosquitoes behind. The turbidity from yesterday's rain made reading the river difficult, boulders and snags hidden beneath the surface. Where the river braided out, choosing the right channel was partly luck. Twice we went aground and struggled to refloat.

Again we enjoyed early sun, warmth, and fast water. Thunderstorms warred in the afternoon, and ravenous clouds of blood-guzzling mosquitoes attacked whenever we stopped. With each river mile we learned to work together, and paddling became easier as agendas dissolved. During one rest stop we heard an approaching helicopter. Our clients waved and joked. "It's Jimmy Carter," Chlaus yelled. "Can't be Carter," said the teacher. "He would walk and not pollute the air or bring noise like this to the wilderness." The ornithologist sneered and didn't opt to wave.

(Later we learned that this in fact *was* Jimmy Carter on his way to fish Lakes Peters and Schrader. He also visited the Okpilak drainage. Before clattering about in his helicopter, Carter had held a town meeting in Kaktovik, where he listened to both sides of the development controversy. "Can you protect the beauty of God's work and still take care of the daily needs of people . . . yes," Carter had said. Afterward, Michio got his interview and described President Carter as "nice gentleman.")

That evening we again set up camp in a downpour. Post-storm, in still air, the mosquitoes attacked ferociously, rending the silence with an incessant drone. For peace, I gathered inward, calming myself, trying to blot out the sound. An overdose of repellent prevented bites but didn't lessen the drain from the torturing hum. A few people stayed in their tents rather than face the onslaught.

After a late dinner of freeze-dried lasagna, I again went exploring. I found and photographed a caribou rack partially buried in the river sand and surrounded by wildflowers. On a verdant hillside I spied two maternal bands of Dall sheep, four tiny lambs in the mix. Hours later, I hiked back to camp along sandbars awash in scarlet pea vines. Though sleepy, I wasn't really tired. The short and wondrous arctic summer—bugs or no bugs—needed to be fully savored, the long winter enough time to rest.

Over breakfast the next morning, Chlaus casually recited the perils of the gorge just downstream. Last year, due to high water, he said, the third chute had to be portaged, the rafts and gear ferried up and over a projecting ridge. "We must go now," he said, "to get through the gorge before the river comes up this afternoon." Like all mountain rivers, this one rises and falls with each passing storm.

In midday, welcomed by blankets of insects, we pulled ashore above the gorge and scouted the way ahead. After a long appraisal Chlaus judged the water high but not too high to run. With caution and teamwork, he said, the gorge was navigable, no lining or portaging necessary. He called my attention to the final turn where the current slammed against a rock wall before swinging away at a sharp angle. "That's the critical spot. The current will push you against it," he said. "Enter the turn on the opposite side and have everyone paddle as hard as they can to avoid the rocks."

Back at the raft I checked the lashings and briefed my crew, eager to get under way. We watched the other two rafts launch and disappear into the gorge. Ten minutes later I pushed off. As our raft entered the narrows, the surging current tried to twist the raft sideways, but hard paddling corrected us. Amid the tumult we dodged a boulder, then another. Standing waves sloshed gallons of water into the boat, but there was no chance to bail. I steered us from one side of the river to the other to avoid standing waves. We shot the first chute with little trouble, then the second. Nearing the final turn I shouted

for everyone to paddle hard. The current caught us just before the cliff, and the raft nosed toward the rocks. "Harder! Harder!" I urged my companions. In the full grip of the current, we raced toward the wall and a certain upending. *"Faster! Faster!"* We cleared the cliff with only inches to spare and shot out into a quiet eddy.

We rejoined our companions there, everyone in a vibrant mood. Laughter and backslapping broke the tension. Chlaus's raft had shipped gallons of water, and only fast action kept it upright and racing ahead. The past fifteen minutes demonstrated that teamwork meant the difference between exhilaration and catastrophe. For once, the mosquitoes were forgotten.

That evening we camped on a river bar resplendent with flowers, grizzly tracks, and an entire nation of arctic ground squirrels. After dinner, while I rummaged through the gearbox, the conversation abruptly stopped. *"Shh! Quiet!"* I looked where Chlaus pointed. A few yards downstream, a black wolf stood silent, watching us. Even from a distance its golden eyes judged us. Suddenly, as if satisfied, the wolf trotted into the willows and vanished. For the longest time no one spoke.

Now at the edge of the mountains and about to traverse the coastal plain, Chlaus was peppered with questions: "Where are the caribou? Will we see them soon? Why haven't we seen any? How about photos? Will we get close?" On my flight to the headwaters, I had seen large aggregations near the coast and doubted that the herds had moved inland toward the hotter, buggier highlands. Chlaus said that last year in this very location a large herd had passed right through camp. Tomorrow morning, he said, we would climb a nearby ridge overlooking the plain. Perhaps there would be thousands of caribou, but as the Inupiat say, "No one knows the way of the wind and the caribou."

Our camaraderie was strongest just after the gorge but soon unraveled. My evening cup of coffee, with all the dead bugs in it, looked like thin soup. A tent wouldn't zip closed, and the mosquitoes were relentless, the worst we'd seen. Sealed tents offered the only complete respite and protection from the torment. The tent zipper had been problematic the whole trip but now had failed completely. This small thing, a simple equipment failure, became monumental. Exasperated, the teacher exploded with German curses at the bugs, the zipper, and Chlaus for bringing a faulty tent. The ornithologist stepped in and

somehow resolved the problem for the night but did not appease the teacher's anger, which persisted the remainder of the trip.

Late that night, far from camp and grateful that I was not the guide, I perched on a rise with a fine view of the arctic plain. A light fog drifted across the distant tundra and obscured the coastline. Over the incessant drone of insects, I heard Smith's and Lapland longspurs, plovers, and whimbrels. I saw a pair of parasitic jaegers hunting the flats below. Cotton grass, avens, moss campion, lousewort, and lupine carpeted the greening tundra. From the corner of my eye I glimpsed movement. I turned my head slowly and spotted, just a hundred yards away, a golden-haired grizzly digging at a squirrel hole, sod flying in all directions. When it faced away, I flattened out and crawled the other direction. With many backward glances, I returned to a silent camp, everyone long since asleep.

Sometime that night the wind finally stirred, and for the first time in days the only sound was flapping nylon. Not since the first day had the group truly enjoyed a leisurely morning free of bugs, and we lingered in the cool, morning wind. At midday Chlaus led a hike along a high ridge, from which we hoped to see the first caribou herds. We found two spots where a grizzly had excavated for ground squirrels. Near one of them, on a willow twig, a small piece of golden fur wobbled in the wind. The ridge provided unhindered views of the tundra, but not of caribou. "Tomorrow," Chlaus told us, "tomorrow."

With the whitewater behind us, the next day's float seemed tame. Within hours of our departure from camp we floated out onto the tundra plain. There the river shallowed out and widened, slowing our pace; the turbid water hid gravel bars we hung up on. At each stop I took time to climb the bank and look around—still not a caribou in sight. From atop a jumble of *aufeis* (overflow ice) a snowy owl watched us float by. When the raft ahead of us ran aground, the owl flushed. Late in the day Chlaus hastily beached his raft and ran up the bank, his companions close behind. A few minutes later we joined them just in time to see a single caribou running in the distance. The brief glimpse buoyed everyone's spirits—perhaps the herd was close by.

We stopped for the day at a site pocked with tracks, the tundra littered with hair and droppings, the air redolent with the passage of caribou. Less than fifteen miles from the Arctic Coast, the air here was cool and breezy, the

mosquitoes much diminished, conditions ideal for grazing caribou with young calves. To arrive here, we'd navigated eighty miles of river but had seen just one caribou.

During dinner, another raft appeared and beached near ours, the first people seen in ten days. Chlaus offered tea and a snack. These four Norwegian men were giants, long-haired and young. *Vikings.* Before anything else, they asked: "Have you seen any caribou?" Chlaus told them that he thought the herd had moved east, but only recently passed. Over drinks they told us that they were from Oslo and had come here to see the migration. Their chartered flight dropped them at the headwaters a day after us, and they would paddle to the sea then east along the coast to Kaktovik. (I was glad it was their plan, not ours. The route offshore is a mudflat covered in places with mere inches of water, often a laborious slog.) After swapping news we watched them float off downstream.

That night we wandered in different directions in search of caribou. I found myself oddly longing for darkness or twilight. We'd had ninety-six hours of uninterrupted sunshine. No clouds, no shade, no night. I found it somewhat disorienting because

Bull musk oxen butt heads in the warm glow of Arctic midnight. Small herds wander the Arctic plain.

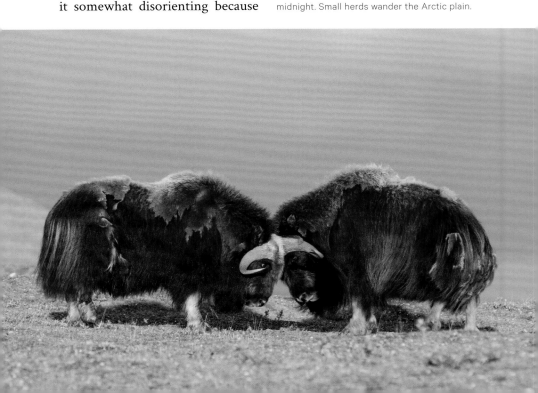

cloud cover provides some sense of circadian rhythm. I longed for darkness but not in the same way that I crave light in winter. From a vantage point, I watched the sun traverse the northern horizon, knowing it would be days before it would set again.

Just before launching the boats the next morning, the last day of our float trip, Chlaus gathered the group and spoke about the issues of oil development here. At some point since leaving the mountains, he said, we'd crossed the unmarked boundary of the 1002, an area of 1.5 million acres between the Canning River on the west and the Aichilik River to the east, the contentious heart of the refuge. Sometimes he spoke in German, sometimes in English. His message resonated with his clients, the geologist and ornithologist outraged. The response was intense: "Protect it . . . leave it alone . . . fools . . . too important to ruin . . . typical American money grab . . . God damn greedy politicians." I found the response curious. We had not seen the vast caribou herds; had been assaulted by hordes of stinging insects; had worked hard; and had gotten tired, cold, and hungry—yet even so, these cosmopolitan Europeans saw the refuge exactly as I did, a place to treasure and nurture.

That evening, as planned, we reached the end of our river journey, a tundra airstrip four miles from the Arctic Ocean. A Japanese film crew was encamped there, the first campers we'd seen. They said that three nights ago ten thousand caribou had crossed the river marching east, and they had seen nothing since except for a few wandering musk oxen.

That night, with rafts unpacked and deflated, I noticed a tangible separation among the group. Ours had been a bond of simple necessity, of pulling together. We were strangers woven together only by a common desire to see an unsullied part of the world, a region of water, mountains, tundra, plants, and animals. That night the tents seemed spaced farther apart, and instead of bear stories and mosquitoes, the conversation revolved around plane schedules and work.

On a late hike across tussock fields and frost polygons, some of us saw our second caribou—it too headed east. Far out on the tundra we split up and took different routes back to camp. I found a ground squirrel den and lingered to photograph the baby squirrels munching wildflowers. The geologist surprised a wolf at close range and watched its panicked escape. The teacher and his wife hiked with me to a high bluff overlooking the next drainage but saw no other

caribou. This couple seemed the most disappointed, the trip having been a once-in-a-lifetime adventure. At one point I asked the woman what the lack of caribou meant to her. "Heartbreaking," she whispered so her husband couldn't hear. I sat with them in the bitter wind and, to lighten the mood, I repeated something a Yup'ik friend once told me. "The old people say that caribou can go underground. I don't know how they can do that, but I kinda believe it." The couple just stared at me and said nothing.

The next morning, with our plane due that afternoon, we again split up in another fruitless search for caribou. "Not seeing the caribou herd is a disappointment," the engineer told me as we hiked along. "But there have been compensations. The tundra is *wünderbar*." The ornithologist returned from his hike thrilled with his photographs of three musk oxen. "Pleistocene," he gushed. "Ice age remnants. Mystical."

The plane landed at midday and hauled away the first load. It would take three flights in all to get us back to Kaktovik. I chose the last flight, with the gear, in order to savor the time alone.

Fifteen minutes into my flight we flew over hundreds, perhaps thousands, of caribou massed along the coast, some even perched on the sea ice. At my request the pilot circled one small group standing belly-deep in the seawater for relief from the relentless bugs and heat.

Later that afternoon, after the usual goodbyes, I flew alone to the former pipeline construction camp of Deadhorse to catch the Alaska Airlines flight to Fairbanks. Groups of oilfield tourists crowded the dingy terminal. I overheard talk of the snow and cold, "thirty-eight degrees in July!" that had fallen on their bus tour north through the Brooks Range. I picked up a discarded brochure that described Prudhoe as an "engineering and technological marvel that has been developed sensitively without disturbing the wildlife and tundra." Unkempt, dirty, and reeking of repellent, I boarded the jet with the tourists, each carrying a complimentary blue-and-white tote bag stenciled with "Open ANWR—America's energy future—Alaska."

# *Calving Grounds*

## I

**A MILE OR SO NORTH** of my camp at Sunset Pass, in the Arctic National Wildlife Refuge, I sat on a knoll absorbed by the sight of the tundra rolling away to the coast. I'd come north again to photograph the spring caribou migration and had camped in a prime location. To the south, patches of blue sky broke through the clouds draping the peaks of the Brooks Range; to the north, gray fog cloaked the Beaufort Sea coast. At least six hundred caribou grazed on a ridge to the west of me. Not far away, a grizzly rambled up the ridge toward them. The bear dawdled, stopping often to dig roots or graze fresh spring shoots. Two hours passed before the grizzly wandered behind a rocky outcrop near where the caribou grazed.

Caribou are seldom quiet in calving season. Even at a distance I could hear their talking. Soon, their nervous chatter grew louder, their agitation palpable. A few turned to run; then the entire herd bolted, the grizzly splintering the herd. Some caribou raced uphill, some downhill, others right and left. Most of the panicked herd outdistanced the bear. After several false turns, the grizzly cut to its right, intent on a calf trailing its mother.

Just when escape seemed impossible, the calf topped a slight ridge and veered right and away from the bear, joining a small band stampeding down a nearby swale. Losing sight of the calf, the grizzly topped the ridge and slammed to a stop. Much like a bloodhound, it cast about for the calf's scent. The bear trailed away from the calf, following by scent the calf's back trail.

Several hundred caribou scattered onto the tundra flats while the remainder regrouped higher on the ridge. An hour later, the lower herd bolted as the grizzly charged into them again. The scattering caribou seemed to confuse the bear, lunging right, then left, and back again. Like the hub of a wheel, the bear was surrounded by caribou.

The instinct to keep together and follow the others governed the frantic herd. Small bands doubled back to rejoin larger ones. Their routes brought them close to the bear. Here was the grizzly's opportunity: a calf lagged behind. When the calf stumbled in thick tussocks, the bear was on it, crushing it to the ground. Too late, the cow raced by trying to lure the bear away. Less than fifteen minutes later, little was left but scraps of hide and tiny bones.

This was the first time I'd seen a grizzly catch a calf. Through sheer persistence and energy, after a chase of nearly eight miles over broken ground, the bear had made its kill. What animal could outlast a determined bear?

## II

The pioneer naturalist Ernest Thompson Seton described the caribou migration as "living tides flowing over the arctic prairies." In the midst of a herd, the very earth seems alive and in flux. Caribou never seem content to stay in one place very long, with their lives best depicted as an endless journey. According to radio telemetry, a cow caribou in the Porcupine Herd moved over three thousand miles in a single year, the longest recorded movement of any terrestrial mammal. Long-distance migration from summer range in the Arctic to winter range in the Yukon Territory—often between tundra and taiga—is a strategy that allows these animals to survive in some of the harshest conditions on earth. Winter range and summer range may look surprisingly similar, but the difference is snow texture. Caribou can find winter forage, including lichens, by smell through three feet of *loose* snow and paw down to it. But in the treeless Arctic where constant winds create iron-hard drifts, winter feed is locked away from these hardy animals.

Spring migration to the arctic plain may take over two months and is the most crucial for arctic herds. The calving grounds must be reached despite any and all hazards encountered. It is theorized that these traditional North

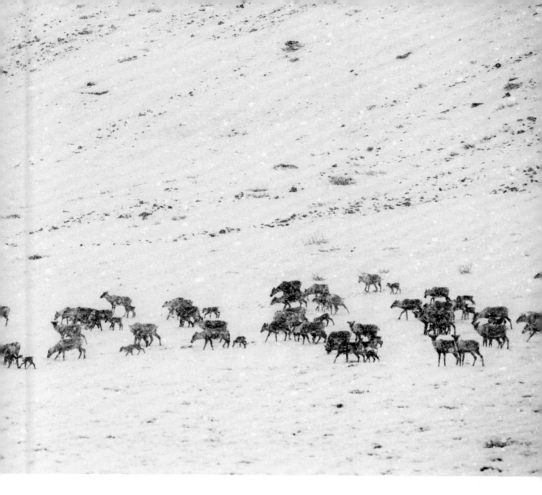

Spring snow in the Brooks Range challenges newborn calves and slows the migration of the Porcupine Caribou Herd.

Slope calving areas evolved because they offer newborns the best chance for survival. The open tundra supports fewer bears and wolves, and it thaws later than southern habitats, delaying by almost a month the onslaught of tormenting insects.

In most years, long skeins of animals filter out of the south and into the Brooks Range, moving swiftly over the rugged terrain. They conserve energy by walking single file, exploiting any advantage the terrain offers: frozen rivers, windblown ridges, anywhere the hard-packed snow will support their weight. Spring snowstorms, unusual cold, or early breakup of northern rivers can slow the northward movement.

Calving occurs in the first two weeks of June (earlier in the south) in a spurt that improves overall calf survival. In most years, 80 to 90 percent of mature females are pregnant with a single calf, twins being rare; thousands are born

over a few peak days. Weighing six to eighteen pounds at birth, a calf can stand and suckle within the first hour of life, and within hours is strong enough to follow its mother. Once imprinted on each other, a cow and calf can recognize each other by scent even in a herd of thousands. A healthy calf doubles its weight in ten to fifteen days.

Young calves fall to accidents, disease, and predators. Mobility is vital for a calf's survival. Although migration may slow once the herd reaches the calving grounds, caribou are always on the move in search of food or to avoid predators or insects. In late summer, the arctic herds are already heading south. By the time the first killing winter winds come to the tundra, packing the snow into concrete-hard drifts and sealing the forage below, the arctic herds are nearing their southern winter range.

Sun cycles may trigger migration, but we can only speculate how caribou navigate over the long miles to specific locations. Do old, experienced caribou memorize the routes and lead the way? Do they follow the wind? Read celestial or magnetic road maps? No one really knows. Only the strongest—and sometimes luckiest—calves will survive the first year to return north the next spring.

The Porcupine Caribou Herd, named for the river where it winters, migrates each year almost seven hundred miles to and from traditional calving grounds on the coastal plain of the Arctic National Wildlife Refuge. Over the decades, the herd has fluctuated in size, but in early 2017 it stood at a record 218,000, utilizing most of its Wyoming-sized piece of Alaska and the Yukon Territory. Alaska is home to nearly three-quarters of a million caribou, in thirty-one herds, with the Porcupine Herd second in size only to the Western Arctic Herd.

Conservationists argue that oil development on the coastal plain will irreparably damage a thriving arctic ecosystem and the dependent caribou. Alaska Natives are divided. Some Inupiat living in Kaktovik fear threats to their traditional lifestyle, while other others push for jobs and cash income. On the south side of the Brooks Range, as many as seven thousand Gwich'in Athabascan rely on the Porcupine Herd for subsistence and cultural identity. They strongly oppose development and deem the coastal plain a "sacred place." Gwich'in elder Sarah James, of Arctic Village, told me, "There is no oil technology that could make the coastal plain safe for calving caribou."

Each year, with few exceptions—usually weather related—most of the calving and postcalving aggregations occur on the coastal plain. Commonly one-half to three-quarters of the herd's calves are born there. A veteran caribou biologist adamantly believes that late-term pregnant cows, and those about to calve, will not cross or approach roads. Even as little disruption as a dirt road, he says, can adversely impact the herd segment that is most critical.

Conservationists cite these statistics for the wildlife that call the area home: 180 bird species migrate from four continents; thirty-six species of land mammals live in the area, including North America's northernmost Dall sheep population, two caribou herds, and all three species of North American bears; nine marine mammal species live offshore; while inland waters support thirty-six species of freshwater fish.

Overlooked in the debate over oil versus caribou is the issue of preserving one of the world's great wildernesses. Already 95 percent of the Arctic Coast is open to drilling, including the huge 23-million-acre National Petroleum Reserve-Alaska. "The 1002 area is about 104 miles in length," estimated biologist John Schoen, "and if opened would leave only about 45 miles of refuge coastline protected."

"Anwar"—as the acronym for the refuge is pronounced—is a heated issue in Alaska. (In Arabic, ironically *Anwar* means "brilliant, light, enlightenment.") I have found the Arctic National Wildlife Refuge to be a place extraordinarily harsh and devoid of life one minute, and extremely fragile and vibrant with life the next. Most people, from all sides of the argument, have never been there but only view the issue from their own bias or self-interest.

### III

Spring storms in 1991 delayed the northern migration of the Porcupine Caribou Herd, and the herd calved in the mountains. So I changed my plans and decided to camp in the mountains.

Flying north from Fairbanks, bush pilot Steve Porter and I flew just east of 9,020-foot Mount Chamberlin, its hanging glaciers in stark contrast to the sea of ice-free summits around it. Twenty miles from the coast we dropped below a cloud layer. Over Kaktovik the ceiling was less than seven hundred

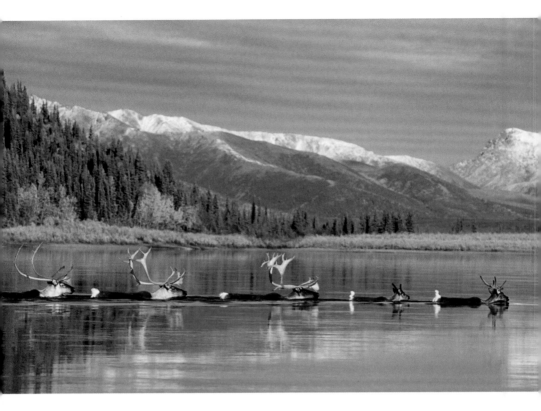

feet above the tundra, and we made a har-
rowing landing in ice fog, the temperature
22 degrees.

Caribou in the Western Arctic Herd cross
the Kobuk River during their autumn
migration. Across the Arctic, caribou
traverse mountains, plains, and rivers to
complete their annual cycle of life.

Steve gave me the news that icing con-
ditions would keep us in town overnight.
The ubiquitous coastal fog finally burned off late the next afternoon. After
Steve made a couple of short hauls with his Cessna 185 to pick up some rafters
waiting at the mouth of the Kongakut River, he flew me to Sunset Pass. It was
clear, windy, and bumpy on final approach to the short gravel airstrip. A mile
downriver from the strip, we spotted two grizzlies grubbing in the willows.
From the air I saw a thousand or more caribou spread out in the valley.

I had flown with Steve on previous occasions, and I considered him a friend.
After we unloaded the plane we sat on the riverbank and shared lunch and sto-
ries under the warm sun, the mosquitoes held down by the breeze. The "Save
the Arctic Refuge fad," as Porter described it, had begun to wane, and he told

me about the summer of 1989 when the celebrities began to appear. It was the year of the *Exxon Valdez* oil spill, and a trip to the refuge seemed the in thing to do for the jet-setters. In Fairbanks, Steve's colleague had met model Cheryl Tiegs, her publicist, and Tiegs's high school friend. "My partner met them at the airport," Steve said, "and they took off on the most thunder-stormy, turbulent day of the year. By the time they got to Kaktovik, they were airsick and scared to death."

With little introduction, Steve's partner turned his passengers over to him for the flight into the mountains. "So what do you say to someone famous like that?" Steve asked. "'Hi, I'm Cheryl,' she says in this cringing, frightened voice. Now what was I supposed to say, 'Yeah, I know. I seen you naked in *Playboy?*' So I said nothing. Already she's looking at me with bug eyes like a frightened raccoon, like I'm gonna hurt her or something. Crazy.

"I shrug and start transferring stuff from the other plane to mine. The three of them just stood there shivering in the northeast wind and didn't lift a finger to help. They have a waterproof duffle, probably weighed a hundred and fifty pounds, all full of stuff you don't need here like wine, brie, and all that stuff. Maybe even tablecloths. Who knows?

"So I land them out in the mountains, and as I unload everything, they don't say a word. They just stand there staring around like parka squirrels alert for danger. The mosquitoes are horrible. Tiegs is spraying herself with repellent from a can the size of a fire extinguisher.

"Just as I climbed into the plane to leave, she starts snapping her fingers at me. 'You, you, hey you,' she says, 'come back tomorrow.' So I say, 'But I'm not due back for four more days.' Then she says, 'Come tomorrow. We may want to leave.' Now you got to remember," Porter said, "this is around the time her and her husband, ex-husband, whatever, Peter Beard, had been labeled 'Conservation's Cutting Edge Couple,' or some such nonsense, by *Outside* magazine. One day in this beautiful place, and that's enough for her. Bugs. Imagine? Bugs driving them off. When the wind blows, there ain't any bugs." Steve said that he never went back to pick them up—he sent his partner instead. "Bad vibes," Porter explained. "Way bad vibes."

After Steve left I spent the afternoon setting up camp on a ridge overlooking the airstrip, a site that allowed an unrestricted view of the valley and the approach of bears and caribou. Clouds late in the day erased the sun, and a cold,

hard wind began to blow. I awoke the next morning to eight inches of new snow and no end in sight.

That day I watched hundreds, perhaps thousands, of caribou migrating slowly through the pass. I could not accurately judge numbers since the animals wandered widely before moving on. I hid in the willows below camp and photographed the cows and calves that passed close to me.

Over the course of the next few days the migration changed somewhat. The caribou fed less and quickened their pace. Perhaps the plain had begun to green up and somehow the caribou sensed it. Certainly there would be fewer bugs along the coast than here in the mountains.

The constant, inexorable movement of thousands of caribou took my breath away. My photography went well. I photographed caribou in herds—mothers and calves—as well as bears, jaegers, arctic ground squirrels, and golden plovers. I saw twenty-four bears and seven wolves, and witnessed some incredibly wrenching scenes. One day while hiking back to camp I blundered on a calf alone in the willows. It raced to within ten feet of me before deciding I wasn't its mother. It exhibited no fear and followed me, calling plaintively. No other caribou were in sight when finally it dropped behind. Once back at camp I watched through binoculars as the calf wandered slowly downstream toward some willows where earlier I had seen a grizzly. I hadn't the heart to continue to watch.

The summer solstice, June 21, rolled in clear and cool. Between midnight and four, another two to three thousand caribou trotted past my camp, mostly cows with calves. By midday the migration had slowed to a trickle. That night a bitter wind drove me to shelter. Two days later, the bugs undiminished, I wandered upstream through the brush lining the creek. I saw redpolls in the willows, heard longspurs on the tundra; gulls and jaegers were coursing overhead. On a tussock far to the west of my camp, a short-eared owl stood silent sentry. The calling of caribou—cows to calves, calves to cows—seemed like the excited chatter of children home from school. Hundreds trotted by me, many less than a hundred yards away. Some saw or smelled me, but as I remained motionless, they did not panic. Again I reveled in the illusion of invisibility, the rock on the tundra.

Over the next few days the caribou seldom slowed or paused for any length of time. They

A peak in the Brooks Range, in the heart of the Arctic National Wildlife Refuge, glows in the light of summer solstice.

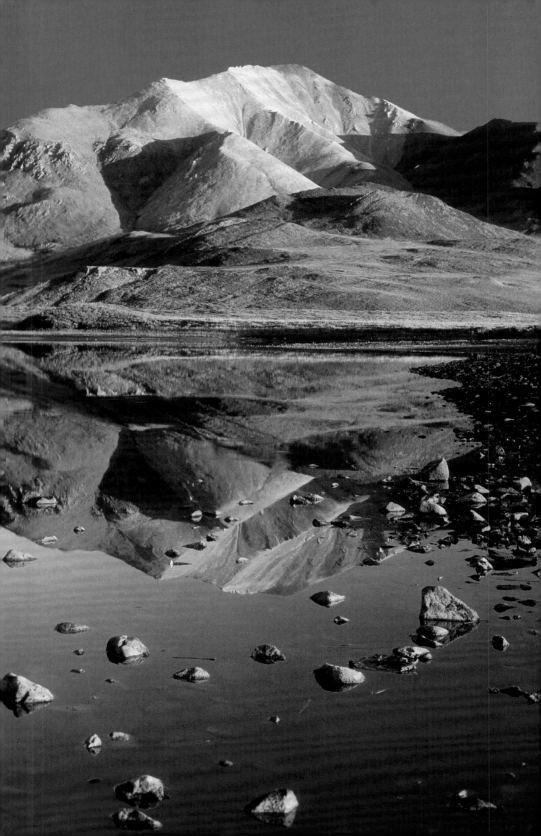

seemed driven, as if hurrying someplace in particular. Snatching bites of food here and there, they gave their own meaning to the phrase "eat and run."

Caribou streamed through the pass in varying numbers and compositions. Perhaps because of all the activity, I failed to notice the lone cow grazing just south of my camp. It wasn't until the second day that I began to sense something amiss. A number of caribou passed by, yet she followed them only a few yards before turning back. I saw her sniff at a motionless shape on the ground.

My curiosity aroused, I went closer. The cow pranced away, circling in obvious agitation. A small calf lay dead on the tundra. There was no sign of injury or trauma; the calf appeared to have fallen in stride. A powerful scent of death hung over the still form. I took one picture then hurried away, the cow resuming her vigil.

Three long days ground away, yet the cow remained near her calf. The stench must have been incredible, and I worried that it would attract a grizzly. Given the prevailing wind, a bear might pass uncomfortably close to my camp. Each day was the same. Bunches of caribou, large and small, migrated by, some bands enveloping the lone cow before moving on. She appeared torn in her loyalties. Twice she ran off with the passing animals, but each time she stopped and sprinted back to her calf. Once she went a half mile before returning.

Late one night the migration dwindled to a trickle. The next morning, a herd of about seventy-five, the first group in over eight hours, hustled downriver and passed the cow and dead calf. This time she seemed especially agitated and made several false starts at joining them. With the herd already a mile away, she belatedly made up her mind and raced to join them. Three or four times she stopped to look back but kept going until out of sight.

Five hours later, a grizzly appeared on the ridge above camp, nose on a scent trail that led straight to the dead calf. On a run, it pounced, as if on a living animal, seized the carcass in its jaws, and dragged it off into the rocks. In less than a half hour the satisfied bear wandered off upstream.

I didn't see another caribou until late that night when I spotted a lone cow running from the north. Nearly a full day after leaving, the mother caribou was back. She circled the spot where her calf had died, but when she caught the grizzly's fresh scent, she sprinted away. She stopped, came back, and circled again. Over the wind I heard her mournful calls as she followed the drag marks uphill to where the grizzly had fed. There she nudged a remnant with her

muzzle, then pawed it with a front hoof. For a half hour she searched through the rocks.

Sometime later, several hundred caribou swarmed through the pass, heading north. The cow sprinted to catch them. Finally, after five long days, the cow rejoined the migration.

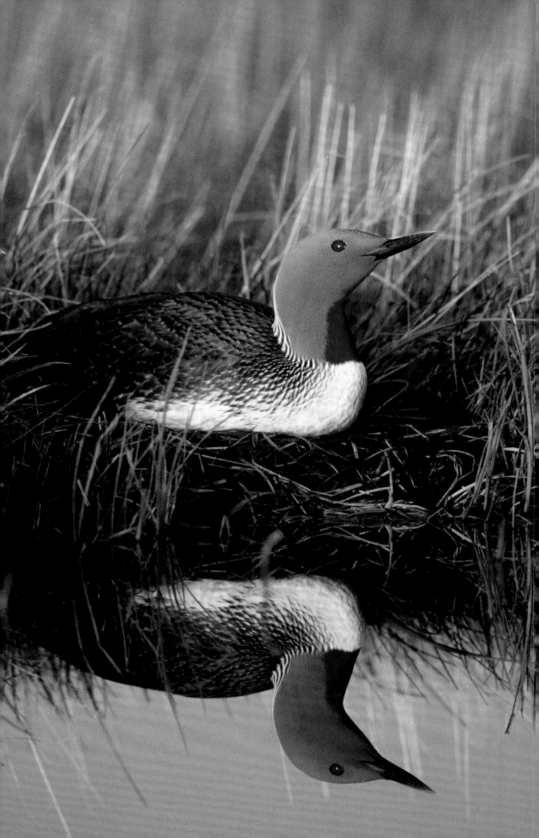

# *Arctic Loons and Foxes*

## I

**WILDLIFE PHOTOGRAPHY IS FAR DIFFERENT** from popular perception. Upon viewing my photograph of a nesting red-throated loon, a woman remarked that she wished she could have been there that night and seen the loon on its nest beside that peaceful, tranquil pond. The reality wasn't that pleasant.

To get that picture, I'd waited for days. The wind blew across the tundra day after day without letup. Cold, snowy days alternated with sunny, warm ones filled with mosquito legions that turned the inside of my blind into a Dantesque hell. I opened the blind once, and a swarm billowed out as thick as smoke. My food ran low, and for three days I suffered from a miserable flu-like illness. When the wind finally died one night at around two o'clock in the morning, the lull only lasted three hours. The sky was clear, the arctic sun unobscured. As the wind faded and the water stilled, the loon seemed unable to stay awake. It settled deeper into its nest and closed its eyes. Anticipating the wind to pick up at any moment, spoiling the reflection, my tension level steadily rose. Here was warm light, golden grass, a gorgeous bird, a marvelous reflection in the water; I willed the bird to open its eyes and look alert.

When an arctic fox sortied across the marsh, the loon's head snapped up, its eyes sparkling with the light. After the fox moved on, the loon stirred and rose to turn its eggs before settling down again. In those few precious, quiet moments, I made my picture, oblivious to the cold, fatigue, and mosquitoes.

Wildlife photography in true wilderness often means camping for days in a small tent, subsisting on simple food. It requires rigorous hiking across rough terrain while burdened by a heavy pack full of absurdly expensive, high-tech equipment that must be protected from impact damage and the elements. Even good days can mean being cold, tired, and hungry. Wildlife

On a tiny pond close to the Beaufort Sea, a red-throated loon incubates her eggs on a grass nest.

photography can be described as hours of boredom interspersed with brief moments of elation.

Then why do it? I think wildlife photographers do what we do because we fantasize endlessly, imagining the perfect picture. I envision scenes I want to photograph, no matter how pie-in-the-sky: a wolverine digging for ground squirrels, wolves testing a moose, a black bear with a bright-red salmon in its mouth. Even when beaten by physical toil, bad weather, or short rations, the only way to succeed is to be out there day after day.

Some dreams are elusive. Over the years I've been fortunate enough to see fifteen different wolverines roaming wild and free, but I have only one good picture. Once while sitting on a hillside in the Brooks Range, enjoying the view of snowcapped Mount Chamberlin, I thought, *If only a herd of caribou would come into view.* Less than a half hour later a herd of caribou trotted over the ridge precisely where desired. (The fantasy image, as it turned out, was more compelling than the actual photo; again, the mind a more sensitive emulsion than film.)

In winter I often awaken at night with vivid dreams of wildlife. Perhaps the single reason why I persist in photography, despite the challenges, is because, in the end, associating with wild animals is my one enduring joy.

## II

Loons fascinate me, and I've made multiple trips to the North Slope to photo-graph them. Prior to one trip from Fairbanks to Barter Island, I sat on Frontier Flying Service's loading dock swatting mosquitoes in a sweltering eighty-degree day. Although late June, the heat was likely the last warmth I'd see for a while.

The flight north was uneventful without a cloud in the sky, what bush pilots sometimes call "severe clear." We crossed the Brooks Range and droned out over the coastal plain in smooth air. Nearing Kaktovik we swung out over the sea ice. Except for a few leads and a narrow opening along the coast, the pack ice stretched unbroken toward the pole. As we crossed the coastline the Inupiat man sitting next to me pointed to the driftwood-lined coast below. "See that little point," he yelled over the engine noise. "I was born there, in camp, seventy-five years ago." It was the first time he had spoken during the long flight. I saw nothing distinctive, not even a break in the gray jumble of

drift logs. Hard to imagine the privation and struggle of an isolated family subsisting off the sea and land, or a woman giving birth in a crude shelter there. His face creased with a huge smile as if remembering a happier time.

The plane banked sharply, and when the pilot leveled out we could see the Barter Island airstrip straight ahead. The island itself is flat and treeless, with the village of Kaktovik huddled on a low rise above the airstrip. In the heart of winter under the onslaught of drifting snow, it would be difficult to pinpoint the demarcation between land edge and the sea ice. To the south, the Arctic National Wildlife Refuge spans the tundra and eastern portion of the Brooks Range, all part of the village's traditional hunting and fishing territory. Local Inupiat people hunt caribou, polar bears, seals, whales, and waterfowl.

When the plane rolled to a stop, the pilot opened the door, cold air flooding in. Some of us donned heavy coats before climbing down into the wind, a 15-knot northeasterly. Pilot Steve Porter met me at the hangar and told me that the wind had been 40 knots earlier and the temperature 34 degrees. "A typical July day on the Arctic Coast," he said, smiling.

Within a half hour of landing we were in Porter's Cessna 185 and headed for Camden Bay. Our route for the most part followed the coastline, and I got a good look at the sea ice, which was spottier than it had been near Barter Island. Years ago, flying this same route, pilot Walt Audi had told me that he'd once counted ninety snowy owls perched on sandbars along the coast. Now, I saw none.

Near our destination I began to worry about the landing. The "airstrip" at Camden Bay was a sloping, gravel beach; a strong crosswind would make the landing tricky. Steve circled the beach several times, studying the terrain and buffeting wind. After one last pass and a final look, he turned downwind and proceeded straight and level; he then banked left, then left again, and lined up for an approach, establishing a textbook left-hand pattern. With full flaps and near full stall, we touched down without so much as a bounce and rolled to a stop on the slanting cobblestone beach.

"Nice landing," I said after Steve shut down the engine.

"Really? Well, thanks." All in a day's work for him, I guess, but I wiped my sweaty palms.

I rapidly unloaded the plane while Steve held the door to protect it from the stout wind. A few minutes later he was on his way back to Kaktovik. The wind bit like winter, and I hustled to get my tent set up in the lee of a driftwood

mound. Just beyond the beach berm, several ponds and open tundra sheltered a variety of nesting birds. On rare occasions, when brown lemmings are numerous, snowy owls nest here. On this trip I was after Pacific loons, with the remote chance for owls. Always a dreamer.

After setting up camp and sorting gear, I went on a hike. I paused on the highest berm and studied the sea ice with my binoculars. In the distance I saw skeins of eiders racing on the wind; dark spots on the ice were seals. Seals and ice meant polar bears, a sobering thought. An ice bear wandering into camp could be nightmarish. I shrugged from the bitter wind and, more vigilant, hiked on.

The tundra was still mostly brown and broken by a maze of frost polygons and fields of soccer-ball-sized tussocks. Moss campion, lupine, avens, scarlet plumes, and lousewort danced in the wind. The ground was sodden, meltwater held at the surface by permafrost just inches below. The snowy Brooks Range rose on the far horizon.

Within a half mile of my camp I spotted two tundra swans guarding their tiny cygnets. By the time I returned to camp late in the day, I had tallied Lapland longspurs, wheatears, arctic terns, white-fronted geese, pintails, long-tailed ducks, ruddy turnstones, golden plovers, semipalmated plovers, Baird's sandpipers, dowitchers, and numerous dunlins. I saw predatory birds too—a northern harrier, a golden eagle, several jaegers, and one short-eared owl, identified by its erratic flight. Through binoculars I saw a yellow-billed loon flying over the sea. I found two Pacific loon nests and one of a red-throated loon. The nest of the red-throated loon was on the same pond I'd seen used last year, just about six feet from its former location. In several places I found feathers and pellets of a snowy owl.

Later, I located two nests occupied by red-throated loons within the surrounding two square miles and three nests of Pacific loons. I've learned that in some parts of the refuge coveted by the oil industry, the best Pacific loon habitat may contain five nests per square mile. Red-throated loons use very small ponds, Pacific loons larger ones, and yellow-billed loons claim the largest ponds and lakes. Yellow-bills are like jumbo jets that need long runways for takeoff and landing. Red-throated loons use smaller "runways."

A Pacific loon nests on a tundra pond rich with feed for her and her mate, who shares nesting duties.

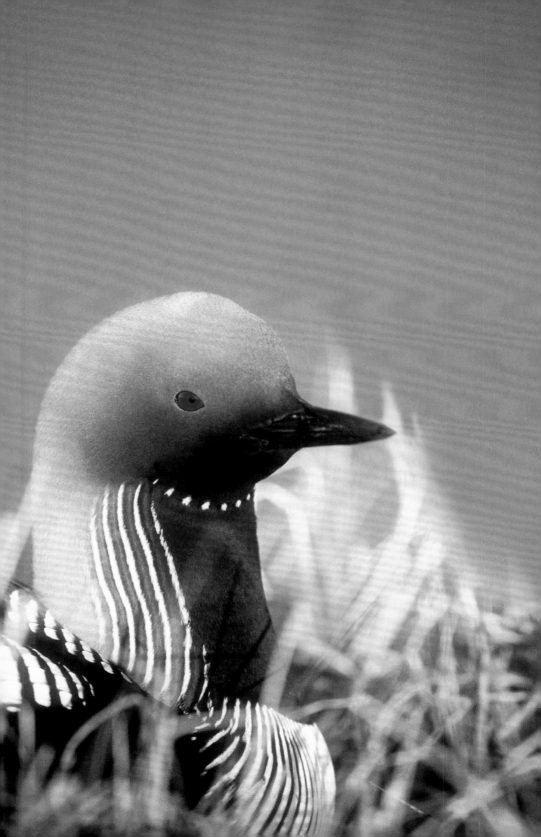

Sometime during the night, the wind quit and my small thermometer read an unexpected 58°F. I awoke to the drone of mosquitoes and an evanescent light on the tent. Dressed and outside, before lighting my camp stove, I doused myself with extra-strength bug repellent. In the calm, breathless air, the hordes swarmed my steaming coffee and bowl of instant oatmeal, more than a few bugs adding protein to my meal.

I quickly loaded my pack with my blind, nylon line, and assorted paraphernalia and went to the edge of a pond where a Pacific loon nested. The pair was near the nest but quickly swam away. Hurriedly I set up the blind, staked it down, and left. I wouldn't go back for two days, giving the loons ample time to acclimate to its presence. Since the tundra here was not pristine, strewn with fifty-five-gallon drums and other Cold War flotsam, the blind proved to be unobtrusive.

I spent the rest of the day exploring the marsh and bluffs to the south. On the hike, I added rock ptarmigan, willow ptarmigan, and phalaropes to my bird list. At midday I paused for lunch on a high bluff overlooking the sea ice. The prevailing northeasterly knocked the bugs down, and I sat in peace. Over the sea, the fata morgana, an unusual and complex form of mirage, transformed blocks of ice into shimmering summits. Some of the shapes looked like skyscrapers, and I understood how these mirages could have tricked malnourished and dispirited mariners. In the land of the midnight sun, anything seems possible.

Intense sundogs bracketed the sun. At Arctic Village last year while I was talking with Gwich'in elder Sarah James, we admired another brilliant sundog. She said, "What do you think causes that?" My friend naturalist Karen Jettmar piped up: "They are parhelia, or mock suns, rainbowlike spots, twenty-two degrees on either side of the sun caused by high-altitude ice crystals." A slow smile spread across Sarah's face. "It means the sun is cold. Those are little bonfires to keep him warm."

On the North Slope arctic foxes use traditional den sites year after year, many for decades, some three hundred years old and having as many as a hundred entrances. On the way back to camp, I examined a den that I had photographed several years before. Fresh diggings and a ripe odor indicated recent use. Mosquitos patrolled the openings.

The arctic fox is one of six Alaskan animals that turn white in winter; the others are the arctic hare, snowshoe hare, collared lemming, weasel, and

ptarmigan. This nomad of the circumpolar north leads a solitary life except when congregating near abundant food, such as a polar bear's kill or a whale carcass, and ranks as the world's farthest north terrestrial mammal. (Polar bears are classified as marine mammals.) Breeding range extends from the tip of Greenland (88°N) to south of Hudson Bay (53°N). Explorers reported an arctic fox within eighty-seven miles of true north and another within fifty-three miles of the northern pole of inaccessibility (the point in the arctic ice pack farthest from land).

To live in the brutal conditions of the arctic night, these six- to ten-pound foxes have evolved the densest winter pelage of any land mammal, perhaps rivaled only by that of the land otter. Underfur can be two and a half inches thick and guard hairs five or more inches long. Densely furred paws insulate pads from the cold and provide traction on ice. Short ears, legs, and snouts radiate little body heat. Because winter fur molts in early April and transforms to brown and tan, on this trip, I expected the foxes to be in summer camouflage.

Curious arctic fox pups peer at me from the safety of their den beneath a pile of driftwood.

Courtship begins in early March and April, two months before the end of winter. As spring days lengthen, the pair returns together to traditional den sites, where after a pregnancy lasting less than two

months, the female gives birth. Litters vary from six to fifteen, but Russian scientists once documented a litter of twenty-two. Pups emerge from the den when about three weeks of age and are fully weaned by six weeks. At age three months they begin to range away from the den to hunt on their own. Pup mortality is very high.

This den bore watching, the pups old enough to be outside and active. I was cautious of unusual behavior from the adults—arctic foxes are the reservoir for rabies in Alaska.

Late the next evening I hiked to my blind with a full pack of camera gear. One of the loons was on the nest, but at my approach, it swam off. I settled into the blind quickly. Less than ten minutes later the loon paddled back and climbed awkwardly onto the nest. After rolling the two green eggs, the loon settled over them. In the evening light the feathers on its head and purple throat patch glowed as if velvet, the red eyes almost molten.

Just after midnight, clouds smothered the sun, ending my photography. As the weather changed I watched the loon on the nest, heard the calls of long-tailed ducks, and saw a drake king eider land at the far end of the lake. At two fifteen in the morning I hurried back to camp through an icy, wind-driven rain.

The next morning I rose late with the beginnings of a cold. I'd slept little the past two days and felt exhausted. The last time I had camped here the wind had quit only once in ten days, and I'd pushed to take advantage of the lull and lambent light. Now, I'd tried to rest, and by the time I finally crawled out of the tent, the wind had shifted to the northeast and the sky began to clear. The mountains to the south glowed with fresh snow.

I felt weak so was thankful there were no bugs to contend with. I spent the remainder of the day in my tent resting, eating and rehydrating. Late that evening the wind faded, and once again the sky turned completely clear. Despite feeling sick I hiked to the loon blind. An hour later, the bird wobbled to her feet and looked down. One of her eggs was hatching. The loon used her bill to turn and adjust the egg to avoid pressing down on the opening. Every few minutes the hen stirred and checked her egg, the hole larger each time. Eventually the loon turned completely around and settled with her back to me, blocking my view.

Inexorably the sun sank closer to the northern horizon, painting the pond and tundra with golden light. Sometime after midnight the wind died and a thin fog drifted over the pond. Despite my heavy parka I shivered and fought to stay warm. At four in the morning the loon finally revealed her eggs. The hatchling, half-emerged from its egg, was dead. To my sorrow, I watched the hen poke it with her bill, then pick it up and dive into the pond. She surfaced a few minutes later without the dead chick, likely tucked into the mud below. From the water she reached into the nest, gathered the egg shards in her bill and dove again. When she surfaced, the "burial" was complete, the nest clean without a dead chick or egg fragments to lure a fox. She labored back onto her nest to tend the remaining egg.

I hiked back to camp under a pall. To me, the loss was tragic—and if the second egg failed to hatch, or the chick died, the loon's long migration had been wasted. I wondered again if and how animals grieve.

That night I slept fitfully for a few hours, the chick's death filling my thoughts. Had the egg been weakened by pesticides or chemical agents? Had the loon somehow crushed her own chick? What was the cause?

Later I awoke with chills, fever, headache, and a minor cough. I rummaged through all my gear and found that I'd completely forgotten to bring medication of any kind—no aspirin, painkillers, nothing. *Stupid.* The weather was ideal, but I had no energy to leave the tent. Wracked by chills, I slept poorly into the afternoon.

Sometime that day, or night—I'm not sure when—it clouded up and a light rain dimpled the tent. My entire body ached, and despite my down sleeping bag, I could not get warm. Sometime the next day the fever broke but returned later that afternoon. I had no appetite but forced myself to drink lots of hot tea.

For three days I remained sick in the tent, at times with bizarre, vivid dreams. I saw my late father walking across the tundra. In the dream he was fifty-five years old with graying hair. I called out to him. He came to my tent only reluctantly and told me to quit "whining." In another dream I was driving an ancient truck across the tundra on a date with a woman I once knew casually. She was naked, singing a tune, her body hairy with mosquitoes. We stopped for a horse in the road, a construction zone, and a school zone. Next came an unsettling dream about a man I once worked for who posed some

vague threat to my daughter. I told him if he touched her, I would kill him. When I spoke he disappeared and I awoke, disoriented, not knowing where I was.

On day four I awoke to silence, the tent pressing down on me. The weather had turned cold, and a heavy snow had fallen. Freeing one arm from my sleeping bag, I knocked the snow off my tent then fell back asleep. When I awoke again, the sun was out and a chill breeze rattled the tent, but the fever was gone. That morning I built a fire in the lee of the driftwood berm and ate until I could hold no more. I still felt weak, with slight chest congestion, but nothing more.

The snowy, untracked tundra was proof the caribou were gone and would not return until next year, the nesting birds soon to follow. I felt a powerful loneliness, my brief illness leaving a sense of vulnerability.

That afternoon I took a short walk to Marsh Creek to get water and examine the remains of an old Inupiat sod-and-driftwood hut. I saw two lemmings scurry through the grass at the edge of the berm and found the feathers of a snowy owl and several pellets.

Late the next day I again visited the fox den. As I approached the den I could see pups playing in front of it and an adult lying on the tundra above. The adult's warning bark hurried the pups into their burrow. I sat within camera range of the den and waited. The adult fox seemed unafraid and soon returned to its nap. One by one the pups emerged from the den and frolicked in the grass. Near midnight another fox, obviously the female, returned to the den with a green loon egg in her mouth. When she spied me she barked a warning, and the pups dove into their tunnels. She followed them without a backward glance. Her mate stood above the den looking for the threat; he no longer considered me one.

The male soon trotted off on a hunt, and I leaned back to wait. The light was golden, and the brisk wind kept mosquitoes at bay. Feathers, small bones, a ptarmigan wing, tufts of caribou fur, and the skull of a ground squirrel littered the den site, all perfumed by the strong scent of foxes. Mosquitoes swarmed as the wind died down.

In less than a half hour the male came back with several lemmings clamped in his jaws. He whimpered at a burrow, and all five pups charged out from the den. They snatched up the prey and disappeared underground.

Four hours later I hiked back to camp under the amber light of the midnight sun. The night was alive with the calls of loons, terns, and long-tailed ducks. Somewhere in the south, sandhill cranes greeted the day.

Late the next day I returned to my blind but found the loon nest empty, no bird, no egg, no feathers, nothing. I remembered the female fox carrying a loon egg to her den, and wondered. After rolling up my blind I glassed the pond and saw a loon floating at the far end with a single, charcoal-gray chick riding on her back. As I watched, a second loon swam to her and fed the chick a tiny morsel.

I revisited the fox den several more times and shot pictures of the adults and pups cavorting in the wind. On the last visit I saw a red fox running from the den, an arctic fox pup clamped in its jaws. As the climate has moderated, red foxes have expanded their range northward, in the process displacing their smaller cousins.

The last night in camp I pondered the weave of predator and prey, the loss of life to sustain another life, the empathy I hold for one species over another. Was the loss of a pup a greater tragedy than the loss of a loon egg? Why do I loathe the parasitic jaegers that spiral above the tundra in search of unprotected eggs and baby birds yet admire the foxes as they pounce on rodents hidden in the grass? Or exalt the snowy owl as a master of the north wind but quick to perish without lemmings?

When Steve Porter flew in to pick me up, I climbed aboard the plane with the usual mix of emotions: sorry to leave the wilderness but glad for a break from the wind, cold, and mosquitoes. On the flight back to Kaktovik I looked down at the bright tundra, watching for caribou and musk oxen. At one point I slipped my hands into my parka pockets and felt my bag of exposed film, a pocketful of loons and foxes.

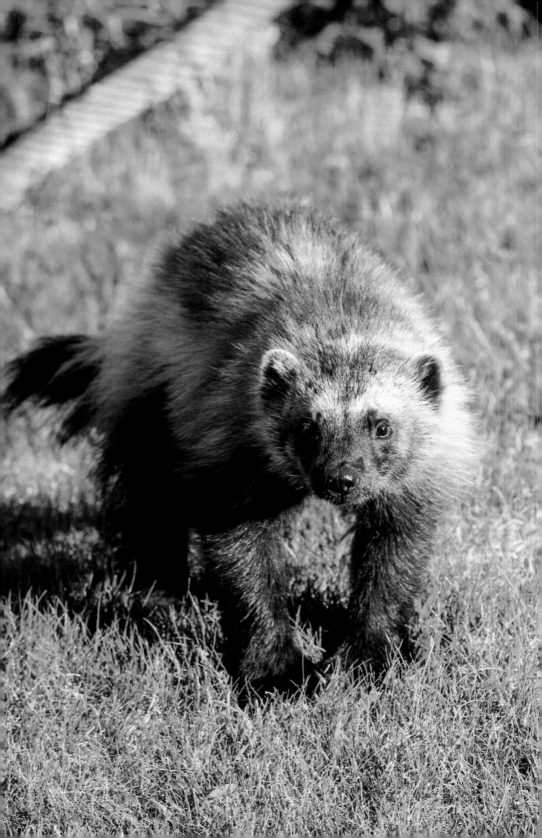

# *Wolverine*

**ONCE WHILE TRAVELING HOME FROM** Whitehorse, Yukon Territory, I saw in a restaurant a strange bug-eyed alien that glared at diners from inside a glass case. At a distance it looked like a giant furry toad with spindly legs and vampire dentures. I went closer. WOLVERINE, read the placard, THE MOST FEARED AND HATED ANIMAL IN THE NORTH. I wondered for a moment if the description referred to the specimen or the unskilled taxidermist.

I sat down as far from the case as I could get with my back to it. Stuffed animals, from birds to bears, are found all over the Yukon and Alaska. Most don't bother me, some I even enjoy. Halfway through my soup I realized the problem here was not so much the grotesque workmanship but the hyperbole. *Most feared and hated?*

I know little about wolverines. Few people do. The stories that circulate are extreme. Wolverines are ferocious predators. Pound for pound the meanest animal in the north. They drive wolves and grizzly bears from their kills—no small feat for an animal that weighs about thirty-five pounds. They escape from steel traps by biting them in two. They terrorize traplines and, once inside cabins and caches, they eat, destroy, or foul everything. Wolverines are so cunning and secretive, it is said, that even outdoor professionals might go a lifetime without seeing one.

Every animal's reputation is part fiction, part fact, but the wolverine's seems to be unduly myth based. Hollywood fantasy films of mutant humans have not helped. Nowhere are wolverines considered abundant. Perhaps mere scarcity accounts for the persistence of these and other stories.

Our knowledge of wolverines comes from several sources. Scientists know basic biology: when they breed (May through August), how many young they have (two to three), how far they travel (female home ranges thirty to one hundred square miles, males four to six times larger), what they eat (almost

---

After years of failing to photograph any of the dozen wolverines I have seen, I spotted this one hunting alongside a road where he paused long enough for the camera.

anything). Many common facts, however, such as abundance and population dynamics, are still a mystery. One Alaskan biologist, Audrey McGowan, spent much of her career studying these animals, including rearing two juveniles, and discovered many traits.

Trappers know things about wolverines too. They know where to look for them, and baits and sets that will capture them. Few trappers, if any, however, have ever specialized in catching wolverines despite their valuable fur. Alaska Natives, and other northerners, prize wolverine fur to use as parka ruffs because the fur does not ice up like other types of fur. Most catches are incidental. Some trappers have had wolverines follow their lines and wrench frozen marten and foxes from traps: "Wolverine TV dinners," one man quipped. Trappers say that porcupines and squirrels are greater threats to their cabins and caches.

Athabascan traditions hold that the wolverine is an animal of great power, perhaps the most potent in all nature. There are special words for it. To avoid offending its spirit, traditional people never speak of it directly. Women can never say its name. When one is caught, certain rituals are observed to placate, honor, and thank it. No wise person ever intentionally antagonizes a wolverine.

A few animal trainers possess special knowledge of wolverines. They know that if procured early in life, wolverines can bond to humans and become gentle associates. An old book, *Demon of the North* by Peter Krott, tells the story of a Scandinavian man who kept them as pets.

Not long ago I met a man in the Lower 48 who trains animals for the movies. He was in the process of training a newly obtained wolverine. Though born in captivity, it had become an untutored, dangerous adult. At first the trainer could not approach it. To develop trust, he sat in its cage reading a book for hours at a time. The wolverine's behaviors of threat and wariness slowly gave way to indifference, then acceptance. Eventually the wolverine took scraps of meat from his gloved hand.

One day the wolverine climbed onto his knee and bared its teeth. The fearful trainer leaned away, but instead of a growl or lunge, there was just the toothy display. Several times over the next few days the wolverine repeated the bared-fang grimace. Puzzled, the trainer sought the advice of a Canadian who had trained wolverines for Walt Disney's True-Life Adventures series. "You've

almost won him," he was told. "He wants you to rub his gums." Incredulous, the trainer nonetheless decided to give it a try.

"Next day I went in the pen, and when he climbed on my knee and bared his teeth," he said, "I pulled off my glove, stuck my finger in his mouth, and rubbed." The wolverine writhed in ecstasy. Today the two are bonded. Amid much growling—animal and human—they wrestle, chase, and roughhouse. Each day the wolverine begs to have his gums rubbed.

Some animal behaviors are inexplicable, the wolverine's no exception. Several years ago while counting salmon from an observation tower on the Kvichak River, David Rhode saw two animals approaching from downriver. He could not at first believe his eyes. Soon the pair, a fox and a wolverine, walked side-by-side under the tower. "I watched them for over a mile," he said. "They were so close that at times their flanks touched. It was like *The Incredible Journey* or something."

In 1969, on the lookout hill behind Puntilla Lake in Rainy Pass, I saw my first wolverine digging ground squirrels on the slope west of the summit. In a strong wind I crept within seventy-five feet. I watched it dig out and eat a squirrel before it caught my scent and ran off.

Since then I've seen a wolverine bluff charge a bear cub at McNeil River and another do the same thing at Denali Park. Once in the Brooks Range, a sudden crashing in thick brush startled me. My first thought—*grizzly*—set me pawing for my gun, but then a wolverine ran up a slanting deadfall over the creek. It took one long look before bounding off, a shaky human in its wake. For three consecutive summers, I saw a wolverine in the same alpine basin that overlooked a north-flowing Alaska Range river. Once, I saw it stalking white-tail ptarmigan, the last two sightings in proximity to Dall rams. Each time, the rams alerted but did not flee as the wolverine passed within yards of them.

Once, years ago on a boat trip along the Katmai coast, the skipper spied something swimming across a wide bay. "Seal," I said. "No, it's a sea otter," he said. "No, a sea lion." Back and forth went our tentative identifications. Intrigued, we turned and followed the animal to shore, where it climbed out on a rock and shook off. A wolverine. *Swimming the ocean.*

THE ANIMAL WE KNOW NOTHING ABOUT is what the placard in that restaurant should have read. Perhaps that in itself, though, is reason enough for some people to fear and hate the wolverine.

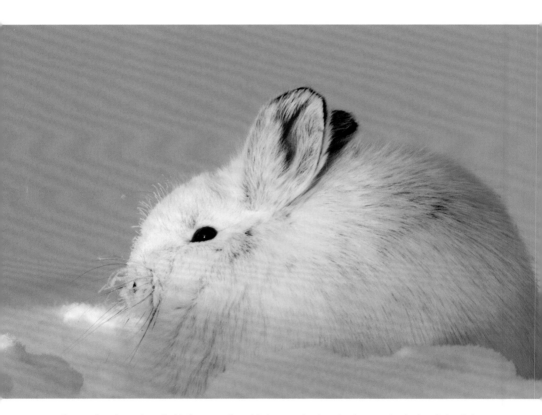

A snowshoe hare, tinged with frost at minus 30 degrees, hunkers in the snow in the last light of day.

# *Hare Today,*
# *Gone Tomorrow*

**IN A SHELTERED COVERT,** an all-white snowshoe hare sat motionless in the late autumn sun. Snow was overdue, and its coat—recently molted from summer brown—offered exposure rather than camouflage. The hare remained motionless as I glided through the surrounding thicket pretending I didn't see it. A short distance from the first hare crouched another, also exposed by its coloration. A few feet from that sat another, then another. The surrounding spruce forest held no hares, yet in that dense thicket—a refugium—I counted twenty-two hares in an area of more than two hundred square yards.

A friend, a bear biologist, recently asked me what my favorite animal was, assuming I'd say wolf or bear or some other charismatic critter. When I said, "Snowshoe hare," she seemed shocked. *"Really?"* Yes, really. Even before I came to Alaska, I was enthralled by the cycle of hares, spellbound by stories of animals beyond count and the lynx that stalk them. Their biology is remarkable. What other animal mates the same day it gives birth? Right from my cabin window I can watch their spring mating behavior and rituals as they course through the willows around my home.

Their remarkable population fluctuations provide a unique opportunity to study the interconnectedness of northern wildlife. Predators, everything from great horned owls to grizzly bears, feast on hares; populations of other species, like spruce grouse, respond to the cycles in subtle but profound ways. Four times I've witnessed the hare population cycle from boom to bust in Interior Alaska. Now, in the spring of 2018, the hares are on the increase once again, bringing change to the subarctic.

Every nine to eleven years snowshoe, or varying, hares cycle from scarcity to remarkable abundance. While the tight concentration I saw was not indicative of area-wide numbers, it did mark the zenith of the cycle. Over the

next winter the hare population crashed. The following spring not one hare, or set of tracks, crossed the same thicket.

Snowshoe hares range widely across North America, from western Alaska to the Atlantic Ocean, the northern limit coinciding with that of the boreal forest and the southern limit extending into the Rockies. Hares are relatively sedentary, with maximum home ranges of about twenty-five acres, half their activity confined to less than two and a half acres. Hares sometimes wander short distances from winter to summer range, depending on the quality of the habitat.

Adults average eighteen to twenty inches in length, with males weighing about three and a half pounds, females slightly less. A hare's summer coat is a mottled brown or gray with white underparts. As winter approaches, a glandular adjustment triggered by decreasing amounts of sunlight causes a pelage molt to white, thus the name varying hare. Huge, furred hind feet act as snowshoes, enabling travel over deep snow.

"All wild animals fluctuate greatly in their populations, none more so than the Snowshoe or white-rabbit," wrote pioneer naturalist Ernest Thompson Seton in his 1911 classic, *The Arctic Prairies*. "The species increases far beyond the powers of predaceous birds or beasts to check, and the Rabbits after 7 or 8 years of this . . . number not less than . . . 6,000 to the square mile. . . . Following the population peak, hares die off until they seem almost nonexistent."

Seton accurately concluded that predators, no matter how numerous, could not control the hare population explosion. Initial research in the mid-1920s detailed the hare's remarkable fertility, which powers the expansion. Breeding season begins in early spring. Females breed when they are about a year old and can mate on the same day they give birth so that litters might be spaced apart only by their thirty-six-day gestation period. Nearing peak population, each female has three or four litters per summer, each litter numbering from one to nine. Reproductive rates vary geographically, highest in Canada's three prairie provinces, lower in northern Alaska. Hare populations in one Alaskan study area peaked at 1,600 to 1,900 animals per square mile, while those in an area in Alberta reached 3,000 to 5,900 animals per square mile, a figure remarkably close to Seton's guess. At the low end of the cycle, these same habitats may harbor only 20 hares per square mile.

Birthing and rearing is simple. Unlike rabbits, hares do not burrow but instead bear their young on the ground in an unlined hollow, or form. While rabbits are born blind and hairless, young hares, called leverets, are born with their eyes open, fully furred, and nearly ready to hop. They nurse only once a day and begin to browse shortly after birth. At three weeks of age they are self-supporting.

The cyclic pulse of hares between superabundance and virtual absence has long fascinated observers. The fluctuations can be traced back over two hundred years in the fur records of the Hudson's Bay Company. The cycle of lynx, an animal peculiarly adapted to feasting on hares, somewhat parallels that of the hare.

Hare populations crash dramatically. Seton, like many early naturalists, blamed the decline on a virulent "plague" that killed off all but a few random survivors. Seton estimated the density of hares in prime habitat after a crash at one per square mile. People to this day still cling to the notion of a mysterious, lethal disease periodically savaging the hare population. Despite extensive research, no single parasite or disease has been identified. Researchers agree that heightened mortality and decreased reproduction lead to the crashes but debate the sequence and triggers of such events. A few ecologists believe the trigger for the decline is an inherent population regulation mechanism, or "stress," while most researchers assign the cause to a nutrition/disease/predation complex.

Lloyd B. Keith, professor emeritus at University of Wisconsin–Madison, and his students studied hares in northern Alberta continuously for over five decades. Their research focused on long-term population fluctuations with related investigations into nutrition, predation, disease, and physiology. They tested and evaluated several divergent theories. In one study, hares were transplanted onto islands and the artificially high densities monitored closely. Keith found that populations were adversely affected by food shortages with no indication of self-regulation through stress or disease.

"We could find no evidence that either parasitic or viral disease, or social stresses were acting as direct mortality factors," Keith told me. Pregnancy rates and adult survival rates in these high-density populations did not differ from natural populations. "But juvenile survival was markedly lower," he said. "Their loss appeared to have been directly linked to food scarcity."

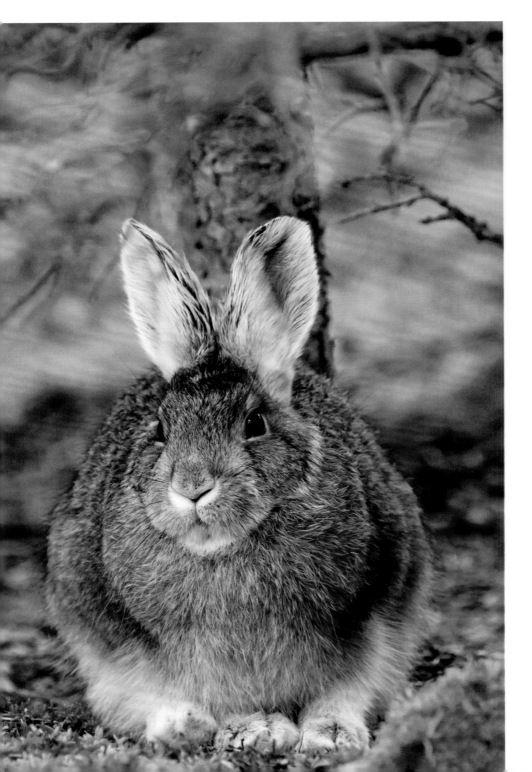

In summer, hares graze leafy plants, grasses, and forbs; in winter, they browse bark and twigs of favored foods like willow. Because hares are not self-regulating, they are able to expand their populations beyond the carrying capacity of their habitat. Intense overbrowsing destroys both bushes and trees, and can be catastrophic. The hare-vegetation interaction becomes critical when essential browse falls below that needed for the population's winter survival. When forage becomes scarce and of reduced quality, reproductive rates decline, juvenile mortality increases, and the entire population weakens and starves.

In controlled feeding experiments in Alaska, hares maintained weight and health indefinitely under winter conditions if fed a diverse diet of high-quality plant material. By contrast they survive only a few days when fed nothing but alder and other less palatable plants.

At the peak of their cycle, hares occupy all available habitat, but as the population declines, the first areas vacated are the more open, marginal zones. Research has shown that the interaction between hares and their food is more complex than simple overuse. Woody plants respond to severe browsing by producing toxic resins that discourage, even sicken, browsers, which further limits food availability. When browsed, young spruce trees put out a concoction of potent chemicals that affects hares.

Some observers thought the last hare cycle in Denali Park peaked in 2007. Instead of a sharp decline, however, the population continued to expand for another year or more. On one evening drive from the Toklat River to Highway Pass that year, I counted 110 hares along the road. The peak cycle, at least by my estimation, came two years later. In the aftermath, huge swaths of terrain stretching west from Igloo Creek to beyond the Toklat River looked as if a mowing machine had trimmed the woody plants at snow line, some down to ground level. Many plants were entirely girdled and killed. In the wake of three consecutive winters of overbrowsing, areas in Sable Pass formerly covered by dense shrubs morphed into open fields of dead sticks. Prior to the peak, a moose could have easily hidden in those mature thickets that afterward could scarcely hide a fox. Abundant hares had accomplished a large-scale alteration of the dominant plant community on par with the way wildfire alters a landscape.

By early autumn, a hare's summer coat is already beginning to molt to white for winter.

I have witnessed high numbers of hares, and the aftermath, on the Delta River, on the Koyukuk and Wood Rivers, but never to the extreme seen in Denali. I do recall some severe, localized overbrowsing along the Koyukuk River in the early 1990s but nothing so widespread. In some instances hares at peak cycle can out-compete moose for available browse, putting further stress on the big deer's ability to survive the winter.

It appears to me that weather fluctuations impact hare cycles. A succession of mild winters, with minimal snow cover, likely played a huge part in allowing hare numbers in Denali to cycle so high and persist so long, culminating with the overbrowsing and habitat alteration so obvious to even casual observers.

The habitat transformation leaves several questions: What plants will thrive in the open spaces? Will invasive plants conquer newly opened terrain and benefit from a longer growing season? What animal species will benefit from the new growth? Moose? Caribou? Only time will reveal the winners and losers in the lottery of climate change.

Snowshoe hares are a biological force of nature that transforms the landscape and plays an outsized role in the food chain. It is evident that as reproduction falters from nutritional stress, intense predation accelerates the decline. "Predation does not initiate population declines among hares," Keith said, but rather "predation tends to be a dominant depressive form of mortality on declining and low populations, [which] may increase intervals between population peaks."

Almost every land carnivore feasts on hares, including wolves and grizzly bears. Wolves rear larger litters when hares are abundant than in years when they are absent. I once tracked a grizzly through fresh, calf-deep snow. On that occasion I carried a shotgun as well as a camera. At one point the trail abruptly stopped, as if the bear had vanished. Yards away, on the far side of a dwarf birch thicket, I found where the bear had pounced on a snowshoe hare, the sullied snow stained with blood and hair.

Cyclic changes ripple through the entire ecosystem. Reduced wolf populations result in more coyotes, and more coyotes mean greater predation on Dall sheep lambs. When hare numbers are up, so are coyotes, and more coyotes eat more lambs.

The flood of hares benefits avian predators of all kinds but especially goshawks and great horned owls. In Alberta, the relative biomass of hares in the diets of nestling horned owls increased from 23 percent during one hare

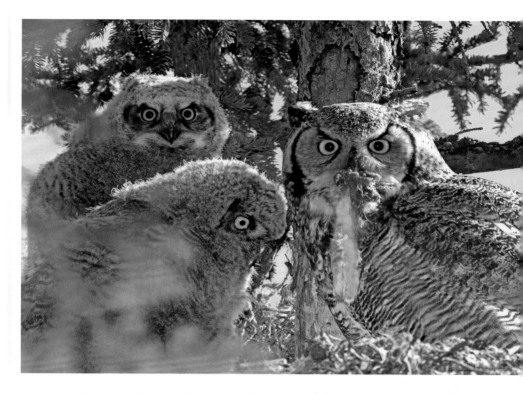

A great horned owl feeds her owlets pieces of a snowshoe hare, their almost exclusive diet during peak cycles.

low to 81 percent during the following peak. In Alaska, researchers found that goshawks failed to nest at all in years of low hare populations. One summer I kept watch on a horned owl nest and saw the female feed her owlets a nearly exclusive diet of hares. (One morning I watched her swallow a small whitefish and then feed the owlets a leveret.)

Mark O'Donoghue and Susan Stuart, of the Yukon's Kluane Boreal Forest Ecosystem Project, discovered that red squirrels are the chief predators of hares less than two weeks old. In fact, during the decade-long study, red squirrels killed and ate nearly half of all the snowshoe hares born at Kluane. If the leverets survived for two weeks, they were strong and agile enough to avoid these enemies.

"Of all the northern creatures none [is] more dependent on the Rabbits than is the Canada Lynx," wrote Seton. "It lives on Rabbits, follows the Rabbits, thinks Rabbits, tastes like Rabbits, increases with them, and on their failure dies of starvation in the unrabbited woods."

These large, amber-eyed wildcats possess oversized paws that allow them to float atop the snow, enabling pursuit of hares in places where foxes or coyotes would only flounder. (In square measurement, a snowshoe hare hind foot is bigger than a lynx's.)

Lynx reach their population peak one or two years after the hare peak and can become quite numerous. Lynx on the upswing have three to four kittens—on the downswing of the cycle, one or none. Until 2008, I had seen less than a dozen lynx in the wild, including a sighting of a female trailed by five kittens. In 2008, in and around Denali, I saw nearly twenty lynx, including six near my cabin. I photographed a lynx hiding in the snow near my bird feeder in quest of an unwary bird.

When hares are abundant a lynx may make a kill every one or two days, devouring an entire hare in one meal or caching some for later. A study by Professor Keith and his students revealed that at the cyclic low in 1965 to 1967, hares accounted for 40 to 50 percent of the lynx's prey. At the next peak in 1971 to 1974, hares comprised essentially 100 percent of their food. Even during summer, with an increased availability of other prey, hares still comprised 91 percent of the lynx's total diet.

Lynx hunt by stealth, often from ambush on a well-used trail, and use their retractable claws to bring down

A lynx pauses in its hunt for a snowshoe hare. A quick dash from ambush is its usual hunting method.

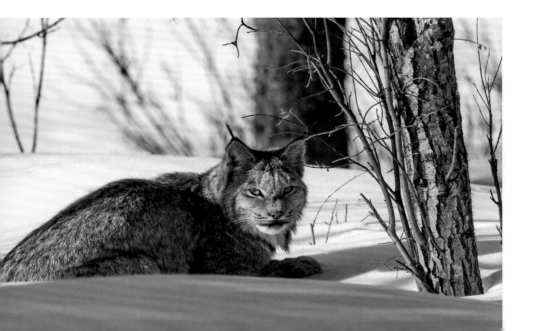

their prey. Lynx are excellent swimmers and will stalk waterfowl. After the hare population crashes, lynx turn to red squirrels, rodents, and birds for sustenance. (Voles may be more important prey than squirrels.) A trapper told me that lynx are very skinny when feeding exclusively on hares but fatten dramatically when they turn to squirrels and grouse.

Lynx sometimes kill bigger animals, even mountain sheep. On an island off Newfoundland, lynx killed 65 percent of spring caribou calves. These silvery cats have their predators too. Wolves kill and eat them. A friend saw three coyotes drive a lynx onto an open lake, attack, and kill it.

Lynx kits are born aboveground in April and May under the shelter of uprooted trees or in hollow logs. In mid-May 2005, I found a lynx nest. My notes: "A furtive movement in the brush. A shadow of gray and tan flowing toward and into a dense tangle of branches at the base of a blowdown. A ripple of fur flutters on a twig. Through binoculars the yellow eyes burn through the slight opening in the jumble. The warning implicit, direct. The feral response of a protective mother. I have no intention of going closer but content myself with the sounds of mewling kittens."

Female lynx may breed at about one year of age, dependent on the availability of prey, with rearing success directly tied to hare abundance. As hares decrease, it becomes increasingly difficult for a female lynx to rear her young. Over 70 percent of the total lynx population may starve following a hare crash. During the following three to four years, as the hare population starts to rebuild, lynx will breed, but the kittens die before winter, the adult female simply unable to support both herself and her litter. Hunger sets these usually sedentary cats to wandering. A lynx tagged at Kluane Lake ended up on the Porcupine River, 450 miles to the northwest. In late 2018, one collared Alaskan lynx had roamed a thousand miles to the east into Canada's Northwest Territories and was still going.

For about a year following the peak in the hare cycle, intense predation on the hares depresses their numbers well below the habitat-dictated potential, thus accelerating the period of decline. The continuing hare shortage leads to high predator mortality. As predators rapidly decline in numbers, and intense predation fades, the hare population rebounds. As vegetation recovers from overuse, hare birth rates and juvenile survival zoom upward, fueling another population expansion.

In 2017, eight years after the cycle crashed in Denali, hares were on the increase. Following a winter of normal snowfall, red-backed voles abounded. Consequently, short-eared owls and northern hawk owls appeared in uncommon numbers. (In 2017, I saw twenty hawk owls—my previous record, two in one summer.) Spruce grouse were also abundant. The absence of foxes, coyotes, lynx, and owls and the rebounding vegetation benefited all the prey species. (In the Yukon Territory, researchers concluded that numbers of grouse, willow ptarmigan, and ground squirrels often mirror the swings in the hare population.) That spring I saw the first lynx in five years, when it trotted across the road with a hare clamped in its jaws. Soon, a multitude of golden eyes would sear the coverts as owls and cats searched for hidden prey.

# To the
# Mountains Again

## I

**FRESH SNOW BLANKETED THE PEAKS** of the Chugach Mountains, vast forests of autumn gold shimmering to the snow line. Shafts of light dappled the ridges, and I watched geese winging low over the treetops. Nearer, two ravens circled on the breeze. Instead of tranquility, an overwhelming dread colored my spirit.

I was standing at a wall-sized window in a high-rise in midtown Anchorage, far from where I longed to be. A kind man sitting at a desk had been speaking in measured tones for some time, yet I'd heard almost nothing since his opening words: "You have cancer."

Dr. Dale Webb held the biopsy report in front of him, and he read and explained all the details, yet all I could hear were echoes of that word. All the futile thoughts and emotions raced by. *This can't be right. I'm thirty-seven and healthy as a mountain sheep. I'm not ready for this. I have a daughter in third grade. What about her? I'm all she has. Why now? Why me?*

The day before, I had been on Round Island in Bristol Bay with friends, enjoying one of the wildest places in Alaska, savoring the wildlife and wind and sea, the anthem of the wild. Only my daughter and the family she was staying with while I was gone knew my whereabouts. Three weeks before the trip, I'd had a biopsy taken of a troubling lump. Doctor Webb had told me to check back for the results after my trip. He only knew I was going to the bush, not where or for how long. Since he didn't seem too worried, neither did I.

Round Island then had no development of any kind except for a small shack that housed the sanctuary staff. On an evening visit there, the HF radio crackled to life for the daily report to Dillingham headquarters. Weather, walrus counts, observations, and grocery orders were transmitted. Then came a

stunner: "Tom Walker's doctor wants him to come to town." I looked at my friends, incredulous. "What doctor?" I asked. "No one knows where I am." They relayed the comment, but the message came back the same, more emphatic than before.

But how to get off the island? I'd arrived by floatplane, but a storm and nightfall prevented a charter now. Three commercial fishermen had come ashore that day to view walrus, and their boat was anchored in Boat Cove. They radioed that they were going to the village of Togiak in the northwest corner of Bristol Bay, the only safe port in the waxing storm. If I could be ready in fifteen minutes, I was welcome to join them.

We pulled anchor in darkness and motored off into the rolling sea. The storm intensified as the long night wore on, turning the trip into a nightmare. I'd crewed on similar boats and never been seasick, even in heavy water, but this night was different. The plunging and bucking in total darkness created havoc on all but the captain, who sat at the wheel staring into the green glow of the radar, the sum of his visible world.

Near dawn, when finally we pulled into the calm of Togiak Bay, I was never more thankful in my life

In 1983, instead of being in the outdoors where I longed to be, I was mired in another wilderness that tested my spirit and endurance.

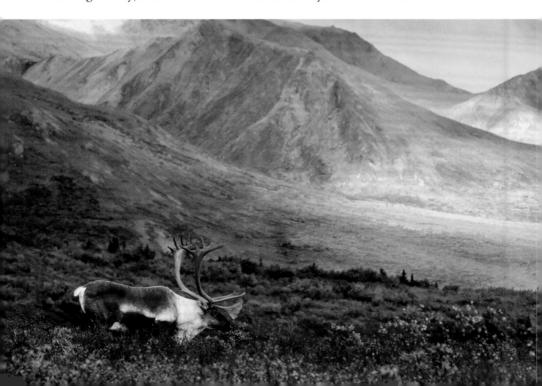

to set foot on solid ground. I hurried to catch the mail plane to Dillingham, where I then caught the scheduled flight to Anchorage. There, I drove to the doctor's office. Redolent with the scent of a seabird island, and dread dogging my steps, I signed into reception.

"Oh, here you are," said the nurse. "Thank goodness. Doctor Webb has been trying to get ahold of you." She explained that Doctor Webb had remembered me saying that I was going to Southwest Alaska, nothing else. When Webb got the pathology report back, he instructed his nurse to call every natural resource agency around Bristol Bay to see if they knew me or my location. The nurse called the National Park Service, the Department of Fish and Game—and everyone else she could think of—in King Salmon, Togiak, Dillingham, and even Kodiak before connecting with the wildlife biologist in Dillingham who knew me.

After three surgeries and six weeks of radiation therapy, I was sent home, the future uncertain but better than it would have been without Doctor Webb. During the long weeks of treatment, just when the crushing burdens seemed the worst, images of nature buoyed my sagging spirits. Just as conservationist Rachel Carson once said, "Those who contemplate the beauty of the earth find reserves of strength that will endure as long as life lasts."

## II

Thirty-five years after my cancer diagnosis, sawtoothed mountains pierce leaden clouds that hint at rain. In the calm, cool air, swarms of mosquitoes torment us and nearly drown out the sound of the river purling over the riffles. My friend Sam and I shiver from immobility as we wait for the salmon to arrive and the nearby bears to respond.

Behind an enormous driftwood log, we sit primed for action. The salmon are just now trickling in, and the nearby riffle is a favored spot for hungry bears. Six of them graze or sleep on the strand waiting for the wake-up call of splashing fish. Yesterday, a chum salmon struggled into shallow water and a bear raced in from fifty yards away for the catch. Three distant bears also zeroed in. In moments the chase was on—the bear with the fish clamped in its jaws leading an ursine version of capture the flag. At one point a bald eagle tried to steal the fish, repeatedly dive-bombing the leader, a testament to the desperation felt by all the fish eaters.

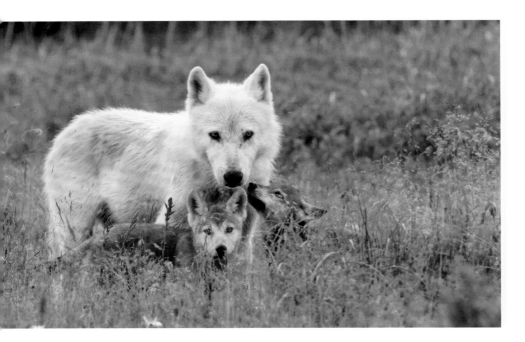

Today the incoming tide is perfect for propel-
ling a run through the shallows, but we've not seen
or heard a single fish. In nine days we've seen three
fish caught, two by brown bears and one by a wolf.

A white wolf stands over two of
her four pups, part of a pack of
seven that depends on salmon
for their summer sustenance.

Two of the catches were in the same evening, all within five minutes, then
nothing more.

So far our trip has been unproductive, long days of slogging over meadows
and tundra, stakeouts and searches, patience and perseverance, in the waning
hope for salmon to materialize.

The wait is not without compensation: vistas of snow-pocked mountaintops,
foggy tendrils drifting over emerald slopes, and sedge flats ablaze with pushkis,
wild geranium, chocolate lily, and fireweed. To the east, the tidal flats stretch a
half mile offshore to rocky islands entangled in mist. Eagles, gulls, and ravens
soar and dip over the sand beach covered post-storm with seaweed and flotsam.
A lone bear, matted by rain and mud, digs for clams, engraving the flats with its
tracks and excavations—a mere dot against a vast tidal flat sweeping to distant
horizons. A flight of mallards passes overhead, high and riding the north wind.

TO THE MOUNTAINS AGAIN

We came to photograph bears, but infrequent sightings of wolves have jolted us. Distant glimpses and nightly howls engender dreams of photographing wolves fishing for salmon.

Our time is running out, our last day waiting for salmon. Today we've spent hours waiting while summer pelts us with handfuls of mosquitos. The long, slow wait hidden behind the drift log has not extinguished our hopes.

Hours into our vigil, Sam leans over and whispers, "What d'ya think?"

"About?"

He laughs, "Anything?"

"The salmon will show up in fifteen minutes," I say, to lighten the moment.

He laughs again—then his eyes grow wide, staring past me and over my shoulder. "Look!"

A tawny-colored wolf has emerged from the tall beach grass and begins to hunt voles in the sedge, unaware—or uncaring—of our presence. I slowly roll to my knees, spin my camera to track the wolf as it wanders our way. Several times it stops, cranes its head side to side, picking out the sounds of scurrying rodents. It pounces once like a fox but comes up empty.

The wolf must hear our camera shutter clicks but only briefly looks up. As the minutes tick by, it seems obvious that it knew we were here long before it came into the open and has dismissed us as a concern. It wanders to within a few yards of us, pausing on the bank to look and listen for salmon. Disappointed, it turns away and resumes the search for voles. It passes within feet but deigns to give us only one quick stare.

My pulse soars. Seldom have I had such a close observation of a wolf hunting voles. I'm totally absorbed in its search, the stonelike stance as it listens for movement, the intensity of its focus. Chickadees fuss in the alders behind me. (I heard their alarms once before when wolves passed by.) I look over my shoulder and see a line of wolves emerging from the alder and beach grass. A large white wolf, a female, is in the lead, two slightly smaller wolves at her heels.

I dare not move or breathe, experience telling me the leader will see us, stop short, and bolt back into the brush, leading the pack to cover. Incredibly, they keep coming, none looking our way. Then more appear. Four small pups trot into the open.

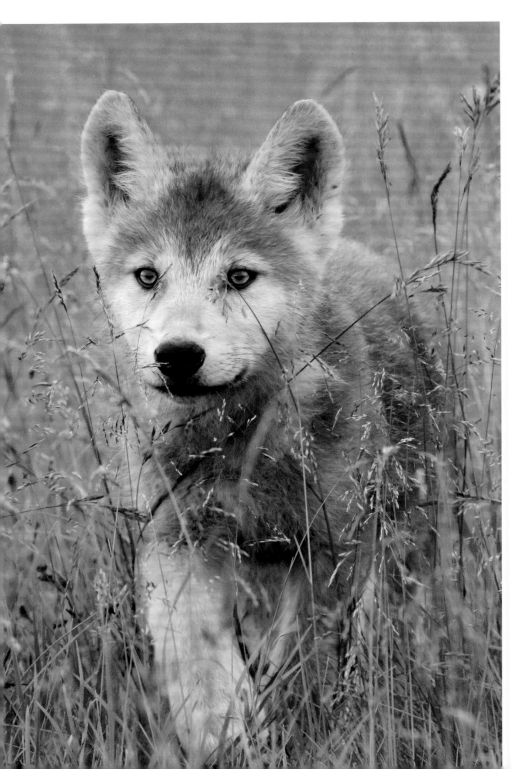

The white wolf leads a single file of two yearlings and four pups into the sedge meadow. Lagging behind, a large gray wolf emerges from the tall beach grass, the big male we'd seen fishing in the riffle several days before. He spots us, freezes, barks out a warning. The pups race back to him and into the thicket. The yearlings seem confused, nervous, eyes darting everywhere but at us. The white female remains serene, as if to say, "What's the fuss?"

The yearlings take their cue from her and calm down. The pups bolt back into the open as if summoned, surrounding the female to beg for food. The male, now silent, emerges from cover but hesitates.

With trembling hands I begin taking pictures. The wolves clearly know we are here, but the leader seems not to care, appears totally relaxed. I watch the pups nip at her muzzle. She puts her head down, regurgitates a morsel, and a pup snaps it up. She has nothing more.

The brown pups look to be about six weeks old and weigh around fifteen pounds, still too wobbly to have moved any distance from a den or rendez-vous site. The white and gray are full-grown; the three smaller, tawny-colored wolves are two-thirds size, last year's litter. A week ago, we saw another adult wolf, alone near our camp, perhaps an adult separated from this pack.

A yearling begins to hunt voles, two pups at its heels. Another yearling pauses to study the riffle, alert for salmon. Only the gray wolf seems wary.

The wolves disperse around us, none giving us more than a passing glance. Thirty yards behind us, the pack—sans gray male—comes together. The vole hunter joins in, fawning and cringing before the female, assuming classic sub-missive postures. One by one the pups nip at its mouth, begging to be fed, but it has nothing to give.

The alpha female accepts the commotion but seldom takes her eyes off the river. In tall grass she sits, then lies down, facing the water. The pups surround her, but she ignores their clamoring. The yearlings wander, one trailed by a pup, exploring the riverbank and meadow, another hunting voles. The large male is still unsettled, as if uncertain of our threat. He wanders the far side of the pack, picks up a long stick, and prances away, enticing two pups to follow him into the brush.

A curious pup approaches us for a close look. Nearby adult wolves allowed the pups to wander at will.

As if settling in for a long vigil, the white wolf puts her head on her paws and soon dozes off. A yearling reclines nearby. A pup wanders back out of the brush

near where the male disappeared and returns to the pack. Other pups wander fairly far from the immediate protection of an adult. One pup approaches to within ten feet of us and stares with inquisitive eyes.

Soon, all the wolves except the male and one pup are sprawled asleep in the grass. Partly hidden behind the log, I slowly stand up so that I can shoot over the tall grass that obscures the view. Sam maintains his lower angle. The female takes one glance my way then lolls to her side like a dog before a warm hearth.

I gape in wonder. Seven wolves, pups to adults, all within a stone's throw, totally relaxed and unconcerned. I read the scene with reverence. We have all the impact of a lichen-covered rock.

The silence is broken only by the creek and distant squabbling magpies. A serene tranquility transforms the day, the pestering bugs long forgotten. Several times the white wolf rolls onto her back, writhing on her spine, all four legs twitching in the air.

The wolves' apparent inattention is deceptive. When a brown bear ambles along the edge of the meadow, the female and one yearling spot it immediately. Even in sleep they seemed to have heard it shuffling though the grass. As the bear ambles off, the wolves relax.

As the day stretches on, we watch the pups wander off one by one into the beach grass where they came from. The female never looks up, somehow assured that her pups are safe.

A flooding tide late in the day forces us to leave. Moving cautiously, Sam and I make a wide loop around the resting wolves, only one yearling studying our passage. From a hill a short distance away, I look back as if into a dream at the wolves sprawled asleep in the grass.

# *About the Author*

Tom Walker, a fifty-year resident of Alaska, lives near Denali National Park. He has worked as a conservation officer, wilderness guide, wildlife technician, log home builder, documentary film advisor, and adjunct professor of journalism and photography.

He is a full-time professional photographer and writer specializing in Alaska natural history and wildlife. His credits include numerous national, local, and international publications. Some of Walker's nature images have won local, national, and international competitions.

Walker is the author and photographer of sixteen books and coauthor of four travel books. His natural history writings have been anthologized in several collections. His book *Caribou: Wanderer of the Tundra* won the 2000 Benjamin Franklin Book Award in the category of Nature and Environment. In 2006, Walker won the Alaska Conservation Foundation's Daniel Houseberg Lifetime Achievement Award for still photography. In 2013, the Alaska Historical Society named him Alaska Historian of the Year by for his book *The Seventymile Kid: The Lost Legacy of Harry Karstens and the First Ascent of Mount McKinley.*

In 2002, Alaska's governor appointed him to the Citizens Advisory Committee for the Alaska Interagency Kodiak Brown Bear Management Team, and Walker helped draft the first comprehensive brown bear management plan for the Kodiak Archipelago. That same year, his photographs appeared at the Canadian embassy as part of a traveling photo display entitled *Saving the Arctic National Wildlife Refuge.*

recreation • lifestyle • conservation

**MOUNTAINEERS BOOKS**, including its two imprints, Skipstone and Braided River, is a leading publisher of quality outdoor recreation, sustainability, and conservation titles. As a 501(c)(3) nonprofit, we are committed to supporting the environmental and educational goals of our organization by providing expert information on human-powered adventure, sustainable practices at home and on the trail, and preservation of wilderness.

Our publications are made possible through the generosity of donors, and through sales of more than 800 titles on outdoor recreation, sustainable lifestyle, and conservation. To donate, purchase books, or learn more, visit us online:

**MOUNTAINEERS BOOKS**

1001 SW Klickitat Way, Suite 201 • Seattle, WA 98134

800-553-4453 • mbooks@mountaineersbooks.org • www.mountaineersbooks.org

*An independent nonprofit publisher since 1960*

## YOU MAY ALSO LIKE: